THIS BOOK IS THE PROPERTY OF
NATIONAL CITY PUBLIC LIBRARY

P9-DWU-846

84-11

NCPL J

DATE DUE
18 96

National City Public Library
200 East 12th Street
National City, California 92050

DATE DUE
02 20 98

TO SMILE IN AUTUMN

GORDON PARKS

To Smile in Autumn

in Autumn

A MEMOIR

W · W · Norton & Company
New York · London

Grateful acknowledgment is made for permission to reprint previously published material.

The material from the article *Jazz* was first published in *Esquire* magazine.

A selection from "A Certain Weariness" from *Extravagaria* by Pablo Neruda, translated by Alastair Reid. Translation copyright © 1969, 1970, 1972, 1974 by Alastair Reid. Originally published as *Estravagario*, copyright © 1958 by Editorial Losada, S.A., Buenos Aires. Reprinted with the permission of Farrar, Straus & Giroux, Inc., the Estate of Pablo Neruda, and Jonathan Cape, Ltd.

"The Negro Speaks of Rivers." Copyright 1926 by Alfred A. Knopf, Inc. and renewed 1954 by Langston Hughes. Reprinted from SELECTED POEMS OF LANGSTON HUGHES, by Langston Hughes, by permission of Alfred A. Knopf, Inc.

Abridged and adapted entries from GI DIARY by David Parks. Copyright © 1968 by David Parks. Reprinted by permission of Harper & Row, Publishers, Inc.

Specified excerpts from THE LEARNING TREE by Gordon Parks. Copyright © 1963 by Gordon Parks. Reprinted by permission of Harper & Row, Publishers, Inc.

The author has here recast material dealing with the 1960s earlier presented in his BORN BLACK, copyright © 1971, 1970, 1968, 1967, 1966, 1965, 1963, 1948 by Gordon Parks, published by J. B. Lippincott Company.

"If As You Say" and "Child Coming" from A POET AND HIS CAMERA by Gordon Parks. Copyright © 1968 by Gordon Parks. Reprinted by permission of Viking Penguin Inc.

Copyright © 1979 by Gordon Parks
Published simultaneously in Canada by George J. McLeod Limited,
Toronto. Printed in the United States of America.
All Rights Reserved
FIRST EDITION

Library of Congress Cataloging in Publication Data
Parks, Gordon, 1912–
 To smile in autumn.

 1. Parks, Gordon, 1912– 2. Afro-American
photographers—United States—Biography. I. Title.
TR140.P35A34 1979 770'.92'4 [B] 79–19225
ISBN 0-393-01272-7

Book Design by A. Clark Goodman
Text type is VIP Bembo
Manufactured by Vail-Ballou Press, Inc.

1 2 3 4 5 6 7 8 9 0

For Rose

Contents

Illustrations

Red, Herbie, and dead gang member, New York, 1948
Red and Herbie at gang rumbles, Harlem, 1948

Author's family, White Plains, New York, 1949
Gordon Parks, Jr.

Between pages 96 and 97

Ingrid Bergman and Roberto Rosellini on Stromboli, 1949
Ingrid Bergman on Stromboli, 1949

Place de la Concorde, Paris, France, 1951

Maxine de la Falaise, 1949
Bettina, Sophia Malgot, Jackie Stoloff, and Janine Klein
 modeling evening gowns, 1949

Paris, 1951
Author at piano working on *Concerto for Piano and Orchestra*, 1951

Pastor Ledbetter, Chicago, 1953
Pastor Ledbetter with dying woman, Chicago, 1953

Baptism, Chicago, 1953

Author explaining jet fighter maneuvers to Betty Baker, San Juan,
 Puerto Rico, 1955
Author with Patricia Blake, San Juan, Puerto Rico, 1954
Fighter jets over Puerto Rico, 1955

Between pages 160 and 161

Author and Gloria Vanderbilt, New York, 1954

Author's portrait of Gloria Vanderbilt, 1960

Duke Ellington, 1960

Author in New York
Author in Peru

Elizabeth Campbell Parks

Two roads passed my father's house
They went everywhere, with tolls
unfixed on unmarked distances
Paved with roses and thorns.
He said a few things
When I was packed to go:
The feel of your feet
Will reconcile the differences
Of which road you take.
There will be sign posts
 along the way
Giving out devious directions.
It's your right to question them.
But don't ignore them.
Each one is meant for something.

You will find that summer grass
underfoot, will be kinder
To your touch than autumnal weeds
Yet, during winter storms,
It will be the taller stalks
Leaning above the snow
That will catch your eye.
And you will learn
 that
All the same things
Are really not the same,
 that
You must select your enemies
With the same care I gave
To choosing your mother, or
Maybe the wood to build fences.
Avoid those things that die easily
And get your own soul ready
 to die well.
Don't get gray by yourself,
And don't be surprised

When as you grow older
You begin to pray more
And worry less.
Remember most that everything
I have told you might very well
 amount to everything
Or
Perhaps nothing. But be most thankful, son,
If in autumn you can still manage a smile.

TO SMILE IN AUTUMN

1

Garbage cans and supper

I spent months waiting for some logical starting point to declare itself, something which would help to put this memoir in its proper perspective. The wait ended one night during a party in a candlelit living room of Gloria Vanderbilt's summer place on the Southampton shore. I was a weekend guest, and I smile now, remembering the pleasure of that evening, warmed with celebrities of the Hamptons sipping champagne and good wines and chewing at delicacies from a well-spread table. A foreigner to myself, I had comfortably covered my skeleton with the distinction of the gathering. Then suddenly from across the room, knifing through the soft laughter and polite conversation, came Robert Alan Arthur's voice. "Gordon!" it boomed, "They're bringing in watermelon! Are you going to eat it?"

I glanced at the noted author and remained outwardly cool, but I would be lying to say that I accepted his jibe in the same spirit with which he delivered it. I was jolted back to those demeaning childhood days when I would have starved rather than eat watermelon in the presence of a white man; wrenched back to the brutally carica-

tured pickaninny with eyes popping, grinning behind a crescent-shaped hunk of fire-red watermelon.

The memory rumbled inside me, clamoring for reaction. Conversation between actress Dina Merrill and myself had stopped as though we had been struck mute; around us polite chatter paused and then continued discreetly. I smiled, went to the table, and chose two of the largest slices I could find. Caught up in his own indiscretion, Bob couldn't turn loose. He eyed me as if I was about to hang myself. "You're really going to eat it?" he asked almost dolefully.

"I love it, Bob," I said. "Always have, and I'm secure enough to enjoy it, even here." I sat down and finished the once forbidden fruit and went back for more.

I had crossed the world, completed the journey that had begun many years before when I was an angry youth trying to set things straight with myself. The crossing hadn't been easy. Two knife cuts—one beneath my dinner jacket, the other one on the left side of my nose; two crooked fingers and a dozen body scars from being shoved through a plate-glass window by three Irish lads many years before. Now, after this tiny incident, I sat unashamedly devouring watermelon in a candlelit living room that was fragrant with expensive perfumes.

Later that night I lay awake measuring the wide distance between then and now, knowing firsthand the things, the terrible things, poverty and bigotry can do to soul and body. No matter how many rewards the universe bestows upon you, to have undergone stonings, beatings, and being called "shine," "nigger," and "darky," remains unforgettable. But despite all this I had the good fortune of being born to Sarah and Jackson Parks—he, an impoverished dirt farmer. The love they gave to me and my fourteen older brothers and sisters was enough to offset the misery of growing up black in America. I remembered other things about those early days—the lush green cornfields bending and tearing apart during the frightening Kansas twisters, my sister Anna hiding beneath the bed, screaming in terror with each lightning flash; on calmer days the flowering apple trees, the gurgling streams, so clear one could see minnows scurrying to shelter beneath the rocks; the long sleepy summers for swimming the creeks, catching June bugs to buzz on dirty strings; the butterflies fluttering over chin-high grass on their undetermined

flights; the bluebird; the fireflies flickering the blue-black nights; the cold silver rains of September and white Decembers when food grew scarce and there was nervousness in our laughter. After Momma died and our family broke up, I was shipped off to the cold reaches of Minnesota. And there, at sixteen, I became an expert student of poverty and hunger. Much later, I wrote about the bitterness of those times—first in *The Learning Tree* and later, *A Choice of Weapons*. So I go on now to begin where I left off. For me, it suffices that having once foraged in garbage for my supper, I have since eaten watermelon in public.

<p style="text-align:center">* * *</p>

In late December of 1943, having been stripped of my Office of War Information correspondent's credentials, I left a military embarkation port at Newport News, Virginia, drove to Washington D.C., and boarded a plane for New York City. A few hours before I had said goodbye to the pilots of the 332nd Fighter Group whom I had been assigned to cover overseas. Following the all-black 99th Pursuit Squadron, they would be the first group composed only of black pilots to fight in World War II as a totally segregated unit. Europe and Great Britain were reeling under the relentless Fascist bombings. America's forces were bleeding, too, but America was still Jim Crow. These particular pilots would fly their operations under great odds. Unlike their white counterparts, they would not be split up and placed among the seasoned allied squadrons for their first flush of battle. The whole group of inexperienced fliers would meet the Luftwaffe fresh from a Michigan training field, where the sky's most hostile adversary had been a chicken hawk. Now they were headed for the real thing, an enemy who fired real bullets and dealt death.

I had desperately wanted to be with them, but I had been evicted from the embarkation port a day before the group was to sail. It was crushing. I had grown fond of these men during the months I'd flown with them. I admired their humor, their courage as they went about the serious business of becoming fighter pilots. Already they had fought valiantly just to become airmen—to fight for a country that would still ghettoize them even in the enemy air corridors. A plea to Colonel Benjamin O. Davis, the black commanding officer,

proved fruitless. He was a West Point man, and West Point men follow orders. My credentials, cleared two days before at the Pentagon, were now mysteriously "out of order." That was it. No explanation was offered. Ted Poston, an agency official, explained later. "It's simple," he said. "Several Southern Congressmen are dead set against OWI giving international publicity to black airmen." It still remains a mystery who actually sent the Colonel my eviction order. Certainly it didn't come from the Pentagon. The officials there, authorized to issue such an order, denied it to the last man.

As my taxi reached the high point of New York's Triborough Bridge I could see Harlem's dreary rooftops on the horizon. I didn't know what lay ahead of me. Suddenly, with two children and a pregnant wife back in Minnesota, I was broke and out of a job. It would be like starting all over again. The taxi left the bridge and rolled into Harlem, the battered place of tired tenements and garbage cans. Icy winds swirled trash up from the gutters and sent black people hurrying along in its fury. I had a hollow feeling where my stomach was supposed to be, and clenched my jaws as I braced for another struggle.

I was born with a stubborn need to be somebody, but New York's Harlem, back in the 1930s, had already taught me how hard it would be to fill that resolve. There I had found out the difference between rural and urban poverty. As a boy in Kansas I eased the pain of hunger by turning to a mulberry tree, digging a turnip or a potato from the earth, or snatching an apple from some farmer's orchard. In Harlem there had been only the garbage can to forage for supper. It was a dirty poverty, filled with stink, fright, and loneliness. The knife and gun were always there offering survival—along with imprisonment or maybe death. Those had been bad days. The fear of them, even after my horizons brightened, haunted me, drove me to try and keep moving forward.

My lack of education had also helped perpetuate the fear, and perhaps that is why I eventually tried so many different things to stay alive. If one failed there would always be something else to fall back on. I imagined all the possible nightmares I might have, and I thought up ways to escape them. If I went blind I could still play the piano well enough to make a living. If I lost my legs I could still

compose music or even take pictures. Nothing was overlooked. I didn't want to be that poor again.

The safest and cheapest place to stay in Harlem was the 125th Street YMCA. I had the taxi wait while I went inside to get a room. When the clerk told me that they were filled up, desperation set in. Night was close; a good hotel was too expensive to consider, and the shoddier ones were too dangerous. As I was about to leave, an attractive young woman took the clerk's place at the window. "With the Air Force, soldier?" she asked, glancing at my crushed officer's cap.

"Until a few hours ago."

"The 332nd?"

"That's right."

"Selfridge Field?"

"Until they moved us out."

"Know Spurgie Ellington?"

I brightened. "You bet I do. Is he a friend of yours?"

Her smile revealed a lovely set of teeth. "My husband." Leaning forward she whispered, "Do you know where they're going?"

"Nope," I lied, knowing that at this very moment they were probably sailing toward Italy. "So you're Marie?"

She was surprised to hear me call her name, and pleased when I said Spurgie had often talked about her. Joy spread over her face. "You want a room? One moment," she said and disappeared. After a few seconds she returned. "We're all booked but we'll find someplace to put you up." Spurgie, good old Spurgie who had once landed his P-40 on a Michigan highway after running out of petrol. I blessed him as I headed for the taxi to get my gear. Later that evening over coffee and a sandwich we talked of Spurgie and the other pilots. "They're gone by now," she said. It was both a statement and a question. I had the answer but I couldn't give it to her. There were too many good men aboard that ship. And General Davis had sworn me to secrecy. One innocent slip of the tongue, one German torpedo, and the 332nd Fighter Group could meet its end at sea. Her eyes moistened. "I wonder if I'll ever see him again." As I assured her she would, I wondered with her.

There was no time to waste. My pockets held barely two weeks rent—even less for food. Early the next morning I was once again on the streets of New York, hunting down work. But this time there

was a difference. Now, at least, I was prepared as a photographer and had definite hopes of becoming a journalist.

In 1942 I had trained as a Julius Rosenwald Fellow in the photographic section of the Farm Security Administration—a government agency set up by President Roosevelt to aid submarginal farmers. I had worked under Roy Emerson Stryker, a remarkable man with sparse technical knowledge of cameras but an acute awareness of their power to communicate. An ancient, red brick building had headquartered us. From it the world's finest documentary photographers had fanned out across Oklahoma, California, and the deeper South to capture stark images of men, women, and children caught up in the confusion of a devastating poverty. Dispossessed and beaten by dust, storms, and floods, the migrants had roamed the highways in caravans of battered jalopies and wagons, scrounging for work. Some were so poor they had traveled by foot, pushing their young and newborn in buggies and carts. The makeshift shanties dotting the desolate landscapes were built of scrap wood; the walls were covered with newspapers. I had known poverty firsthand, but there I had learned how to fight its evil—along with the evil of racism—with a camera. Among the photographers who had been working at FSA were Dorothea Lange, Russell Lee, Carl Mydans, Arthur Rothstein, John Vachon, Jack Delano, John Collier, Walker Evans, and Ben Shahn. Their memorable photographs, full of the intolerance of the poor, indicted America and could only have been done under a president like Roosevelt. But late in 1943 the FSA had collapsed and most of our group had been dispersed to the Office of War Information. But the OWI had met its end shortly after and the photographers had scattered. Stryker, it was rumored, was going to Standard Oil of New Jersey and might take some of his staff. Now, in 1944, I had no hopes of joining him there; the only blacks this huge conglomerate hired, at the time, were either messengers or janitors. Yet I was assaulted that first morning with a mixture of fear and hope. Earlier, Stryker had given me the names of the renowned photographer Edward Steichen and Sarah Little, a magazine editor. I called Ms. Little and she asked me to come after lunch. This pleased me since it gave me more time to collect my thoughts. I drifted over toward the East River and walked alongside it for an hour planning and wishing. The morning had opened up and everything was sud-

denly bright; the water sparkled like a jewel. In the distance I saw a tugboat, jet-black against the sun, inching a line of coal barges through the river. Raising my camera I took a shot of it, and headed off for the appointment.

Sarah Little received me and my photographs with enthusiasm. Then, having arranged for me to meet with Alexey Brodovitch, the art director at *Harper's Bazaar,* she rushed him my portfolio. I should wait a half hour, she said, so that he could study my work in privacy. When his secretary took me into his office, Brodovitch looked up at me and his face paled. Confusion covered him like a blanket, but he rose and shook my hand. "You're Parks?" I assured him I was and he asked me to sit down, struck silent then by something I failed to understand. He began shuffling my photographs nervously. "Fine work," he said. I thanked him. He took a deep breath. "I must be frank with you," he said finally. "This is a Hearst organization. We can't hire Negroes. I'm embarrassed and terribly sorry, but that's the way it is. I hope you understand. Maybe. . . ."

"Of course I understand, Mr. Brodovitch," I said, gathering up my photographs. "I appreciate your frankness." I headed for the cold street again, hoping Mr. Brodovitch's sorrow and embarrassment was clean. On the way out I stopped at Sarah Little's office and told her what had happened. She remained silent for a moment and then, seething with rage, headed for Brodovitch's office. I never knew what happened between them; I never saw either of them again. Years later some of Brodovitch's students told me he had often praised my work to his classes. At least this was some solace.

The next day Edward Steichen was also shocked when he learned of my experience. "The scoundrels!" he fumed as he chewed at a corned beef sandwich. Ripping paper from a notebook, he scribbled down a name and handed it to me. "Go see this man tomorrow and get back to me." The man turned out to be Alexander Liberman, editorial director of *Vogue* magazine. It would be naive to think Liberman wasn't also concerned about taking on a black photographer at Condé Nast Publications, but if he was he didn't show it. He looked at my work, said simply, "We must try," and sent me off to Tina Fredericks, senior editor at *Glamour* magazine, that was also published by Condé Nast. Tina was a warm, gracious woman—I will always remember her with gratitude. After talking with her, I

knew I would be getting enough free-lance assignments to keep me going, although I was not hired on the staff.

I lived a hand-to-mouth existence for a week at the end of which Stryker, having heard of my eviction from the port of embarkation, called me in. It was true, he said; he would be setting up a photographic section at Standard Oil for a five-year period. Was I interested in working for him again? Nothing stood in my way, or so I thought at the time, unaware of the pressure he was under to keep his staff white. But Roy, being Roy, held his ground. If they wanted him they would have to accept whomever he brought along. So it was that a couple of Jews, an Italian, three Caucasians, and a black came to work on that hallowed thirtieth floor at Rockefeller Center. In time Stryker's section became an oasis for those seeking warmth from the chill of that big place.

My monthly salary of one thousand dollars was handsome in terms of buying power in 1944, but working for Stryker was, at times, akin to working for an overindulgent father. This could be to your advantage or disadvantage, according to his ever changing attitudes. Although he was a thoughtful and kind man, at times Roy became too involved in our private lives. We were always being tested on those virtues he advocated as the ideals of good human behavior. He always knew how much of our salaries we were salting away; he knew all about our domestic problems; he disliked a suit or overcoat that was too nattily cut and concerned himself with the length and styling of our hair. "Roy, the good Jewish mother," we used to call him—behind his back, of course. One cold night I offered him a ride home. He accepted, but when he found me waiting for him in a Lincoln Zephyr he flushed red and began looking around for a taxi. The situation was so comical that I started laughing. Suddenly he broke into a grin and climbed in beside me—hoping, I was sure, that no one saw him enter that "vulgar vehicle."

Shortly thereafter Roy urged me to bring my wife Sally and our two children, Gordon, Jr. and Toni, my daughter, to New York, arranging a healthy advance to make it all possible. They came, but when my children took a look at Harlem with its crowded streets and unfriendly tenements, they wanted to go home to Minnesota. The alternative was to buy a home in the suburbs.

Stryker liked the modest house I bought, but he hated the sound

of the address. "Adams Place—damned pretentious. Why couldn't they just call it a street?" Six months after I had made a down-payment and settled in, Stryker calmly informed me I was being laid off for three months; he gave no specific reason. This was naturally a shock, and a test of courage as well. With false, but equal calm, I left, damning him silently. Three months later he was surprised and pleased to learn that I had written a book on photographic portraiture during the time I was away. I had passed his "courage" test, but I had also missed a few meals. The lesson sank in.

David was born to us on March 4 of 1944. By August 1, I had returned the loan Stryker had given me. Although he accepted the check, two days later it was returned in the form of a savings account for my newborn son. The following week my first fashions were published in *Glamour* and *Vogue,* bringing criticism from some of my fellow photographers for "wasting time photographing models." Stryker's answer was to the point. "There's nothing wrong with your photographing fashion. It pays the rent."

<p style="text-align:center">* * *</p>

During the intervening months very little news got back to the States about the 332nd Fighter Group. No doubt this pleased those who had opposed my going overseas. But to the white pilots and crews of the big Allied bombers, who the 332nd escorted on their runs over the targets, the fighter group had become known as the "red tails."

Time magazine's report of their first skirmish with the Luftwaffe was hardly a flattering one. No mention was made of the Air Force segregation policy—a policy that had much to do with the success or failure of those initial air battles. For the pilots one thing was clear. Mission after mission would have to be flown without relief. There were no black backup squadrons. Stateside leave came only after they had flown an excessive number of sorties beyond Allied requirements. But they were good pilots, green as highland grass perhaps, but well trained, recklessly brave, and anxious to prove themselves. Before long they earned the respect of British pilots and finally—reluctantly—the Americans. Eventually even the Luftwaffe respected their airspace: Lee Archer shot down four, Wendell Pruitt got three, Lucky Lester bagged one plus a probable, Roscoe Brown blasted one

of the first jet Me-262s out of the sky over Berlin, and Spurgie Ellington accounted for two in one day. I called Marie and told her about reading of Spurgie's kills. She was elated. I asked her if she wanted my paper, but she told me she'd pick one up herself. When I saw her four days later she still hadn't read about the skirmish, but it looked as if she would be taken on as a vocalist with Duke Ellington's band. I was happy for her and told her so. I also made a point of leaving my paper for her at the YMCA.

But then came the bad news. Several of the fighter pilots I had gotten to know so well had been shot down. Squadron leader Robert Tresville, flying his P-51 a few feet above the water to escape radar, burst into the glassy sea off the coast of Sicily. Four others of his squadron plowed in after him before the others gunned their ships upward and on toward the target. It was a big loss. Tresville was one of the "red tail's" finest, their only other West Pointer beside Colonel B.O. Davis.

Nearly a year after my separation from the 332nd Fighter Group Spurgie Ellington telephoned me. He was in New York on leave, having flown a P-40 Thunderbird up from the Tuskegee air base in Alabama, and he wanted to have a drink and talk about Marie. Things had gone bad between them and she was now singing with Duke Ellington's band in Chicago. Spurgie wanted her back in New York but it wasn't likely that she would return—so he was going out there to do something about it. He met me at the Theresa Hotel up in Harlem, ate a fine meal, and drank too much whiskey. By the time he departed for the airport he had grown angry. "She'll come back or else," he said.

It turned out to be "or else." Two days later he returned without her. I sympathized with him; his spirit had hit bottom, and so we both drank that evening as if a lot of whiskey would take care of all his problems. Before leaving him, I asked if he'd have breakfast with me the following morning.

"I'm flying back to the base tonight," he said.

I stared at him. "You're kidding, of course."

"Nope. I'm dead serious. A young mechanic's hitching a ride with me. I'm flying a trainer."

"But you're tired, man. And furthermore you're blotto. Don't do it, man. Don't do it."

"After Italy it'll be like a taxi ride to Times Square."

If there had been a C.O. around I would have tried to have him stopped. But there was no one to call. I didn't even know where his ship was hangared.

He never made it. Somewhere in Virginia he flew into a rainstorm, and crashed into the ridge of a mountain. The *New York Times* carried a small item about his death the next day.

The three years I put in at Standard Oil as a documentary photographer were somewhat humdrum after FSA and OWI, but they were valuable years that enabled me to get on my feet. Stryker built up an impressive photographic file there, but nothing to match the famous Washington collection. I never clearly understood the true purpose of that file. Our photographs were used in the *Lamp*, a company journal, and offered to the news media free of charge. I can only assume that the project was meant to bolster the company's public image. Mostly we covered rural America, its people and their way of life, and the nature in which their existence depended on the various industries of Standard Oil. Occasionally we shot a refinery or an oil field, but usually it was small towns and hamlets. Very often I was sent to document the regions in Upper New York state, New England, and Canada.

My last assignment for Roy Stryker sent me to Yellowknife, an isolated village sitting in the vast wilderness of the Northwest Territories. It was a haven for prospectors seeking gold, and possibly uranium. Beneath this endless flatland of tundra lay great depths of glacier ice. In the summers the prospectors dug down a foot or so, and put their beers there to cool.

I was told, more than once, that I was the first black man there, although I don't know whether that's really true. Certainly the Indians hailed my arrival on the white man's airplane as something very special. Confusion swept them when they saw a small delegation of city officials haul me off in one of the few cars in Yellowknife. When I asked the hotel clerk for my room key he smiled. "You won't need one," he said. Very soon I knew why. I shared a room with about six others, two of whom were women prospectors.

The place was surrounded by many lakes, big and small. The best known and probably the largest, which stretched for miles up into the wilderness, was Great Slave Lake. I stayed at Yellowknife a

good part of one winter, photographing the area. During those months there was only an hour, or a little more, of daylight. It was lonely and desolate. The biggest event of the year was the ice thaw, when the supply boats nudged their noses into shore loaded with food, clothing, and beer. I flew the bush country with Brett Craig, a sturdy young Englishman who had once been a bomber pilot with the Royal Air Force. We flew over the vast wasteland looking for stranded prospectors and miners during the frigid winter, searching the gray landscape for smoke that signaled some sort of distress. Down we would go, landing on the frozen surfaces. The cold was incredible, reaching to seventy degrees below zero. At times it was so cold that before cutting the motor off we drained the oil from the fuselage. To start the plane again we heated the motor with blow torches, poured in boiling oil, hopped in, and revved her up. If the engine didn't turn over, we drained the oil and began all over again. Such cold was frightening.

Brett had made many bombing runs over Germany. When I asked him if he had ever seen the black pilots, his face lit up. " 'The red tails?' " He smiled, remembering. "We loved to have them escort us over the targets. They came roaring in with their white scarfs blowing, their thumbs up, all but slapping their wings together. Then they would flash up to cover us on the long runs. Our big danger was from the flak below. No kraut would attack us while the red tails were over us. When we were out of the run and heading home they would peel off like humming birds—smiling, with their thumbs still up. I saw one or two of them go down in flame."

Brett warmed my heart with good stories about the 332nd. His squadron was based in England and he didn't get to know any of the red tails personally, but he had been close enough during some of those runs to remember their faces. Where were they now, with the war about to end? How many had survived it? Would America acknowledge their worth at last? Would the Air Force halt Jim Crow? Would the country's airlines take them on as pilots? I doubted it.

Only one Indian, at least that I knew of, spoke English at Yellowknife. I remember him only as Chocko. He came to the hotel one summer morning carrying word that his chief wanted me to visit him. I accepted the invitation but the hotel owner advised me not to

"After Italy it'll be like a taxi ride to Times Square."

If there had been a C.O. around I would have tried to have him stopped. But there was no one to call. I didn't even know where his ship was hangared.

He never made it. Somewhere in Virginia he flew into a rainstorm, and crashed into the ridge of a mountain. The *New York Times* carried a small item about his death the next day.

The three years I put in at Standard Oil as a documentary photographer were somewhat humdrum after FSA and OWI, but they were valuable years that enabled me to get on my feet. Stryker built up an impressive photographic file there, but nothing to match the famous Washington collection. I never clearly understood the true purpose of that file. Our photographs were used in the *Lamp,* a company journal, and offered to the news media free of charge. I can only assume that the project was meant to bolster the company's public image. Mostly we covered rural America, its people and their way of life, and the nature in which their existence depended on the various industries of Standard Oil. Occasionally we shot a refinery or an oil field, but usually it was small towns and hamlets. Very often I was sent to document the regions in Upper New York state, New England, and Canada.

My last assignment for Roy Stryker sent me to Yellowknife, an isolated village sitting in the vast wilderness of the Northwest Territories. It was a haven for prospectors seeking gold, and possibly uranium. Beneath this endless flatland of tundra lay great depths of glacier ice. In the summers the prospectors dug down a foot or so, and put their beers there to cool.

I was told, more than once, that I was the first black man there, although I don't know whether that's really true. Certainly the Indians hailed my arrival on the white man's airplane as something very special. Confusion swept them when they saw a small delegation of city officials haul me off in one of the few cars in Yellowknife. When I asked the hotel clerk for my room key he smiled. "You won't need one," he said. Very soon I knew why. I shared a room with about six others, two of whom were women prospectors.

The place was surrounded by many lakes, big and small. The best known and probably the largest, which stretched for miles up into the wilderness, was Great Slave Lake. I stayed at Yellowknife a

good part of one winter, photographing the area. During those months there was only an hour, or a little more, of daylight. It was lonely and desolate. The biggest event of the year was the ice thaw, when the supply boats nudged their noses into shore loaded with food, clothing, and beer. I flew the bush country with Brett Craig, a sturdy young Englishman who had once been a bomber pilot with the Royal Air Force. We flew over the vast wasteland looking for stranded prospectors and miners during the frigid winter, searching the gray landscape for smoke that signaled some sort of distress. Down we would go, landing on the frozen surfaces. The cold was incredible, reaching to seventy degrees below zero. At times it was so cold that before cutting the motor off we drained the oil from the fuselage. To start the plane again we heated the motor with blow torches, poured in boiling oil, hopped in, and revved her up. If the engine didn't turn over, we drained the oil and began all over again. Such cold was frightening.

Brett had made many bombing runs over Germany. When I asked him if he had ever seen the black pilots, his face lit up. " 'The red tails?' " He smiled, remembering. "We loved to have them escort us over the targets. They came roaring in with their white scarfs blowing, their thumbs up, all but slapping their wings together. Then they would flash up to cover us on the long runs. Our big danger was from the flak below. No kraut would attack us while the red tails were over us. When we were out of the run and heading home they would peel off like humming birds—smiling, with their thumbs still up. I saw one or two of them go down in flame."

Brett warmed my heart with good stories about the 332nd. His squadron was based in England and he didn't get to know any of the red tails personally, but he had been close enough during some of those runs to remember their faces. Where were they now, with the war about to end? How many had survived it? Would America acknowledge their worth at last? Would the Air Force halt Jim Crow? Would the country's airlines take them on as pilots? I doubted it.

Only one Indian, at least that I knew of, spoke English at Yellowknife. I remember him only as Chocko. He came to the hotel one summer morning carrying word that his chief wanted me to visit him. I accepted the invitation but the hotel owner advised me not to

go. They would rob me, murder me, and throw my body into the lake, he said. The same warning was offered by others.

After thinking it over for a couple of days, I told Chocko I would go. On the following Sunday morning five canoes arrived filled with braves, squaws, and children, who gawked at me as though I was something from outer space. Without ceremony I was motioned into the lead canoe and we paddled off. After an hour's ride up Great Slave Lake we went ashore, climbed a muddy bank, and entered an encampment of tents circling the edge of a clearing. In the center of the clearing were slabs of fish hung on poles, drying in the sun. I was taken first to a tent sitting about five yards from all the others. Chocko pulled back the flaps and we entered. His hand motioned toward ten children lying on paddings of gunny sack. Ranging in age from about two to five years old, they wheezed, coughed, cried, and shivered in the chill of the tent. One was vomiting badly. Certainly they were sick, very sick, and all looked tubercular. They were fleshless, dried up, and covered with sores. An older boy fanned flies off them with a tree branch. "How long have they been like this?" I asked Chocko.

"For long time. Tent is always full. Always. Some die and we bury them. There are always others to go in. Always."

Next I was led to the chief's tent. An ancient man, thin, with white hair and skin like parchment, sat on the bare earth, his winkled legs folded beneath him. He greeted me with a double bow of his head and, motioning that I should sit next to him, watched me with eyes that were faded and marbled. He spoke to Chocko, who translated for us. "The chief wants to know what tribe you from and what is your dealing with white man at Yellowknife. He wants to know why he treats you with good honor."

For half an hour I explained my job and the fact that I was a Negro whose great grandmother had been a Cherokee. I spent another half hour trying to explain what a Negro was. I doubted that he ever understood. What could they do to get the Yellowknife white man to give them jobs and respect them? How could they stop the children from dying? How could they get the government white man to help? The questions went on for two hours. I didn't have the answers but I talked education and health and about the black man's

problems in the United States. What was this place, the United States? I explained and in the end promised help. This seemed to satisfy the chief. How soon would the help come? "Right away," I said, without a single good reason. He thanked me and afterwards we ate dried fish and roasted corn together, along with Chocko and three other braves.

The five canoes took me back to Yellowknife. Chocko thanked me profusely for coming, and then asked for five dollars to cover the ride—a dollar for each canoe. I gave him ten. He was truly grateful and all of them waved to me as they paddled off.

That same night I put a call through to Stryker and told him about the situation. Two days later the office cabled me three thousand dollars.

With the help of Brett Craig and two of his pilot friends we got the sick children to a clinic in Ottawa. The money was to be used for educating the most intelligent young brave and then he in turn was to come back and teach the others. It was a thin, long hope. Only one child died before we got them out three days later. The chief, via Chocko, sent me ten beautiful feathers from his own headdress— which made them very special—and somewhere in that desolate region a body of water is named for me. It is called Great Gordon Lake.

Even now I wonder about those impoverished Indians. At the time their hardship brought memories of my own cold, foodless days; recalled the archaic system that still destroys the hopes of so many black people in this country.

2

"Welcome to Life!"

*I*t was August 1945, the Second World War had ended. How were we black people of America faring at this tumultuous time, with Roosevelt—our savior—gone, and our country, as well as its armed forces, still discriminating against us? Not too well. We had been in an Allied camp fighting the kind of racism and tyranny in Europe that we ourselves had been victims of here at home. It is remarkable that twelve million of us gave allegiance to a country that had held us in bondage for so long. Only we knew what we were honestly thinking as the victory bells tolled. Just a few—like Paul Robeson, William E. B. Dubois, and Richard Wright—had dared to speak out; the price of doing so had been too high. But Dubois minced no words, saying: "It is the glory of God and the exaltation of man that the Soviet Union, first of the modern nations, has dared to face front-forward the problem of poverty." He, and later his widow, would pay for saying it.

Along with those liberal voices came, now and then, those of politicians, black and white, promising laws in our behalf. But we knew by now that hatred and bigotry could not be legislated from a

man's heart. The Civil War had taught us that. No, America would continue to spawn witches for a Joe McCarthy to hunt one day. Several times I found myself innocently seated in gatherings that were disguised as something other than what they turned out to be—recruiting sessions for the Communist party. The messages and doctrines handed down neither turned me toward socialism or away from it. I just sat there and listened. Nothing was ever said that I as a black man, living in a racist country, hadn't known all along. The reason I didn't join the party is simply because I'm not much of a joiner—of anything. That trait, perhaps more than anything, kept me off Joe McCarthy's list. I had fought so hard and so long by myself that I had grown comfortable with fighting alone. Communism wasn't the answer to fascism, but neither was Jim Crow. The solution, I realized, was a democracy, but surely not the kind that tolerated—as it did in the autumn of 1946—the lynching of two black men and their wives in Walton County, Georgia. Young black men were on the move. In the end they would fight the battle their way, but for the moment I would keep fighting my way.

Even during the worst times there was always a feeling of promise deep inside me—a feeling to either grab at or let fall away. Such feelings seemed trivial then, but now I realize how important they were to my reaching out for whatever it was I was after. Every nudge upward played its part, helping me toward whatever I would eventually become. My mother used to say that I was just like a seed that had been planted: I would either sprout or die. The decision was left up to me. I wanted to take root and flower, so I grabbed at each opportunity, not letting much fall away. Trying was far better than the emptiness that came with doing nothing.

Roy Stryker advised all of us to experiment a lot if we wanted to stay out of the rut and ahead of the crowd. I didn't consider Standard Oil a rut, but I wasn't going to wait for that gold watch presented after twenty-five years of service. For a long time my heart had been set on *Life* magazine—ever since, as a train porter, I had seen the famous logo on a passenger's bag. That passenger turned out to be Bob Capa, the celebrated war correspondent, returning from an assignment in the Far East. "One day that name will be on my camera bag," I told him jokingly. Bob took his suitcase from me and flipped

me a silver dollar. "Fine, I'll reserve a locker for you when I get back." Capa didn't smile; perhaps he felt I meant what I said. I did, but it was logical for me to realize that thousands of white boys also wanted that *Life* logo on their bags. Still, I refused to be logical about that particular desire. My mother's words still rang in my ears: "If a white boy can do it, so can you. Don't ever come home telling me you couldn't do this or that because you're black." I honestly don't know whether she believed it or not, but she certainly drummed that philosophy into my head, day after day, until she had me convinced. The only thing I feared was that I might not be given a chance to prove it. In that case, she would have said, "Make your own chance."

My introduction to *Life* was somewhat accidental. Another magazine called *'48,* run by a group of artistic and literary people, had just folded. Gone with it was the story Ralph Ellison and I had collaborated on, entitled "The Need of Psychiatric Treatment in Harlem," for which Ellison had written the text and I had done the photography. We thought of taking our story elsewhere but it was hopelessly entangled in the defunct journal's legal problems. Ellison left me that afternoon in despair. I had a duplicate set of my photographs, so I sorted them out properly and headed for *Life* magazine.

Several days passed before I got to see Wilson Hicks, *Life*'s picture editor. Wilson was pale, of medium height, slightly paunchy, and with his glasses perched on the end of his nose reminded me of a character out of a Dickens novel. He greeted me gruffly, offered me a seat, and flipped through my pictures without a single comment. His expression was just as noncommittal. Then he called in two other editors—John Dille of the human interest department and Sally Kirkland, the fashion editor. Wilson puffed on a cigarette and read a manuscript while they thumbed through my photographs. Fortunately they liked what they saw and said so. Dille was hungry for a good documentary story, and Sally was in need of a photographer to do the collections in Paris, only a few months away.

Wilson grumbled to himself for a moment and then asked what I would like to do. For no reason that I can remember—even today—I said I would like to do a story on a Harlem gang leader. Dille took to the idea immediately. Hicks remained quiet for a moment or so,

thinking. Then he looked me dead in the eye and made the incredibly low offer of two hundred dollars to do the entire story. "Are you serious?" I asked.

"That's how much I think your chances are worth," he admitted. "It's peanuts and it's a dangerous story, but that's all I can offer. You'll have an expense account, of course."

Expense account. Dille picked up on the magic words, winked at me, and smiled as Hicks turned away from us. I trusted both the wink and the smile. "Take it," Dille said. To Hicks's surprise I accepted the assignment. After we were out of his office Dille told me that such a story would require an *unlimited* expense account. Now I understood.

Frankly I didn't know where to begin. The following morning I went to a Harlem precinct and talked to Jimmy Morrow, a detective I knew. He laughed when I told him what I was up to. What gang leader in his right mind would expose his life in the world's largest magazine? It was like asking the Mafia if the networks could set up cameras in their hideouts.

We had resigned ourselves to the hopelessness of the situation when in walked a stocky, tough-looking boy. He was light skinned, with freckles and crinkly short red hair. His chin jutted out like the prow of a boat; his eyes burned with anger as he verbally attacked the desk sergeant with some rather vile language. The sergeant listened with a patience and concern that surprised me. "Who in hell is that kid?" I asked the detective.

"Red Jackson. You wanted to meet a gang leader. Well, that's the toughest one in all Harlem."

"What's he beefing about?"

"We've been trying to break up the gangs by talking to their leaders, trying to get them to cooperate. At first, Red went along with us and cooled his boys while we went after the others. Then last night we pulled one of his guys out of the Harlem River. He'd been shot and thrown from a bridge. Now he's mad as a wet hen, saying the deal's off and that they're going after the killers."

When Red left the precinct I was right on his heels, introducing myself and offering him a ride home. "I've got subway fare," he answered icily. I moved ahead of him, waved, and stepped casually

into my new Buick Roadmaster. He took one look at it, changed his
mind, and got in. "You a cop?" he asked.

"Nope, a photographer for *Life* magazine."

"What's *Life* magazine? I never seen it."

I explained, stopped at a newsstand, and bought one for him.
He thumbed through it as we drove along, apparently enjoying the
pictures he saw. Picking my words carefully, I told him what I
wanted to do, that I was trying to find the most important leader up
in Harlem. He looked at me and grunted, then turned back to the
pictures—thinking, perhaps, that I was an idiot for not knowing that
he was the most feared and important one. "What's in it for me?" he
asked without a trace of modesty.

Actually I didn't know, but made no false promises. "I'll be a
friend to you. Jimmy Morrow told me you wanted to help break up
the gangs in Harlem."

"Jimmy's a pretty decent cop. There ain't many. Did he tell you
who I was? I saw you talking to him back there."

I agreed that Jimmy was a good cop and that he had given me
the rundown on him. Red seemed remotely intrigued with the idea,
especially the possibility of being chauffeured around every day.
After all, what gang leader in Harlem could boast of having a new
Buick Roadmaster and a driver at his command? I dropped him off
on 116th Street in the heart of the dreary tenement area he called his
"turf." He would think about it and talk things over with his "war
council." I was to come back the next day for their answer. Things
looked more hopeful than I dared expect. John Dille was ecstatic
when I reported back to him.

The next day Red wasn't easy to find. Obviously the entire
block took me for a detective. No one had ever heard of Red
Jackson—no one in the whole neighborhood. Two hours passed. Fi-
nally I had just given up and was pulling away when a younger
brown boy, who resembled Red, spotted me. He wanted to know if
I was the dude who drove his brother home the day before. When I
told him I was, he cupped his hands around his mouth and hollered
out, "Red!" Three stories up a window slid open and Red stuck his
head out. "Yeh?"

"Your man's down here!" his brother shouted back.

A girl came to his side and looked down at me. Red put his arms around her bare shoulders. "Be down in a minute!" he said and disappeared for another hour. By the time he finally came downstairs my car was filled with six tough-talking young members of Red's gang, who called themselves the "Nomads." Those who had taken seats were the "war councilors." Others sat on the fenders and leaned against the sides of the car with a prideful nonchalance. I got the feeling Red had given the word that the Nomads would be riding on rubber for awhile.

It was a long and nervous night. I drove Red and his council around until four o'clock the next morning, going no place in particular—just "cruising" as Red called it. I left them without any promises, feeling it was best not to push for any.

We had gone on like this for over a week, just cruising the streets of Harlem, when Red asked me one day if I was going to start using my camera. Concealing my joy I answered rather casually that if something happened I would be ready. Red lit a cigarette, blew out the smoke, and gave me his Humphrey Bogart look. "You know we like you, Mister Parks," he said. "We trust you—and we don't like double-crossers." All of us shook hands, knowing exactly what he meant. My problem was to walk the tight line between what they considered betrayal and what I felt was reporting. And the difference was thin. The important thing, however, was that I was accepted, not only as a chauffeur to the Nomads but as their friend as well. In the weeks to follow two things happened that cemented the trust between Red and myself. When I found my exposure meter missing I casually mentioned it to him. "The little thing with the numbers and the needle on it?" he asked.

"Yep, the thing the guys were fooling with in the car the other day," I explained. He just nodded. The following day Herbie handed me the meter with apologies and a swollen lip. Then one evening the police paid us a surprise visit in the Nomads basement headquarters. They had been called when someone saw us gathering, thinking a rumble was in progress. When I pulled out my *Life* identification card and convinced the cops I was doing a social study on Harlem youth they left. Red was flabbergasted at my performance. "God-damn, Mister Parks," he quipped, "we're gonna keep you around. If you hadn't spoke up we'd probably got our skulls cracked."

These young boys led tragic lives. Like scores of others in Harlem who took blood oaths to fight and die together, they worried constantly about death, knowing it might come any moment. It didn't take much to bring on violence—a dispute over a stolen baseball or bicycle; the wrong word to a gang member's sister or mother; an accidental bump of a shoulder; the invasion of one gang's territory for a game of stickball. Their kinfolk suffered too. Red's mother feared each knock on her door, afraid the police had come to say that one of her sons was dead. Three of Red's gang had been murdered since he had taken over leadership. Most of them had suffered beatings and bullet or knife wounds. Red had assumed the crown when his former leader was gunned down on 116th Street in a brawl with the "Harlem Dukes." Red had been running alongside him when he was hit. "I saw the blood pop out of his head and I knew he was gone. I couldn't stop to help him," he said rather coldly. "They was coming at us hot and heavy—Pow! Pow! Pow! When he went down I grabbed his gun and kept running and shooting—Pow! Pow! Pow!"

"Why a gang in the first place?" I asked him.

"Protection. You wise up fast here in Harlem. You get your ass kicked enough to know you'd better join up with somebody or keep getting your ass kicked. They say, 'You belong to a gang, cat?' No. 'You got some loot, cat?' No. I ain't got none. Then—Bop! Bop! Bop! 'Next time you better have some, cat.' If you got some the next time you get bopped anyway. But if they know you're a Nomad they think twice before they start any shit with you, 'cause they know they have to rumble."

I was afraid the first night I experienced a rumble. One of the Harlem Dukes had called Red's sister a bitch and spit on her shoe. She didn't know his name. No matter; it was reason enough for a confrontation. My feelings were split. The reporter inside me welcomed the coming action; something else inside me stood against the possible consequences. Yet this was what I had come for, hoping that in some way my story would help discourage black youth from destroying one another. How it would eventually help I didn't know yet.

The morning arrived with a steady downpour and by noon the day had taken on a morbid dreariness. Red wanted a couple of favors

from me—the price of a pair of flashy dark glasses and a loan of my trench coat; both to him were definite badges of leadership. I bought the glasses and made him a present of the coat. He couldn't have been happier.

We moved into the rival gang's territory as night fell. Their hangout was on 8th Avenue between 135th and 136th streets, less than a block from the 135th Street police precinct. Everyone was armed with a ragged arsenal of weapons—pistols, zip guns, knives, clubs, and chains. I carried a 35mm camera loaded with infrared film and flash equipment that produced a light indiscernable to any but a quick eye.

I was amazed at the expertness of what Red called his "pincer attack." As we moved in from both ends of the street people scurried for their doors like frightened rats. In a matter of seconds the street and sidewalks were empty. Red was in complete command, living up to the dark glasses and tightly belted trench coat, cooly whispering orders, moving silently and swiftly. Then he signaled with his right fist and we burst through a basement door and into the Dukes' den, taking them by surprise.

"Tiger" Johnson, the rival gang leader, leaped to his feet but before he could reach for a lead pipe Red was upon him, knocking him to the floor with a brutal right. Then with his left hand he put a switchblade to Tiger's throat, demanding an apology from whomever had insulted his sister. Tiger's eyes turned slowly to a black boy crouching in fear beside him. The look was obviously an order. The boy mumbled simply, "I'm sorry, man."

"Get on your feet, punk!" Red ordered. The boy got up slowly, fearfully. "Open your shirt, punk!" The boy opened the buttons at his chest. Red placed the point of his switchblade just above the heart. "Say it again, punk—and make it loud!"

"I'm sorry, man!" Sweat was rolling down his face.

Red flicked the knife upward about half an inch. The boy moaned as a thin trickle of blood came. "You're lucky I don't cut out you fuckin' heart and make you eat it!" He spit on the boy's chest, then dropped him with a terrible right. "Frisk these punks!" he barked. Red's gang went at it expertly, having involuntarily taken many lessons from the cops up in Harlem. We backed out of the place cautiously, with the Nomads' arsenal swelled by four pistols,

six zip guns, and five switchblades. Nervously I had shot my first pictures. "You punks know where to find us in case you want this shit back!" Red shouted as we backed out the door and into the street. Then we vacated the block as swiftly and as silently as we had entered. The operation had taken less than ten minutes. By the time the police sirens sounded we were piling into my car three blocks away.

As I drove home to Westchester later that night, I couldn't help but admire Red's sense of leadership and his cool. Yet it was tormenting to see such a talent so needlessly misdirected. His life, at sixteen, was crowned with fear, violence, and the constant threat of death. At such an early age he was already lost, it seemed, in the rubble of filth, poverty, crime, and all the other immoral diseases of the big-city ghetto. Headed toward nothingness.

By now Gordon, just turned fifteen, had three horses. He had questioned me constantly about Red and the others, so I invited the Nomads to my house that following weekend. As they walked the green countryside and bounced about on the horses, they were just kids again, enjoying a Saturday outing. They hadn't been around so many trees or seen so much grass in their lives.

My wife had spent the morning buying hamburger, hot dogs, potato salad, apple pies, and soft drinks. She welcomed Red at the door. He spoke courteously, shook her hand, and motioned the others in, introducing them as they came. When Herbie forgot to remove his hat Red knocked it off saying, "Where's your manners, man?"

It was a good day for them, for my family, and for me. Gordon loved teaching them to ride, and he must have asked Red a thousand questions about being a gang leader. Later Red and I sat beside a clear stream. "Why'd you ask us to come up here, Mr. Parks?" (He never got around to calling me Gordon.)

"My family wanted you to come out," I answered.

He smiled sadly and shook his head. "Everything's so good and clean out here. The fresh air will probably get us all sick."

"Wouldn't you like to get out of Harlem someday?"

"Get out of that lousy place with all my brothers and sisters and Momma? No chance. Momma wishes we could."

"Nothing's impossible."

He shrugged. "Momma used to say that but she don't say it anymore. She don't say much about nothing anymore. Just cries and worries a lot about us."

"Where's your father?"

"Father? Man, I ain't got no father. He. . . ." Suddenly Red was laughing, pointing at tall, skinny Link Thomas bumping along on a galloping horse, his knees flapping, looking like a black crane in his broad-brimmed hat, zoot suit, and pointed tan shoes. Gordon rode to head off the horse, but he was too late. The horse stopped abruptly at the stream and Link went over its head and into the water. He was finished for the day. Flopping down on the bank beside us, he pulled off his wet shoes. "Man, I ain't no cowboy," he admitted.

Back in the city that night they thanked me and asked Gordon to spend the following weekend in Harlem with them. They wanted to repay him for their visit to us. My wife would never approve, but I promised he would come. The next Saturday morning I dropped him off at Red's tenement house. I was nervous about this, and Red was aware of it. "Don't worry," he said. "Nothing's going to happen to him."

Nothing did happen and Gordon had a wonderful time— fingering their arsenal of guns and knives, meeting their girls, visiting the juke joints, and watching the gang repaint six bicycles they had stolen the week before. Red wanted to visit us again, too, but he asked, "Could you have beer instead of Cokes the next time?"

I experienced several other rumbles with the Nomads. Each of them were equally frightening and depressing. The most serious one happened after a Nomad named Joey was ambushed and beaten to death. This time the skirmishing went on for three days with knifings and head-splittings on both sides. The police, it seemed, were reluctant to break it up. The fourth day Red said he was going to pay his last respects to Joey at the funeral home. I could come along if I wished, but the killers would be laying for them. "I'm sorry," he told me, "but you'll kinda be on your own." When I told him I was going along he advised me to travel light. "We're gonna have to do some running."

At the funeral home Red and Herbie, his chief war counselor at the time, viewed the body with detachment. After the attendant left,

Red lifted Joey's head off the coffin pillow, felt behind it for lacerations and bruises, and felt the broken right arm. He gave one last look at the battered face and patted the cheek. "The punks did a good job on him," he mumbled. "Let's go." I had a 35 mm camera in my coat pocket and a blackjack Red had loaned me for protection. I hoped I wouldn't have to use it.

Other Nomads were hidden on neighborhood stoops, waiting for us to come out. We had regrouped and walked for nearly two blocks before we saw the other gang moving in on us. "Split!" Red shouted. He didn't have to repeat himself. We split. I heard a shot just before we rounded a corner at 132nd Street and 8th Avenue. Red led us up two flights of stairs into a deserted tenement he had chosen as an emergency hideout. There, with the protection of the building, he could make a better stand. Red hated to run. He was angry, so angry he defiantly exposed himself before a window with his fingers curled around a 45 automatic. "Come on you suckers!" He screamed. "Come and git it!" It was at that moment that I got the portrait of him that has been published so often entitled "Harlem Gang Leader."

Not until the police wheeled into the block did we take off down the back stairs. The fighting went on for another day, ending finally when Herbie got ripped with a butcher's knife. I was astonished when Red sewed him up with a double strand of ordinary thread before taking him to a doctor.

After Red's story was published, Police Commissioner Arthur Wallender called *Life* and demanded all my notes, photographs, and addresses of the gang members. He also wanted to know how I got the story. Inasmuch as the cops knew Red before I did, his inquiry seemed strange. *Life* refused to comply with any of these demands. When Wallender began applying even more pressure, Henry Luce sent him a very curt note hinting that there were unpublished parts of my story that were indeed "unflattering" to the police department. Wallender should let the matter drop. After that the Commissioner fell silent.

One night I went up to Harlem with some copies of the magazine for Red. Beneath the light of a street lamp I read the story to him along with several of the others. When I had finished he said very dryly, "You made me out a criminal, Mister Parks."

"I don't feel I let you down, Red. I hoped you would find the story sympathetic to you," I said.

"I don't know. Maybe you're right, but two lawyers have been bothering Momma about this thing all day, saying you made a criminal out of me and that she oughta sue you and the magazine."

"What did you tell them?"

"I told them to get the hell out and stop bothering her. One got smart and I called him a cheap-ass jackleg." Red began laughing. This pleased me mightily and we shook hands. "Damn!" he said, looking at his picture with admiration. "I looks like Cagney and Bogart all mixed up together. Those blinders you gave me are sharp."

Exactly eight months from the day I first met Red I decided to look him up again. I never found him. The word was that the Nomads had broken up for good. Red, I was told, had moved up some place in New Jersey. Herbie and two others had entered the armed services; the rest had scattered. So for the Nomads, at least, I hoped the terrible days had passed. I was happy for them but was sorry that I might never see them again. I can't say whether or not the *Life* essay contributed to the sudden cessation of their hostilities, but I have alwyas hoped that in some way it did, and also that their need for violence had worn out.

Assignment

*R*ed Jackson's story was perhaps the second most important step in my career; the first was the Rosenwald Fellowship awarded to me in 1942 since it landed me at the Farm Security Administration under Stryker.

Shortly after the essay appeared in *Life*—it reached millions within a few days—Wilson Hicks offered me a staff position. I can't easily express the joy that came with it; it had been my dream for such a long time. Meanwhile, I was to sail for Paris with Sally Kirkland, *Life's* fashion editor, to photograph the French collections. Things were looking up, but to Wilson's surprise—and surely mine—I didn't accept the staff job immediately. John Dillie had advised against it, saying that the money wasn't right. So I held out. On the second day at sea my steward handed me a cable. It read: "$12,000 a year." It was signed "Wilson." I cabled back: "$15,000. Gordon."

The Queen Mary was a glorious ship, a fine hotel at sea, providing an experience I had never quite expected. I marveled at her sleekness, at her majestic bearing, at her awesome power as she knifed

through the rough Atlantic toward France—a country I hardly dared think about when I was a boy. For the next four days it would be late breakfasts, languid luncheons, high tea on deck, and black tie for dinner. The meals were sumptuous and well served. Besides the well-appointed dining room there were swimming pools, sun decks, and pleasureable salons forward and aft with music for dancing and a great hall for classical concerts. Overwhelmed with the luxury of the moment, I placed a ship-to-shore call to Sally, my wife, wanting her to share—if only vicariously—the experience. Our conversation was a disaster. "I'm glad you're having a good time," she answered rather acidly. "I'm sweating over a hot stove frying potatoes for your disobedient children!" I was depressed for the rest of the evening, and walked the deck late trying to hold down the excessive amounts of brandy I'd consumed after the call. Perhaps it was while I was alone and half drunk on the windswept deck that night that I first sensed myself gradually changing clothes for another kind of life. Suddenly came the reality that I was the only black soul aboard this great ocean liner; far from Kansas cornfields; far, so very far, from Harlem's ghetto and the black friends I was leaving behind. I awakened the following morning with a sour mouth and in a gloomy mood. But at breakfast I was somewhat cheered by Sally Kirkland's news that we were to be guests of the ship's captain at a party that night. By noon my troubles had escaped me.

On the third day came another cable: "Last offer. $14,000. Wilson." I cabled back: "Sorry Wilson. $15,000." His final answer came as we neared Cherbourg: "You are mule-headed. $15,000. Congratulations and welcome to the staff. Wilson." From Paris I cabled: "I am happy and honored. I celebrate with champagne."

Paris was far different from the city that my boyhood dreams had conjured up—a landscape of colorful, mountainous caves inhabited by moustached dwarfs who wore red smocks and berets, smoked long pipes, and painted constantly. I had, of course, long since known better, but not until our boat train rumbled into the great city did I reluctantly release that childhood fantasy.

The war had left Paris in want. But the great houses of Christian Dior, Balmain, Chanel, Fath, Schiaparelli, and others were moving again toward the elegance of prewar days. Their plush, coffin-gray salons were packed from the stairwells upward with wealthy clients

from various parts of Europe and the Americas. The aroma of costly *parfums* lay in your nostrils and clothes for hours after the showings. I can't forget the beautifully clad lady furtively plucking a cigarette butt from an ashtray at Dior's—nor forget her scornful glance at me when she realized I had watched her do it.

Now, for the first time, I was photographing those mannequins who graced the covers and pages of the world's most prestigious fashion magazines: Bettina, Dorian Leigh, Suzy Parker, Dovima, Carmen, Sophia Malgot, Maxime de la Falaise, Elise Daniels, Jackie Stoloff, and Janine Klein, to name a few. Each day of work brought pleasure. So much to photograph and to remember forever: the haze-blue dawns with fog lifting off the Seine, the blood-red of an early sun breaking through; the soft, filtered light of spring rain glistening on the Place de la Concorde; the splendid, marbled bridges and ancient buildings sitting, waiting, like glorious stage settings, overwhelming in their beauty. It was a time of finery, of make-believe, of old-world elegance. Transparent certainly, but there to be enjoyed and used as setting for my fashion photographs.

The bureau sped me on to Italy from Paris when news of the Ingrid Bergman-Roberto Rosellini love affair broke around the world—the famed actress was leaving her husband and child for the love of the Italian film director. Besides being the most dazzling romance of the decade, it turned out to be one of the most controversial. Many of Ingrid's fans, having held her in such awed reverence, acted as if she was condemning herself to purgatory, while as many others sympathized with her romantic dilemma.

The melancholy lovers were comfortably ensconced on Stromboli, a volcanic island off the coast of Sicily on the Tyrrhenian Sea. Newspaper and magazine writers and photographers besieged the island; helicopters with curious observers aboard hovered overhead. The big publications were offering a handsome price for just one photograph of the two lovers together. So far none of them had had any luck; Bergman and Rosellini seldom walked about the island together, and they dined and worked in private.

Rosellini, meanwhile, was trying to shoot a film in which Bergman was starring. I had met her in New York and it was an invitation from her that was bringing me to the island.

Stromboli, shimmering under an early morning sun, rose like a

molten jewel from the blue-green sea as our boat approached it. The sand on the beach was as black as the blackest coal—a reminder of the volcano's frequent eruptions over the years. It was a strange and beautiful place. Ingrid waved from the beach as a small tender came to take us ashore. Maria Sermolino, from the Rome bureau, had accompanied me. We landed just as Roberto, in heated Italian, was ordering the last of the reporters and photographers off *his* island.

"Go! If you return you will die at my hand!" he shouted. "You are a miserable fascist ingrate and a liar! If there were swords I would challenge you to a duel!"

A young reporter shouted back from the outgoing boat, "Addio, tyrant, pig! Addio, wife stealer!" Enraged, Roberto ran to the water's edge screaming his fury, but by then the reporter's boat was well out to sea.

Bad weather set in on our second day there, and the film wasn't going well. Dr. Lindstrom, the jilted husband, was posing another problem; he was approaching the island in a yacht, it was rumored, to demand a showdown. Ingrid, obviously distressed, somehow managed to appear unruffled amidst all the confusion.

There was a lot of news to report but the problem lay in getting it off the island without censorship; Roberto lorded over the cable office and the men who staffed it. Messages could be sent by the boat that came from the mainland three times a week, but Sermolino strongly suspected that its officers were also under Roberto's control. Her suspicions were confirmed when a message to our Rome bureau about Lindstrom's pending arrival never reached its destination. The boat's captain had returned it to Roberto who, in turn, had it placed on Sermolino's bed. It was sour grapes between the two of them for several days after that.

I had always admired Ingrid as a person and as an actress; and despite Roberto's gestapolike tactics, I soon grew to like him. In his less harried hours the true charm and gentleness of the man shone through. He treated her with tenderness and concern, and one could sense her warm feeling for him. But, unfortunately, he was under terrible pressure all day. He was filming less and less now and the costs were mounting. During Ingrid's free time I took her about the island for the pictures I needed.

On the way back to her quarters one afternoon she asked if I

would consider staying on to assist Roberto with the filming. I was flattered and surprised, but I knew he would never agree to such a thing; she, however, was convinced he would. That same evening she tried, but without success. Neither of us found reason to talk about it again.

I was quartered in an old house perched on a cliff close to the sea, and there was a lovely view from a big window in the living room. One night I had sat for an hour looking out on the choppy moonlit water before going to bed. In the middle of the night I awoke to a terrible rumbling, then all the doors in the place popped open and my bed slid to the middle of the room. I got up, closed the doors, and pushed my bed back in place, thinking that the camera crews had rigged up some sort of prank. Then it happened again. I got up and searched the hallway; no one was about. Finally I fell off to sleep without any further interruptions.

At breakfast I told the old cook about my strange experience. What I had mistaken for possible human mischief, she informed me, was a mild volcanic eruption. My house was directly over the most active vein, which flowed under the island to the sea. Taking me to a window, she pointed up toward the volcano. Flames, smoke, and lava were belching forth; fortunately, the flow on its far side went directly into the water.

Every day the sky became thick with aircraft; the sea filled with boats of all kinds. Now and then telephoto lenses could be seen reflecting the sun. What every magazine editor longed for was a photograph of that unguarded moment when, weary of caution, the two lovers might surrender themselves to an embrace—even better, a kiss.

One evening, by accident, I walked in on that moment after everyone had deserted the set but Ingrid and Roberto. They stood in the center of a large room, tired, drained from the ordeal, their arms holding their bodies close, comforting rather than caressing one another. Instinctively I raised my camera; then, just as quickly, I dropped it to my side—letting the moment slip away. Ingrid, I knew, trusted me. It was a moment undeserving of betrayal. I eased out of the room, hoping I had gone unnoticed.

The following morning Ingrid knocked on my door. She and Roberto were going for a walk along the shore; would I like to join

them? I answered that I would. "Then hurry along," she said, "and if you don't mind, please bring your camera. Roberto and I would like some pictures together." There was no doubt now; she had seen me the evening before.

A couple of weeks later Sermolino and I left Stromboli. It was, I remember, just after dawn and the sea was angry that morning. A few boats were still bobbing about on the waves; others were on their way to assume the vigil. I remained on deck, my camera trained on the smoke curling up from the volcano, thinking of Roberto and Ingrid back on their black sand island—hoping they would soon be left alone. After awhile Sermolino came on deck and stood beside me, and together we watched Stromboli sink into the sea.

4

An island unto myself

During those weeks in Paris, Sally Kirkland had tutored me in the more tasteful aspects of photographing fashion, the diplomatic maneuvering of the celebrated couturiers like Jack Fath, Dior, and Balmain, and the fine art of spending French francs. In retrospect, my expense account for three weeks was awesome. Wilson Hicks called me on the carpet about it back in New York, and for years to come he would recite my answer to him with wry amusement. According to him I had said, "But Wilson, *Life* was able to publish three fashion stories and two covers from the trip." Sweet naiveté. I do remember Hicks taking a long, bewildered look at me, scratching his head and waving me out of his office without another word.

At *Life,* one quickly realized, you either swam well or sank. I grasped at its journalistic style with great fervor, learning as much as I could, as fast as I could. There was justice in learning; by the end of 1949 I had been assigned to over forty stories, from gang warfare to fashion, to the death of Babe Ruth and the scientific laboratory at Los Alamos, New Mexico, where the atomic and hydrogen bombs were assembled. This trip alone proved more eventful than the assignment awaiting me there.

It was a hot Southern day when the sun turns the land into an inferno, when tempers are inclined to flare. I was waiting in a Texas bus station for the car and driver that would take me on up to Los Alamos when three white journalists recognized me. One, a woman whom I had known for some time, ran over and kissed me; and after a brief exchange of words the three of them boarded their bus for the airport. I was drinking from a water fountain when the low Texas drawl curled over and around me. "We don't like niggers kissing white ladies down here."

Everything blurred. Suddenly I was burning inside, exploding to the extremity of every nerve edge, dreading to look up into the trouble that was waiting for me. Cousin Martin's advice echoed from the past. "If you have to die down there, you might as well take a couple of crackers with you." I looked up finally, into the sweat-streaked faces of three mean-looking white men—wondering if I had come all this way to die in a grubby bus station in a backwoods Texas town. I didn't even have a pocket knife. The only other black was a somewhat sickly shoeshine boy, and he looked frightened to death. The big one had reached for a cord of a Venetian blind and was expertly fashioning it into a lyncher's knot. He looked at the other two, smiling nastily. "This is what we do to smart-ass niggers down this way, boys. Right?" The other two nodded their heads affirmatively. I remember that I was too angry to be afraid, and in that instant I saw the word "Gunsmith" on a building across the road. It was one of those moments when a man must somehow find the courage to hold on. If I had backed off I'm sure it would only have bolstered their intentions—whatever they were. Without further thought, and with my heart pumping widly, I strode across the road, entered the shop, and asked for a 45 automatic and two clips of ammunition while the three, who had followed me, watched through a window. I paid the clerk and asked for a shooting block. The clerk motioned to a tree trunk on the far side of the shop. I loaded the gun, walked over, and fired into the log until the chamber was empty. Then I reloaded and walked back toward the door with the gun in my hand, praying I wouldn't have to use it but knowing I would if I had to. The men backed away as I came out but started following me across the street again, although at a much greater distance. Just as I was about to reenter the bus station, an army car pulled up. It was

my driver from Los Alamos. Nervously he looked at me with the gun and then at the three men following. "What in hell's going on here?" he asked.

"The local welcoming committee," I answered, and hopped into the car. As we pulled off I turned to see the three of them still standing there in the center of the road, engulfed now in the car's dust. We were at least a mile out of town before I finally relaxed and put the gun in my bag. It was then I felt an honest bolt of fear. It was high time, I decided, to begin learning how to die.

Frankly I hate guns, and that one proved an endless source of unrest to me during my stay at Los Alamos and on my flight back to New York. My wife shuddered when she saw it lying on my bed as I unpacked. I called the police chief at White Plains, asking if I should turn it over to him. He wanted to know how it came into my possession. When I told him he laughed. "Bury it!" he said. "Throw it in the river, but don't tell me about it!" Finally I put it in the uppermost part of a hall closet and covered it with clothing, always afraid that one of my sons might find it and fancy himself James Cagney or Humphrey Bogart. Then one night I came close to using it when a radio report stated that an armed, insane convict had escaped prison up near Valhalla, which was just a few miles away. Our whole neighborhood was on edge. I slept lightly that night, stirring to the slightest sound. Near three in the morning I heard footsteps on the gravel drive. Rising, I got up and looked out the window to find the hulking figure of a man trying the knob on our back door. My first impulse was to call the police but the phone was next to the bed and I didn't want to frighten my wife. Enroute to another phone I saw him again, tampering this time with a double French door. He leaned his shoulder against it and a panel of glass popped out. Then he stuck his arm through the opening, trying to open the door from the inside. It was too late for calling the police. Reaching into the closet I took out the gun, loaded it quickly, and switched on the porch light. The convict stared at me with dazed eyes. Blood dripped from his nose. His arm was inside the door. When I pointed the gun and ordered him away he slowly withdrew his arm, keeping his eyes on me. Then he raised his other hand, and seeing an object in it that I mistook for a gun, I was about to fire when I realized it was just a wrench. Suddenly there were lights flashing from two police cars on the prowl,

and he went jogging off into the woods. I stepped out into the light, hailed the police, and sent them in the direction he had disappeared. An hour later they had captured him. Back in bed I made a resolve to get rid of that gun. I'd come too close to killing someone.

* * *

Many people, black and white, assumed I was a seasoned photographer, otherwise the magazine would never have hired me. The logic of such thinking is understandable, but this was far from the truth. There was so much I didn't know yet. The journalistic skills of the veteran *Life* cameraman were far beyond my reach. For me it was a time for hanging on, a time of trial with little margin for error. I asked for and accepted help whenever I needed it, knowing that I walked a tight-rope; feeling the pressure of succeeding for blacks because I was black, and proving myself to certain whites who resented my presence.

Frankly, I liked the publicity that came with my new job, though I wouldn't have admitted it at the time. The trick was to disbelieve my press notices, and to overcome feeling like a pepper seed in a mountain of white salt.

Too burdened with trying to keep up, I seldom saw those blacks I considered my friends. I was wary of most whites and assumed they were equally as wary of me. Some spoke on the elevators, some didn't. It was much easier for them to know me than it was for me to know them. I was black—with a big black moustache. To me they were a blur of silent white. I spoke to them with a guarded tongue and observed them with hard eyes—pulling on their clothes and ways, meanwhile, without being too conscious of what I was doing. Eventually I was an island unto myself, stretched taut over the dream that was now fulfilling itself. No more ill-cut Harlem suits; no more barbeque joints; no more warm black laughter. Only an inexplicable loneliness.

I went to Harlem one night and met a couple of old friends, Cecil Layne and Booker Brown. As we drank at the Hotel Theresa bar a black man rooted his way into our conversation. His dress was Midwestern and a Rolleiflex camera hung from his neck. Being somewhat annoyed at his intrusion, Cecil and Booker began to pull his leg a bit. "You must be a big-time photographer?"

"That's right."

"Where from?"

"Chicago."

"Newsman?"

"Everything. News, fashion, studio, sports, documentary—you name it and I've done it." He motioned to Earl, the bartender. "Heh, buddy, give these three guys a drink on me."

"You must know Gordon Parks. He's from out that way."

"Parks? Gordon Parks? Sure I know the son-of-a-bitch. I gave him his first camera!" I shuddered as the poor man went on. "Do you think he appreciates that, or even remembers to come by and see me when he's in Chicago? Naw. I never see hide nor hair of him. He don't even come to the South Side anymore. And mind you, I helped him get started." The bartender's mouth flew open in astonishment. Booker and Cecil moved in closer, egging him on. I wanted to flee. Booker chided him now. "We've never seen him. What's he like?"

"What's he like? Hell man, don't you know he's passing for white down there at *Life* magazine? They don't know he's a spook. Otherwise he wouldn't be there. His skin's white as that napkin there and he's got them baby-blue eyes. Oh yeh. Baby-blue." My two friends took a look at my black face and broke into uncontrollable laughter. Earl wiped at the bar, observing the man with disdain. I finished my drink and managed to get my two friends out of the place before he realized who I was. Earl, the bartender, finally enlightened him after we'd gone. "When I told him it was you standing right beside him," Earl said later, "he slapped down a twenty dollar bill and took off without waiting for his change."

Two years in Paris

During the summer of 1950 Wilson Hicks called me into
his office once again, looked over his glasses, and dryly informed me
I was to be assigned to the Paris bureau for the next two years. Paris.
The "dream assignment." Even today I don't know why I was se-
lected for the post that usually took ten years of hard labor, luck, and
God's blessing to achieve. Nevertheless Hicks was serious and my
family began making preparations to leave. While the children
crammed in as much French as possible, I went about finding an oc-
cupant for the house, selling the three horses, and farming out the
dogs to responsible families. Only my wife Sally seemed somewhat
apprehensive about the move. For years now she had reacted nega-
tively to our moving from one city to another, to my taking that un-
certain step I thought necessary for an upward swing. She appreci-
ated the rewards of my efforts but each move, each step, left her a bit
more uneasy, more insecure. It was as if she feared that eventually
success might put an end to us. She would have been more content
had I remained a railway waiter with a reliable income and a com-
fortable house in Minneapolis.

Sally was a fine, honest woman and a good mother, but she understood so little of the ambition and drive burning inside me or the artistic leanings of her children. Her dismay and puzzlement were expressed at times, with all of us. I have always believed that her painful, and sometimes lonely childhood condemned her to that feeling of insecurity.

Over the years she carried and treasured an old photograph of her mother in her pocketbook. Now and then she would glance at it wistfully, wishing perhaps that she had known this handsome woman of Swedish descent who had disappeared shortly after she was born. Her father, too, had deserted, leaving her and an older brother and sister to be shunted from one orphanage to another, seldom seeing one another for ten years. Finally she had been adopted by Joe and Ida Alvis, an aged couple more suited to be her grandparents. They were good to her, extremely good, but age had set an unbridgeable distance between them. She was more their beautiful possession, a ray of light in a house gone dark and musty with time. Then when she was seventeen I offered her the kind of love my family had given me. In return she gave me that glorious and unreasonable first love of youth. Love and marriage had brought to her, at last, some sense of security, and she was inclined to protect it. I had assumed she would greet my assignment to Paris with joy, but those lessons taught by an unsure childhood seemed to take hold. The thought of a strange land, a strange language, proved unsettling to her—raising, perhaps, the specter of yet another kind of instability. She prepared for the journey with scant enthusiasm, resisting French even though it was the language she would have to use for the next two years. Paris was suddenly her enemy.

* * *

We sailed on the Queen Mary, and except for the first day out, which is usually hard on the stomach, we had a good crossing. The service surpassed that of my previous trip on the great liner. I realized why when, disembarking at Cherbourg, we were ushered into the diplomatic line. Someone had spread the rumor that I was an African prince enroute to Arabia. The rumor, we expected, sprang from the inventive and limitless imagination of my six-year-old son David. When I questioned him, he denied it with an impish grin.

At customs I realized something would have to be done about the gun I had brought from Texas, which was in one of my bags. I cursed myself for not having thrown it overboard. When the French authorities agreed to keep it until we returned to the States I was relieved. I didn't bother to give them the ammunition that was in one of my camera cases. I had no way of sensing the trouble it would cause me sometime later. That weapon was off my hands for at least two years; that was the important thing. On the way back to America, I promised myself, I would throw it overboard.

Our convertible had also made the trip, and with the top down we started toward Paris. Although the route was well marked on our map, I was inclined to show off my French.

At a crossroad I hailed a boy on a bicycle. "Garçon, s'il vous plaît, le direction à Paris?"

"À droit ici, Monsieur."

"Merci, Garçon, merci," I said and immediately turned left.

The children burst out laughing. "Dad, he said *à droit!*" giggled my ten-year-old daughter Toni.

"I heard him," I answered indignantly. "Why do you think I turned left?"

More laughter. "But *à droit* means right—left is *à gauche.*"

"Aha, I was just testing you, girl," I said, swinging the car back in the other direction. I looked straight ahead but felt my wife smiling.

Sailing down the road I spotted a motorcycle cop in my rearview mirror. He came up alongside and motioned me over, pulling out a ticket book and explaining that I had been speeding.

"But I don't understand you, Monsieur. Don't you speak English?"

He tried again and again as I feigned innocence. Just when he had given up and was about to go, Toni chirped up—in good French—that she would explain to her father he had been speeding. He smiled, wrote out the ticket, and patted her on the head. As he rode off I gave my daughter a look she could always remember.

About ten miles down the road a great cloud of smoke fanned out from beneath the hood. We limped into a gas station. The mechanic, a cigarette hanging from his lip, glanced at the motor and shrugged. Immediately he knew the source of trouble. The problem

was a very common one; the Frenchmen aboard the tender had put kerosene in the transmission instead of oil—a little trick they often played on tourists with fancy cars. The mechanic put oil in the car, but it was far too late. The motor would have to be overhauled.

As we drove into Paris the whole city seemed to be singing, and the children's eyes danced. It was a good feeling driving between the poplars lining the Seine, with sparrows dipping down through the transparent sunlight, up and over the ornate bridges and down to where the barges and boats sailed the dark, silk water below. And everything was smiling, even the old buildings, the stone walls, and the cobbled streets. We drove on until at last we came to the splendid house awaiting us in Neuilly just off the Avenue Grand-Armée—a four-story English Tudor with large rooms, spacious marbled hallways with curving mahogany bannisters, and a kitchen large enough to serve a small restaurant. The Paris bureau had thought of everything—down to the maid and butler, Marie and her husband Claude, who had the place sparkling and the table already set for dinner. Before I slept that night I knew my love for Paris was inexhaustible.

The next morning the street outside our house offered an amusing scene. David, with the curiosity of a six-year-old, was up early and eager to explore the neighborhood. He sat restlessly on the curb. On the opposite curb a French boy, about David's age, sat with a toy sailboat tucked beneath his arm; obviously they wanted to strike up a conversation. From an upper window Sally and I watched, curious to see how they would communicate. Both inched toward one another until finally they stood in the center of the street together, each waiting for the other to speak. Then suddenly they were shaking hands and jabbering away in their respected tongues, coming toward our house. Eventually they wound up in the second-floor bathroom where David filled the tub with water to sail the boat.

Abruptly their voices rose in disagreement. *"C'est bateau!"* the French boy shouted.

"You're crazy! It's a boat!" David shouted back.

"Bateau!"

"Boat!"

It was time to intervene. I explained to Jean Luc Brouillaud that in English the toy was called a "boat." To David I explained that in

French it was *bateau*. Understanding, they grinned and began their French-English game of identifying the objects around them. It was no accident that David, in a short time, spoke better French than the rest of us. He and Toni would attend a French school, while Gordon, being considerably older, would enroll in the American school.

* * *

The Paris bureau overlooked beautiful Place de la Concorde. John Boyle, an affable Irishman, headed the *Time* bureau and John Jenkinson was the *Life* chief. The reporters were Lee Eitingon, Dita Camacho, Dodie Hamblin, and Natalie Kotchoubey, a great-great granddaughter of Napoleon Bonaparte. Dimitri Kessell and Nat Farbman were the other photographers. They were good people and superb correspondents; I was honored to have been one of them. Natalie, after hearing some of my *faux pas* with the French language, took it upon herself to improve my facility—a formidable job indeed.

The first misadventure occurred when a little man came to my door and started plying me with questions. Whenever I couldn't understand someone I had a terrible habit of answering "Oui-oui." This time, however, I obviously overdid it. A couple of weeks later a truck pulled up to my door and unloaded twelve cases of wine—and, I was to find out, very bad wine. The little man had been a salesman from a vineyard. Every time I uttered "oui" I'd ordered another case.

One evening Truman Gibson, one of Joe Louis's former handlers, arrived from London with his wife. He, too, was finding French impossible and asked how I was faring. It didn't take him long to find out. From a box that I was sure held dinner napkins, my wife shook a hefty supply of Kotex. Puzzled, scratching my head during the laughter, I said, "But I asked the jerk for *les grandes serviettes.*"

Then there was my *erreur suprême*. I had just reached the bureau in a sweat after a woman I knew had tearfully informed me of her daughter's death. "I'm glad I know how to tell her I was sorry," I sighed.

Natalie Kotchoubey held her breath. "Tell me, what did you say?"

"Why, I just took her in my arms and said *'tant pis.'* "

Natalie blanched. "My Lord," she said, hurrying me to her car. "You were as much as saying, 'tough—so what the hell.' "

"And what should I have said?"

"Je suis navré! Je suis navré! That's what you should have said."

The dear woman assured Natalie that she was not offended. "I could tell by his touch," she said, "that he really meant he was sorry."

I welcomed the French *dictionnaire* Natalie presented me with for my birthday.

* * *

Early in the fall I was sent off to the resort town of Biarritz near the Spanish border. There, for their wealthy clients, the *haute couture* was throwing the Napoleon III ball. The Duke and Duchess of Windsor headed an impressive guest list. King Farouk of Egypt and his entourage would also attend—thus creating a problem for the Duke and Duchess, who loathed him. Natalie was driving down with me, along with three fashion models, to shoot a fashion story after the ball. As we approached Biarritz we heard a sudden blast of automobile horns. Then at least ten limousines roared down upon us from the rear, forcing us off the road and into a shallow ditch. King Farouk was on his way in. After he had passed, I addressed a few obscene words to his royal highness and pulled back onto the highway. Further ahead, a horse lay in agony beside the wrecked cart it had been pulling. The injured horse's owner sat nearby wailing and nursing his bruises, feeling, I'm sure, no honor at having been a hit-and-run victim of the Egyptian monarch.

Shortly after we settled in at the Hotel Palace, a concierge came to inform us we would have to repack and move to another floor. The King wanted only his party on the floor we'd been assigned. Remembering the ditching he had just given us, we steadfastly refused to move. If the King didn't like it—well, too bad. The poor concierge left wringing his hands, and we went down to the bar for a drink. When I returned an hour later my room was in great disarray. Every drawer had been emptied and searched.

Furious, I went to the manager's office and complained. He lis-

tened with little patience, then made a telephone call. The next moment I was confronted with an Irishman, whose name I fail to remember, and two squat Egyptian strongmen. The Irishman extended his hand, palm up; in the center were several bullets. "These yours?" he asked coldly.

"You should know they're mine since you rifled my room, and I'm goddamned mad about it!"

He ignored my anger, asking, "What part of Egypt are you from?"

"What makes you think I'm from Egypt?"

"What part?"

A clerk entered and handed him a hotel registration card. He read it and looked at me skeptically. "You're a correspondent for *Life* magazine?"

"So I see you can read."

"For how long?" he asked.

"That's hardly any of your business."

"Where's the gun?" He pulled a wallet from his pocket and flapped it open, revealing a gold police badge.

"Just like the movies," I said. Then, tired of the game, I explained who I was and what I was doing there, and that I had left the gun in Cherbourg.

"What's your boss's name?"

"Which one? I've got several."

"Okay—the top one."

"Henry Luce. Happen to know him?"

"I was brought up in New York," he said. He turned and the three of them started out. "How about the bullets?" I asked.

"Since you have no gun you won't be needing them. The hotel will give them back when you leave. My apologies for your room. You realize we must be careful." Knowing Farouk's reputation. I could understand his concern. Obviously I had been suspected of being a possible assassin. Our party remained on the floor, but an armed guard was posted down the hall from our quarters.

At the banquet that night Farouk spent most of his time pelting the bare back of an English woman with small chunks of bread. Her angered husband finally got up and charged the King's table, but was

manhandled back to his seat. When I tried to record the incident with a wide-angle lens, two Egyptians placed themselves in front of my camera.

The Duke and Duchess dined elsewhere. Later, at the ball, they kept to themselves in a small anteroom until Farouk's party left. They seemed tired and weary of the whole affair.

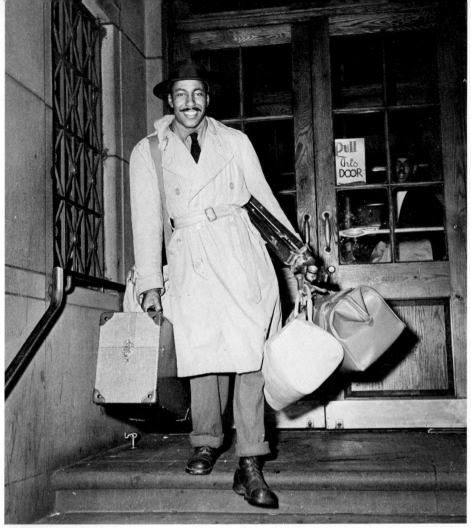

*Author leaving Harlem Branch,
YMCA, 1944.*
Photo: Cecil Layne.

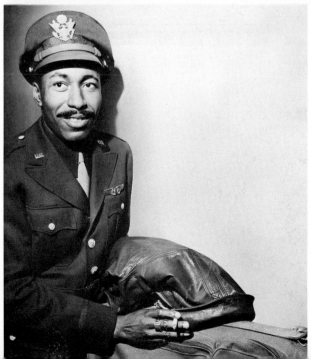

*Author in uniform at
Selfridge Field air base
outside Detroit, Michigan, 1944.*
Photo: U.S. Air Force.

Author's father,
Andrew Jackson Parks, 1937.
Photo: Gordon Parks.

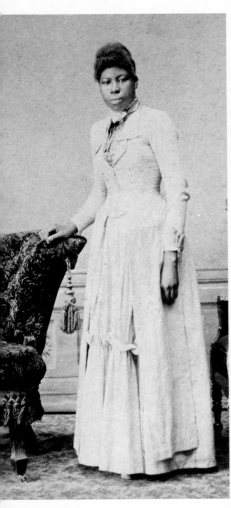

Author's mother,
Sara Ross Parks
(date unknown).
Photo: J. V. Dabbs.

Author in Minneapolis,
Minnesota, 1940.
(Self-portrait).

Sally's mother, Olga Turner *Sally.* Photo: The Dayton Company.
(date unknown). Photographer unknown.

Author's family snow-sledding in White Plains, New York, 1947. (Left to right)
Toni, Gordon, Jr., Sally, Gordon, Sr., and David. Photo: Cecil Layne.

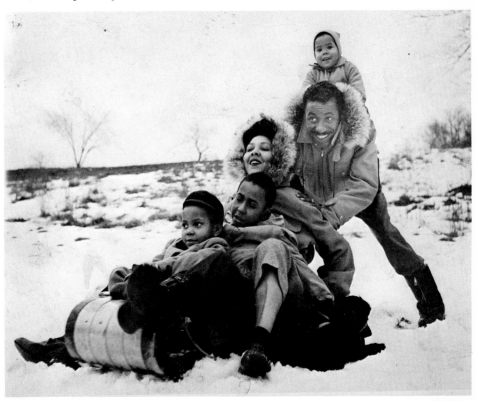

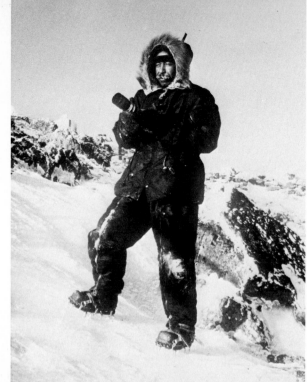

*Author in the wilds
of the Northwest
Territories, 1945.*
Photographer
unknown.

*Portrait of
Roy Emerson Stryker
taken by author
in 1943
at Washington, D. C.*

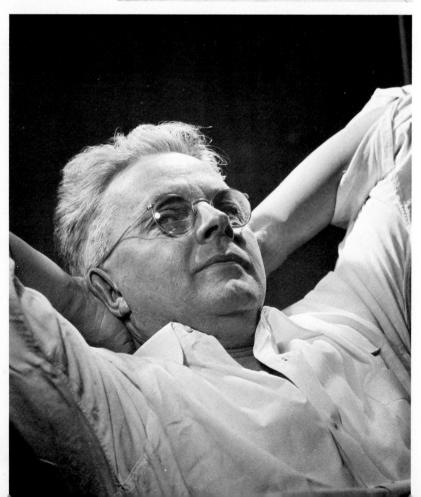

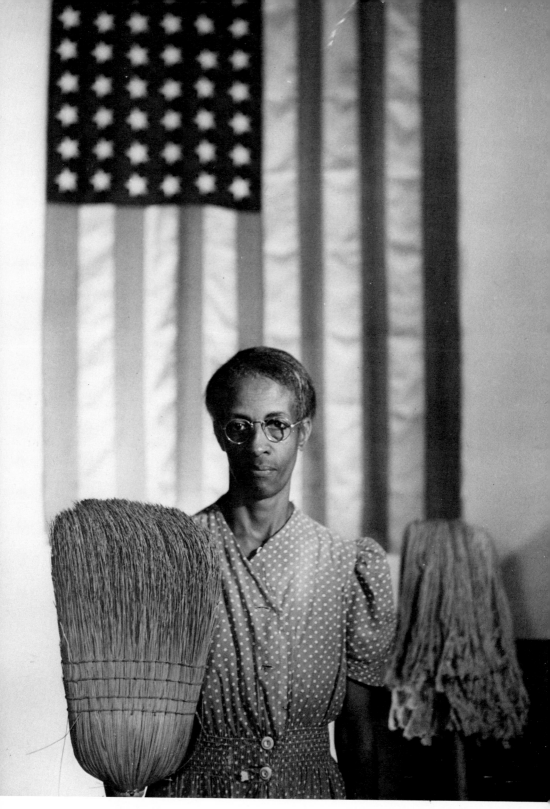

"American Gothic." Washington, D. C., 1942. Photo: Gordon Parks, FSA.

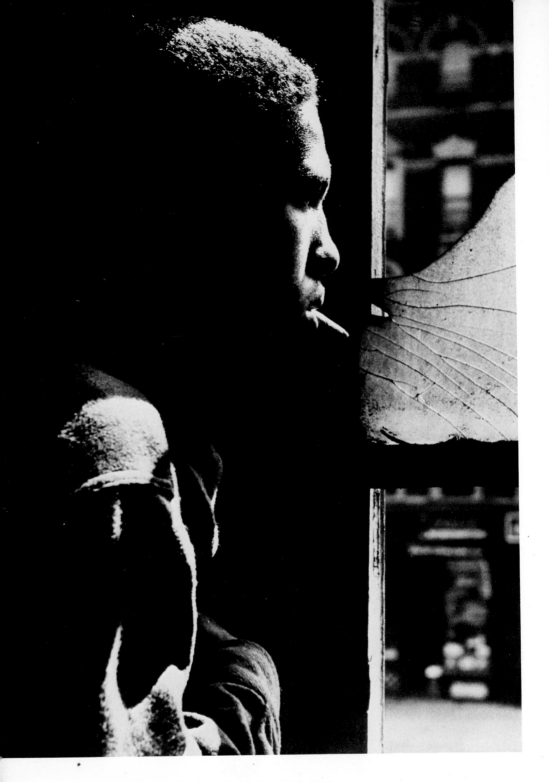

Red Jackson, Harlem gang leader. New York, 1948.
Photo: Gordon Parks—*Life*.

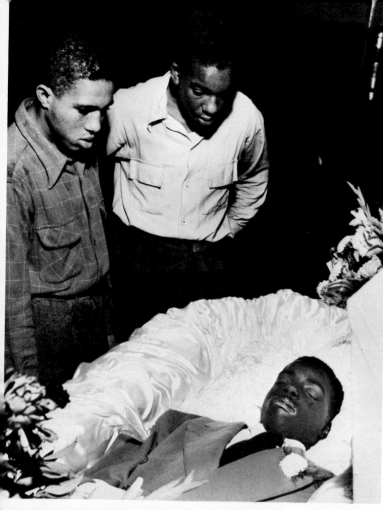

Red, Herbie,
and dead gang member.
New York, 1948.
Photo: Gordon Parks—*Life.*

Red and Herbie
at gang rumbles.
Harlem, 1948.
Photo: Gordon Parks—*Life.*

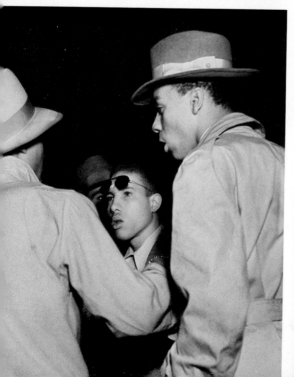

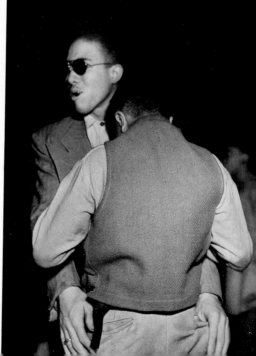

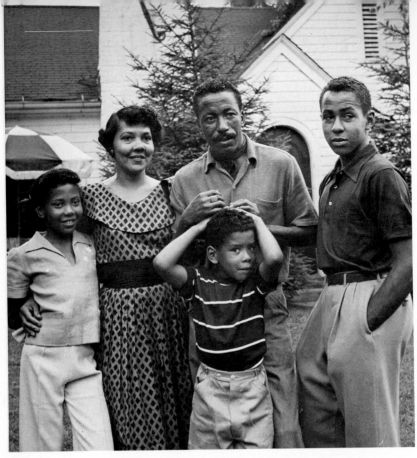

Author's family. White Plains, New York, 1949. (Left to right) *Toni, Sally, David, Gordon, Sr., and Gordon, Jr.* Photo: Cecil Layne.

Gordon Parks, Jr. Photo: Esther Bubly.

6

Music, Poetry,
and discarded Heroes

Thirty-eight years of racism had scratched me raw. Europe was a change and a great relief. Unlike Washington, D.C., which had disappointed me so, it was free of bigotry and discrimination. Traveling from Paris to our house in the south of France was far different from motoring from Minneapolis to Kansas City—where motel after motel would refuse us lodging. No stones had come through our window when we moved into the all-white neighborhood. There had been no emotional outpouring of welcome—just a calm and unquestioning acceptance. No "For White Only" signs, no need for the weapon I left back in Cherbourg. It was a new and enlightening experience. I understood now why Paul Robeson would say that in Europe he felt like a man for the first time in his life; understood why a superb writer like Richard Wright would flee to Paris to escape harrassment after moving into a white neighborhood; why other black artists had chosen expatriation over the evils of their native land. I could never bring myself to say I hated America. I acknowledged her as a great country, but without trembling at her greatness. I damned her at times, but without allowing

her to consume me with bitterness. The ironic thing about all this is that no country in the world offers a black the opportunities America does. The sad thing is that America makes it so difficult for blacks to take advantage of those opportunities.

During the excitement of those days in Paris I was, for the first time, able to relax against the tension of trying to live an individual life. More than ever I appreciated the great composers like Bach, Beethoven, Prokofiev, Mozart, Shastakovich, Rachmaninoff, and Brahms. Now there was time to read Proust, Camus, Dostoevsky. I heard Pablo Neruda, the poet, lecture in Rome that year. I spent Sundays at ballets and concerts; Saturdays at galleries rich with the art of Degas, Braque, Bonnard, Picasso, Van Gogh, Chagall.

What I always wanted to be, and couldn't, was a concert pianist. For his own reasons, my father would never have approved of his son playing a piano for a living. That, however, was something my sisters could do, and he scraped up enough pocket change for them to take lessons from an aged German teacher who cracked their knuckles when they made a mistake. I had persisted, nevertheless, fingering away at our old Kimball upright when my mother was around to still my father's grumbling. But now, years later, here in faraway Paris, time for such intricate learning had passed me by. The huge baby grand I rented was not so much for playing as it was to fill space in the living room. Then again, my daughter might get interested—even one of my sons.

I bought a typewriter, put it on the desk in my study, and placed some blank paper beside it. For a month or so both piano and typewriter sat idle, waiting. Snow was falling on Paris rooftops when at last I sat down to the piano and started fingering an original theme that had come to me one night in Madrid. Obviously I had been influenced by witnessing the fatal goring of a young bullfighter. In less than three weeks I had the central theme firmly in my hands. Finally, to give the household some relief, I turned to the typewriter, writing a collection of poems, observations, and journal entries that I eventually entitled "Paris Notes":

PARIS. *Winter, 1950*

WHILE WALKING
Two young lovers embrace there
On the rue Boissy d'Anglas.
In the mist blue evening
They kiss and kiss again.
A crippled newshawk cries,
 in good Montmartre French
"Le gouvernement fout le camp encore!"
But to them he is oblivious.
 Locked
In ripe understanding
They move off toward the River Seine.

(Of a lady I dined with at Maxims:)

LA VANITÉ D'ALICE	*THE VANITY OF ALICE*
Sa beauté en allée	*With beauty gone*
Son monde rétéci	*The perimeter narrowing*
Elle s'escrimait contre	*She strained against*
l'inévitable.	*the inevitable.*
Elle y était entraînée.	*She was forced along.*
L'énergie	*The energy*
Consumée dans la lutte	*Consumed in the struggle*
Hâta sa chute.	*Hastened the collapse.*
S'effondrer sans dignité.	*Surrender without dignity.*
S'effondrer san honneur.	*Surrender without honor.*

SCENE: *Left Bank*

The couple stands there—cold, directionless, gazing blankly into the gutter. She is sticklike in men's shoes, looking older than he. Her ill-fitting stockings, like screen wire, protrude at the heels, barely touching the bony ankles that are purple-gray from the cold. The coat, a faded green, was cut for a larger body. Its collar, like her hair, is worn and damp from snow. Her face is a troubled mask interrupted by wine-raw lips that twist upward on one side. She jerks about now and then like a weary mechanical toy.

He rocks slowly from side to side, his shoulders slumping, and though his face is grimy and sunken into itself, it hints of a past handsomeness. His khaki uniform was issued for some past war—and to someone much younger; and his boots seem to have taken their shape from another pair of feet. He stands ankle-close as if the heels are weighted with lead. I'd better move on. Both of them

have turned to look at me, smiling now, sensing perhaps the fear I have for becoming what they have become. Now they laugh as I make my hasty retreat.

SOLITUDE	LONELINESS
J'y fus marié dès ma naissance	I was wed to it at birth
Et j'en fait ce que j'ai pu.	And I've made the best of it.
Ne puis m'y fier	I can't trust it
mais je m'y livre.	but I confide in it.
Sans cacher l'action la pire	Without veiling the worst deed
ou la pensée.	or thought.
Récemment dans les froides	Recently in the cold
heures sordides	sordid hours
C'est devenu la seule chose	It has become the only thing
Qu'en raisonnant je puisse	I can truly reason with.
admettre.	

* * *

I'm composing steadily now and feeling good about it. Dean Dixon, after hearing sketches of the first movement, urges me on. He's a fine conductor but because he is black—therefore unacceptable to the large U.S. symphony orchestras—he has come here to work. This saddens him, he said after we had dinner tonight. He seems to be at the height of his creative powers, and despite his acceptance and success with European orchestras, longs to be asked back to America to perform. Once he guest-conducted New York's Philharmonic—after a lot of outside pressure was brought to bear, but the Boston, Cleveland, Chicago, or Minneapolis organizations have yet to invite him. His all-Brahms program at the Salle Pleyel got rave notices last week.

* * *

Dixon startled me by promising to perform my work when I finish it. Vivian Rivkin, his wife and also a brilliant pianist, seems to share his enthusiasm. She anguishes at my fingering, wonders how I can do everything so awkwardly and manage to make it come out alright. All this is more than I dared hope for, and I'm working in earnest. Since orchestration is as foreign to me as it is to a giraffe, I have a problem—which doesn't worry Dixon. His advice is to keep attending concerts and listening to the masters; to acquaint myself with their use of the different instruments. Oh, how easy he makes it sound. What about the actual notation? Well, since I've had no formal training, I had to figure that out for myself. I don't have the

time or patience to learn the normal way so I have concocted a mathematical system whereby each note represents a number. Mind boggling, but it works for me. In a couple of months I will start recording the piano parts and send them onto Henry Brant in New York. He will eventually assist with the final orchestrations when I get back there. It will take another year and a half at least.

* * *

"Paris est toujours une ville en grève," our butcher complained this morning when we passed on the street. He's right; it's a city of strikes. One every other day it seems—gas, electricity, telephones, or whatever. Yesterday the Communists disrupted things with a massive shutdown of the transportation system. Strikers filled the avenues and boulevards all over the city. The dreaded *Compagnie Républicaine Securité* was called out to help the police force. We photographers and reporters have the wisdom to give these particular *gendarmes* a lot of distance and respect. Instead of going in close we use our long lenses when they start beating heads with their truncheons and capes—which are, it is said, lined with lead. Since many of them are members of the party, they don't like being photographed roughing up a fellow member. Jacques Leland, a young Belgian photographer, tried to make a name for himself yesterday during the violence. He kept going in close to the fighting despite our warning. The third time he went in, a cape caught him on the ankle and tripped him. The fourth time a truncheon smashed against his face and sent him down screaming. He was a bloody mess when we dragged him back into our ranks. It was too late. The pupil of his right eye hung on a string of skin down to his crushed cheekbone. Crying and cursing, he did something I will never forget. He tore the pupil from its socket and flung it toward the *gendarmes*. For him it was a hard lesson to learn.

* * *

Toni came home from school last week in a snit, saying she wasn't going back because of a book that a teacher had assigned her class to read. When I saw the book I agreed. Published in England, it referred to American blacks as "darkies" and "pickaninies." I confronted the headmaster the following Monday and enlightened him about the reason neither Toni nor David were at school. He expressed his shock and immediately banned the book. Good for Toni. Gordon didn't fare as well yesterday when he bolted class at the American school and came home to complain that his French

teacher was working him too hard. What's more, he bragged he
had told her "where to get off." I marched him back to school and
instructed the teacher to double his load and find some punishment
suitable to his behavior.

* * *

Sally wants to make hats so I have arranged for her to work as an
apprentice at a good hat-maker just off rue Saint-Honoré. I hope
she likes it. It could improve her feeling about living in Paris. The
grocer didn't improve matters the other day when he tipped his hat
and bid her "bonjour" from a *pissoir*. My wife just can't get used to
seeing Frenchmen relieve themselves in public. She and the maid
aren't hitting it off either. Sally feels that Marie is pocketing some
of the money she gives her to shop with. This is probably so, but
it's an old French custom with maids and there isn't much to do
about it. In any case, being French she gets much better bargains at
the markets than an American housewife could, so it evens out. My
wife refuses to buy such reasoning. *C'est la vie.*

* * *

Todd Webb, a photographer, and his wife Louise—two friends
from New York—are here, living on the Left Bank. [Todd and I
worked together at the Standard Oil Company under Roy Stryker.]
We had a drink together at a bar just down the street from his stu-
dio and talked mostly about the war. Things seem to be going from
bad to worse in Korea, what with the Soviets backing the North
and the U.S. backing the South. Same old game. Truman has or-
dered the U.S. air and naval forces in. Another world war seems
imminent. The draft has started back in the States. What a relief
that Gordon and David are too young for it. Perhaps I should have
packed my old correspondent's uniform. My passport has just been
updated and now permits travel into Korea. That tells me some-
thing. I wish MacArthur wasn't so trigger happy. The man has
always frightened me.

October 12, 1950

The U.N. forces have crossed over the 38th parallel. The Chinese
Communists are sure to intervene. Chou En-lai is threatening and
making noise.

October 22, 1950

Something big is in the wind. Truman and MacArthur met on
Wake Island. There is more and more talk about war from everyone
here at the bureau. I feel a strange excitement about the possibility
of being assigned to Korea. I'm a bit apprehensive about it as well.

October 27, 1950

Todd Webb and I shared a disturbing experience at our favorite bar
this afternoon. A French Communist, introducing himself as Boris,
barged into our conversation and began upbraiding Todd. How
could he (Todd), a white American, drink with a black man in
France, since he wouldn't dare do it in the U.S.? Both Todd and I
laughed, explaining to him that we were old friends and had eaten
and gone drinking together many times in New York. Boris didn't
believe a word of it. For years he had read about the lynchings and
shootings of blacks in America. Why the blacks didn't join in a rev-
olution back there was a puzzle to him. He drained his glass and
turned to me. "Comrade, do you find the same bitterness here
against you that you do back in America?"

In all honesty I had to answer that I didn't, giving credence to his
argument. "Did you hear his admission?" he asked Todd, speaking
with great assurance now.

"But I agree with him completely," Todd said. "The only dif-
ference is that you refuse to understand that we are good friends—
and have been for a long time."

"Then you call your friend here a liar?" He laughed. "He says
one thing and you say another."

It was developing into an awkward situation. Suddenly I found
myself defending and damning my homeland in the same breath,
trying to get Comrade Boris to understand the difference between
the Todd Webbs of America as opposed to those who were indeed
guilty of such crimes against blacks. At one point he accused me of
talking out of both sides of my mouth at the same time, and per-
haps he wasn't far from wrong. Todd, angered now at the in-
trusion, refused to talk further. I asked Boris where he was born.

"Paris," he answered.

"Are there anti-Communists here in Paris?" I asked.

"Hundreds, thousands of them!"

"They are good people, nevertheless," I said.

"Good people? *Mon Dieu!* They are pigs, bastards!"

"Are there any Communist pigs?"

"We will save Paris! We will save Europe! We will save the world—wait and see!"

"Anti-Communist pigs and good Communists, all right here in Paris."

"Absolutely."

"Then there are good people here as well as bad?" I had baited the trap but he wasn't stepping into it.

"My black friend, if you want to defend this murderer, this hangman of your own people, you can do so. *Bon soir!*" he bellowed and stormed out of the bar.

Todd and I stood silent for a moment, our thoughts bleeding from Boris's wicked clawing. "What do you do with a bastard like that?" Todd asked.

"Get him a job with the Voice of America," I answered. Then we had a stiff shot of brandy and talked of war again. Even that seemed almost pleasant after Comrade Boris. However, this isn't the first time I've had to try and explain America. It's not easy.

Estoril, Portugal. November 4, 1950

Natalie Kotchoubey and I are here on assignment for several weeks. Estoril is beautiful, constantly sunny and steeped in the manners of tropical resorts. I've made friends with a young composer, Carlos de Santos, who loaned me a portable and silent keyboard. It's a very practical gadget that permits my working late into the night without disturbing other hotel guests. By now I am well into the second movement of what I call "Concerto For Piano and Orchestra." It's exhausting but exhilarating. During the day Natalie and I search out and photograph those deposed monarchs and would-be rulers who have fled their respective kingdoms to live in luxurious exile. They are a wealthy, spiritless group—King Carol of Rumania and his mistress, Madame Magda Lupescu; King Humbert of Italy; the Hungarian admiral and statesman, Nicholas de Nagybanya Horthy; Don Juan de Bourbon, pretender to the Spanish throne; and a few others. Finding them isn't as difficult as one might imagine. Carol spends most of his mornings at a private shooting range slaughtering doves while Lepescu sits on a veranda and knits. Humbert II is usually in his well-appointed home on a rocky knoll above the sea, working at his memoirs. Don Juan, an excellent golfer, always instructs us to await him at the eighteenth hole for a drink at

the clubhouse. Horthy spends hours in his Rube Goldberg-like laboratory doodling at his outrageous inventions that neither he, nor anyone else, will ever find use for. We came upon him this morning out for a walk with his grandson. He appears to have gone slightly balmy. I have come to admire Don Juan and his family. He seems to be the only one really working at something besides royalty. A younger daughter of his is totally blind but is studying piano. We played for one another the other day, and I find her an interesting girl. Carol and Lupescu are a pleasant couple and both are always elegantly attired. He seems so gracious, quiet, and gentle; it is difficult to associate him with the infamous assassinations and massacres that took place between his royal dictatorship and the fascist Iron Guard that opposed him. Humbert II is very uncommunicative. He appears to be morose, somber, and secretive—yearning perhaps for his throne which was his for only a short time after his father, Victor Emmanuel III, died. He yearns in vain; Italy is finished with kings.

* * *

Natalie Kotchoubey, the daughter of a Baron, and a princess in her own right, is a great asset to this assignment. If at first we are unable to find some notable at home, she discreetly leaves her *pétit* calling card. The next time the doors magically open. She never flaunts her heritage, however, and one would never guess that she is a descendent of Napoleon III.

* * *

Yes, I'm sure old Admiral Horthy is losing his marbles. This afternoon in the midst of his awesome array of glass tubing, bottles, chemicals, and beakers, he stopped work and began reminiscing, mumbling his thoughts back through the First World War when he commanded the Austro-Hungarian fleet. Repeatedly he damned Bela Kun for seizing power in Hungary back in 1919, and he praised the counterrevolutionist forces that put him in command of their armies. His face flushed and crinkled to an evil smile as he described Kun's downfall. Placing his hands on his large hips, he strutted about for a moment telling how he had kept the Emperor Charles I from regaining the throne. Then, sadly, he remembered that with Charles formally unseated he had found himself a regent of a kingdom without a king. He dozed for a few moments, then jerked awake to go on about the U.S. troops freeing him from Nazi internment in Bavaria near the close of World War II. What were

his thoughts about having been a witness at the Nuremberg war crimes trial in 1964? "It was a circus—a mad, mad circus." He waved away the memory of it with his pudgy hand. "I don't want to talk about that."

* * *

King Humbert was certainly not his usually morose self as he dined with a lovely lady at the Hotel Palacio tonight. Later I saw them at the gaming tables, both smiling happily. A usurped throne now seemed the least of his worries. For the once-crowned heads, Estoril is a good life, laced with genteel boredom, plush balls, lavish parties, and make-believe fox hunts. They are still blue bloods—turning gray and wrinkled, swapping memories, and clutching meaningless titles in this lonely royal morgue.

* * *

Enroute to Paris from Lisbon by Air

The sight of the city is falling away rapidly now. Far off to our right lies Estoril, a sunny solitude of white houses, splendid sand, and beyond that—the sea.

Paris. December 3, 1950

There seems to be a general heat strike on today. Everything is cold. The bureau asked for and got permission for me to photograph the Duchess of Windsor selecting part of her new wardrobe at Elsa Schiaparelli's. When I arrived, the Duchess was reclining on a great chaise lounge with her legs being warmed by a mink lap rug. Schiaparelli fawned over her as the mannequins pranced back and forth in the latest fashions fit for the would-be queen. When it was time for the shoes, which had been especially selected and brought in, the great couturière promised the Duchess a treat. It arrived in the person of a mannequin who was making her first appearance. Said Schiaparelli, pointing at her, "She's ugly as sin, but have you ever seen such gorgeous legs and feet?"

"Beautiful," replied the Duchess.

The mannequin, who couldn't understand English, smiled graciously, so very, very happy that her highness was pleased.

December 7, 1950

I nearly cost the Comtesse Maxime de la Falaise her Right Bank suite yesterday. I was photographing her in an adjoining apartment

that belonged to the building's owner. There were candles in a wall chandelier, so to enhance the mood I lit them. We were nearly finished when the owner arrived and found her candles burning. Running to extinguish them she exploded into a tirade, threatening to sue *Life* magazine and eject the startled Comtesse from her suite. It took a carton of new candles and two days of cajoling to smooth things out. It's hard to believe, but obviously there is still a shortage of candles in Paris. Then again, certain people have strong attachments to certain things.

December 23, 1950

Last-minute Christmas shopping with Art Buchwald. He knows all the prettiest clerks on rue Saint Honoré.

January 12, 1951

Eisenhower has taken over as supreme commander of the Allied powers in Europe. I was assigned to make his official color portrait. This morning when I arrived at his headquarters his aides informed me that I would be allowed only ten minutes, hardly enough to unpack my equipment. I asked for more time but they were firm— even five minutes more would wreck his day's schedule. To my dismay, Eisenhower spent at least seven minutes asking about the camera I was using, holding it, and carefully inspecting it. When I explained that my time was about gone, he went on as if he didn't hear me. Moments later his door opened and a major entered to say that my time was up. The General waved him out, and we spent another half hour talking about cameras. He is an incurable photography buff.

January 3, 1951

I telephoned Richard Wright and asked him to lunch yesterday. Like Paul Robeson he is one of my heroes. In 1942 his text for the book, *Twelve Million Black Voices,* became my instant bible; and it remains so today. He, more than any other, stirred my visual and literary aspirations. Since then I have read most of what he has written, and he is no provider of sentimental tales. He writes about the black man's trials in America with a cold, hard realism that Americans can't escape. To him, his *Uncle Tom's Children* was a naïve mistake, a book that whites could weep over and feel consoled by the tears

they shed. Now he writes so hard and deep that their tears alone won't suffice. *Native Son*—stark, brutal, and full of cold terror—burned across America and then, in six foreign languages, carried its message to other parts of the world. He is living here now with his wife Ellen and their nine-year-old daughter. Wright is a delightful, friendly, gentle man who lives simply, seldom goes out, and stays close to his typewriter. There had been a long silence when I asked him where he would like to have lunch. Then he said, "You'll be shocked, but just once I'd like to go to Maxim's." I was shocked, after picturing myself eating with him in a bistro where some of his Communist friends might happen in. It would have been so furtive with a bottle of cheap red wine. We both laughed when I expressed my thoughts. Certainly Maxim's would be a most curious experience for him, with its plushness, fancy food, and stuffy clientele. I got the restaurant's maître d' on the telephone and arranged it. Richard was indeed taken with the whole scene—observing it as he would a play, enjoying each actor and actress as they took the stage. We ate well and finished off the meal with cognac. When the bill came, he inisisted on seeing it and winced at the total. "My God!" he said, "My family eats an entire week for that!" I wanted to talk. Where would he like to spend a couple of hours? "At a bistro on the Left Bank with a bottle of cheap red wine." The rest of the afternoon I listened to him expound the emotion of fear and how it makes men into cowards and beasts. Fear and terror; they thread all of his recent works. How about religion? He will have no truck with that, he says, nor the salvation and heaven it promises. Money? He has found no security in the comfortable royalties from his books, nor for that matter in the fellowship of the Communist party. "My heart's with the collectivist and proletarian ideal, but something deeper than race or politics is at stake—the human right of man to think, feel, and act honestly." He doesn't give a tinker's damn about blacks who don't want the sordid side of our life exposed, and he ignores his Communist friends who feel that he doesn't give enough of himself to the class struggle. Truth compels him. I seriously wonder about Wright, far away here in Europe, away from that Southern fear that seems to have terrorized him into becoming the great writer he is. Will he suffer enough here to continue the struggle? To my daughter he wrote, "Freedom belongs to the strong. . . ." More than anyone else I know, Wright understands the forces that create hatred and strife among men. I remember those words at the close of *Twelve Million Black Voices*. It was as though they spoke to me personally, telling me that, as a

black man, I was with the new tide standing at the crossroads
watching each new processon; that the hot wires carried my appeal;
that print compelled me; that voices were speaking and men were
moving—and, that I would be with them.

* * *

Paris is a feast, a city where so many perfected dreams float the pale
air: dreams of Proust, Chopin, and Daumier; dreams that survived
the Huns, the Hundred Years' War, the English, the black death,
the Prussians, countless revolutions, and two world wars. I sit
sometimes at the Café des deux Magots on the Left Bank, drinking
good red wine, where perhaps Balzac, or Baudelaire could have sat.
On workless days I haunt the tree-lined *quais* along the Seine, her
historic bridges, and the open-air bookstalls. On Sundays there are
family walks and picnics in the infinite depths of the Bois de Bou-
logne; a mile or so further on is a good race track. For other days
there is the rue de la Paix, the Place Vendôme, or perhaps Mont-
martre, where one sits high above the city in the shadow of Sacre
Coeur to look down upon the classical age of Molière, or down to
Notre Dame where Napoleon I was crowned Emperor. Now and
then I think back to the segregated graveyard in Kansas where my
mother and father lie—wishing that they, too, could have walked
here.

* * *

I had a bad habit of calling on God in times of disaster, then after
things have calmed I forget Him—until trouble chooses me again.
My good parents gave me to God in baptism when I was born, but
somewhere along the way He lost His grip on me. But I went look-
ing for Him again last night.

Along with a dozen other foreign correspondents, Dodie Hamblin
and I are following Eisenhower by chartered plane to all the NATO
countries. We were trailing his constellation toward Hamburg, Ger-
many, when his pilot radioed us, warning of dense fog, sleet, heavy
snow, and high winds. The General was advising us to turn back.
Their plane, unlike ours, was equipped with all sorts of instrument
landing equipment. Our pilot, a Texan who had never flown in
Europe before, had only a map, guts, and a dangerous ego. Being a
Texan, he felt that if Eisenhower's pilot could make it so could he,
so he flew on toward Hamburg.

Soon we were in the thick of nowhere, bouncing around, flying
from bad to worse, unable now to see our own wing- tips through
the fog. Abruptly a great shower of snow and sleet poured against

the windows; then a fierce wind struck hard, blowing us all over
the sky. The worst of all the elements, it seemed, had come
together to do us in. The wings iced up, forcing us to a lower alti-
tude, and we courageous journalists sat silent and pale from the buf-
feting, exiled to our private thoughts—waiting bravely, or fearfully,
for fate to take charge. Dodie Hamblin pressed closed to me. I
smiled nervously and took her hand, feeling that we were going to
die. Then, not one to trust fate, I politely asked God to land us
safely.

He didn't respond immediately. Evidently He felt I needed to
pray a couple of hours longer. By now half our fellow travelers
were losing their dinner in paper bags that the charter company had
provided. Finally we started down, turning slowly but going down;
then we burst into an air pocket, dropped about fifty feet with the
plane shuddering from the impact. At that moment nothing else
crossed my mind except death. I braced myself for it, sitting like a
star unmoving in a falling universe, waiting. Then there was a
clank, an unnerving, startling clank (the landing gear locking into
position) as we sped lower and lower until light flashed beneath the
port wing, another and then another flashing past. Thank God. At
last we were about to touch down on the icy runway, speeding
forward, flaps down, straining against the terrible onrush of snow,
sleet, and wind. The plane hit solidly, lunged ahead, and then
started sliding sideways and came to a shuddering halt just short of
a brick wall. We sat silent for a moment, choked with gratitude.
Then a cheer went up for the pilot. God, for the moment, was
forgotten. Up there in the foggy nothingness I had opened up every
drawer in my heart; I had searched for courage but found instead
fear, terror—and the need for Him.

The harrowing experience convinced me that I still love life, and
that I wanted nothing to do with death. If only I could stop using
God so conveniently when I haven't done anything to deserve Him.
Somehow I must bring myself to either fully accept God, or con-
sider rejecting Him completely.

* * *

March 15, 1951

A letter today from E. Simms Campbell. Enclosed was a snapshot
of his daughter Elizabeth, who must be about twelve now. She is
going to be a beautiful lady someday. He also enclosed several
sketches of drawings he completed for *Esquire* magazine. The letter
was written, he says, at four o'clock Saturday morning. Obviously

he was in his cups. Vivian, his wife, threw in a few lines. Both of them think that Joe McCarthy's witch hunt is bringing out the worst in some people. The best of friends are pointing at one another. The Senator from Wisconsin, they think, should be put away. Elmer labels him an "irresponsible lunatic" who's got everybody so scared of Communists that they're building bomb shelters in their backyards. There is also a UFO scare. People are actually spotting ships from outer space.

Elmer, "after an all-night bout with a fifth of Johnny Walker," looked out the next morning to see one parked in his flower garden. Well, he walked right out and made friends with the leader who had a three-foot-long yellow nose, purple hair, and green eyes; and believe it or not the guy was whistling the St. Louis Blues backwards in three-quarter time. He gave the guy a drink (which ran right through him and out of his toenails) and then the two of them went down in the basement and ate chitterlings and pig's feet until midnight, after which they did a little foxtrot onto the ship and flew from New York to Kansas City in less than ten seconds. When he congratulated the leader, Yhtraccm Eoj (Joe McCarthy spelled backwards), on such crazy flying, Yhtraccm just yawned and said, "Hell, Simms, I was taking it easy. Wait till I give you a spin in my 1951 new Spacerollsmobile. We'll do it in half the time." And to prove his point they spent another half hour circling Russia, dropped down for a cup of jasmine tea in Peking, visited a couple of whorehouses in Corpus Christi, Texas, and got back home in time for some hominy grits and sausages Viv had cooked up for them. "Yhtraccm kept asking Viv if he hadn't seen her on another planet someplace, maybe Mars. She didn't think so. But, as you know, Viv could be wrong. She never remembers faces—but she always forgets names." E. Simms offered to sell me his place in Elmsford, New York. Obviously he's forgotten that I know the state is planning to run a highway right through the middle of his livingroom. He sent me clippings on the Rosenberg trial last week. Thinks they will be found guilty. There were a few minor demonstrations here in Paris this week on their behalf.

March 25, 1951

Truman just axed MacArthur for threatening Communist China with air and naval attack. Ridgway is to replace him. This is bound to cause a big stir. MacArthur's got a lot of worshippers back home.

April 6, 1951

Elmer was right. The Rosenbergs have been found guilty and sentenced to death. If it happens they will be the first American civilians to die for treason.

Mid-April, 1951

Paris is more beautiful than ever, but the quiet of it was marred today with a noisy demonstration to save the Rosenbergs. "They shall not die!" was the refrain of the marchers. A woman with a small child in her arms was struck by a bus as she ran away from the violence. The child fell free but the woman's head was smashed flat. The bus driver covered the upper part of the woman with his coat, then he went to the curb, sat down, and vomited. Close to the corpse lay a sign that read, "Viva les Rosenbergs." One life lost trying to save another. The Rosenberg case is a curious one. The death penalty for espionage during war is meant for the enemy—not one's allies. I'm sure there will be appeal after appeal to the Supreme Court.

*　　*　　*

Sugar Ray Robinson's arrival here in his pink Cadillac convertible has shaken Paris. The coming of Napoleon himself on his white steed would cause less excitement. At least fifteen people are in his entourage—managers, handlers, trainers, hairdressers, valets, kinfolk, and some who hang on to him wherever he goes. The police have a problem controlling the crowds when he drives down the Champs-Elysées with the convertible's top down. "Le Sucre Robin-son!" is the steady chant of those who get close enough to see him. Robinson, rated the best boxer pound-for-pound in his time and holder of both the welter- and middle-weight crowns looks to be at his peak. He's handsome and a sharp dresser; the women here in Paris are at his feet. I go to London with him tomorrow where he will defend his crown against Randolph Turpin, a tough dock-side-type brawler who hardly qualifies to be in the same ring with Sugar Ray. No sports writer in his right mind would give Turpin a chance of going even halfway.

London

This big city is also agog at the sight of Sugar Ray and his pink convertible. He and Edna Mae, his wife, were rescued by the police

today from a mob. Ray came out of the melee unscathed but Edna
Mae was approaching hysteria by the time they carried her to the
safety of a building off Piccadilly Circus. Later she came to me in
tears, complaining that Ray plays cards all night. She also feels that
the "good times" in Paris did him no good. Not much I can do
about that. Sugar Ray Robinson is the boss man in this camp.
Oddly enough his handlers don't share her concern.

Sunday. Ray played golf this morning, and he is good. Later we
went to a church where we heard an anti-Semitic sermon that
Adolph Hitler would have been proud to deliver. Several times I
was tempted to walk out. It seemed incredible that a minister,
cloaking himself in the teachings of God, could mouth such a dia-
tribe from a pulpit. He called the Jews everything from dogs to
thieves. Ray didn't seem to be paying much attention; his mind was
obviously back at the golf course. When the good minister invited
us into his private sanctuary and asked for a contribution, I politely
told him off and ushered Ray out the door. Ray, being a very nice
man, thought I was rude. But when I explained the reasons for my
action, he understood. I had won that round and I was proud of
myself.

 * * *

The big fight is on tonight. Every hotel in the city is filled and the
excitement here is unbelievable. No one expects Turpin to win, but
they would love for him to go the distance—just to see as much as
possible of Robinson in action. Ray's doctor arrived last night and
the two of them played gin rummy until two in the morning.
Needless to say, Edna Mae didn't like that one bit. I stayed out of
her way.

 * * *

On a Boat Train to Paris

Incredible. Robinson lost last night. Edna Mae's worries were well
founded. Randy Turpin, to the surprise of everyone, including him-
self, out-brawled him for the decision. Ray fought as if he was in a
trance—not for one moment did he look like the fighter we have
come to know. He was sluggish, tired, and at times pitifully inept.
Both Edna Mae and his sister were in tears during the last three
rounds. None of us could believe what we were seeing. When the
decision was handed down and Turpin's arms raised in victory, a
din erupted like I had never heard before. Randolph Turpin is a
British hero this morning. A knighthood for him would come as no

surprise. Robinson sits next to me, disguised in dark glasses, hating himself. He was too embarrassed to return to his hotel last night, knowing it would be swarming with newspapermen, so we stayed in a fleabag hotel where no one knew who he was. This morning we got out of London as quickly as possible. His car and the rest of his entourage will follow later today, or perhaps tomorrow. Now and then he breaks the awful quiet, saying of Turpin, "I'll kill him the next time—I'll kill him, so help me God." Then he grows still again. He's not a bad loser. He's lost before—but never after such elaborate celebrations. It is, more than anything else, his enormous pride that suffers. He seems to be eaten up by distress. If I were Turpin I would try to avoid a return match.

Brussels. July 17, 1951

King Leopold III, yielding to prolonged pressure of leftist and liberal parties, abdicated his throne here today. This morning, along the broad avenue facing the palace, crowds of Belgians, some crying, some rejoicing, jostled one another as they awaited the fallen monarch and his eldest son Baudouin, who now ascends the throne. When the king and the heir apparent strode out together a great cheer went up. Leopold smiled weakly, waving. Baudouin, dreading perhaps the great responsibility that is about to be thrust upon him, stood unsmiling with that erectness born to kings. Leopold looked out over the vast throngs wondering, probably, how he had failed them during the Nazi occupation of their country. Certainly he had led his troops bravely. It was only after defense became impossible that he—over the opposition of his cabinet—surrendered unconditionally, thus provoking an accusation of treason. With my camera sights trained on a closeup of his profile, I saw the strain he had surely been under, the anguished lines that must have set in while he was a prisoner of the Nazis. The Allies, with the help of the Belgian underground forces, had at last rescued him. The melancholy smile frozen on his face belied, I suspected, the bitterness that was in his heart. He was no longer the lord of the royal house and the master of the lowlands or the restless Belgian Congo. Yet perhaps there was some virtue in the relief. From now on young Baudouin would have to worry about the Congolese cry for independence. I wondered how he, as the new king of a younger mind and spirit, would deal with this rising tide of African nationalism. Would he embrace the program to improve the social and eco-

nomic development launched a year before? Or would he, like Leopold, continue the exploitation and abuse that began back in 1815? Did he know about it? Did he care about it? Observing him today in the depths of such fervent ceremony, it was hard to tell. At times he looked as if he had just awakened in the middle of the confusion—that he didn't know where he was. If this was the case, it was somewhat understandable. Only a few young men face such terrible responsibility.

* * *

YEU ISLAND, FRANCE. *August, 1951*

Marshal Henri Phillipe Petain was buried on this bleak island this morning. I was sent here to cover the occasion. He had been jailed here since 1945 after being convicted and sentenced to die for collaborating with the Nazis. Later De Gaulle had commuted the death sentence to life imprisonment. His wife, heavily veiled and broken with grief, the local mayor, a few clerks, a long procession of curious townspeople, and a few stray dogs followed the coffin up a winding road to the edge of the village. It was an unheroic farewell for the once lavishly decorated hero who stopped the Germans at Verdun in 1916, and who once served France as her Premier. There was no praiseful obituary; no French flag to drape his coffin; no sounding of bugles or rifle fire as they lowered him into the earth beside the other unhonored dead— only a few consoling words from an old priest who could do nothing more than advise the widow to keep her own life moving.

I remained at the burial ground until everyone had gone except his two gravediggers. They finished their lunch, and then—as if to show their contempt for the old traitor—tossed the scraps and an empty wine bottle in beside the coffin. After observing me for a moment, mumbling to one another, they began shoveling in the dirt. Those two had shown me the truth about holes to which the dead are assigned. They hold no mystery; only a soundless space of indifferent darkness where all men, including discarded heroes, are left to rot.

7

From Farouk, a tennis racquet
From Churchill, a fat cigar

The months in France sped by. I was busier than I had
ever been in my life—reading, composing music, and writing in be-
tween assignments. Sally had done so well as a hat-maker that the
firm where she worked as an apprentice offered her the honor of
designing its fall collection. But she declined and—I couldn't believe
it—stayed on with the children at a house I had leased in the south of
France. No amount of persuasion could convince her of the opportu-
nity she was passing up. I had taken the house without having seen
it, but when we arrived there that first weekend we were happy to
find it sitting on a hillside of flowering fruit orchards, smothered in
pink Bougainvillea, and overlooking the Mediterranean. In addition
there was a swimming pool and an Italian housekeeper, who was
also a fine cook.. No doubt to Sally this idyllic place made more
sense than a workaday summer designing hats.

We spent two nice summers in southern France a few kilometers
above Cannes. The children especially loved nearby St. Tropez with
all its shops, waterfronts, and small carnivals. We often took picnics
in the wooded area above the town. After our stomachs were filled

and I had run out of fanciful lies about my childhood, the children would leave me to slumber in some quiet place until the sun dropped into the sea. A motor trip along the waterfront at Cannes always finished the day, and then we would drive slowly up the winding road to the house, inhaling the aroma of bread baking and *parfum* factories on the hill beyond me.

Then there were the evenings for cocktail chatter on the Hotel Carlton's terrace, where a lot of "nobodys," who considered themselves "somebodys," sat about flaunting their movie-star faces and their new love affairs. What I liked most about this famous hotel was its tennis courts and Dino, the tennis pro, who only spoke English when it was absolutely necessary. One day he came to me very excited. King Farouk had been watching us play from his hotel suite. Would I share my court with him for an hour? I thought back to my unpleasant experience with his party at Biarritz; then, deciding to let the past sleep, I agreed to play with him. Ten minutes later Farouk arrived with four bodyguards who bore a half dozen racquets and as many towels—embossed with the Egyptian crown—and a carafe of white wine packed in ice. His expensive flannel shorts seemed tailored by a tent manufacturer and he must have weighed close to three hundred pounds. Several onlookers gathered, but Dino got orders to disperse them. I was then informed that "his royal highness" did not like to run. I was to keep the ball as close to center court as possible. Farouk chose a racquet from the pile as though he was choosing a sword, then nodded at me. I nodded back, thinking that perhaps this was his way of acknowledging my presence. When he nodded again, I realized that he was ordering me to the far side of the net—which meant the sun would be directly in my eyes (a very ungentlemanly act for a tennis player). Well, either I wasn't good enough to keep the ball in the center of the court, or perhaps my mind kept floating back to Biarritz. In any case the king, after puffing after a few errant crosscourt shots, stopped abruptly, downed some white wine, and headed for his suite without as much as a handshake. The following day Dino presented me with a racquet, with a note from "His Most Royal Highness, King Farouk of Egypt." A rather puzzling postscript read, "Learn to better control your *balls.*" The present still lies in my closet; I have never used it—nor have I ever bothered to heed his advice.

I went back to Paris to work, and by mid-June I had recorded a rough sketch of the four-movement concerto and sent it off to Henry Brant in New York. Poverty had forced me into some good work habits. Failure humiliated me and I had never been able to understand it in other people, so I took a solitary course that knew little except a daily grind. In trying to make up for all those things I had missed along the way I felt, at times, suddenly alone; but loneliness, I knew, was a small price to pay. The big push for total emancipation by blacks in America was taking shape. Newsprint and letters from home pointed toward the trouble that would come with the "long hot summers" of the sixties. Subconsciously, perhaps, I was getting my weapons together to help take my place in the uprising. Already I knew that whatever part I was to play would have to be chosen with caution.

Several months before my time was up, John Jenkinson told me I was being reassigned to New York. This came as an unpleasant surprise. In more than a year and a half I hadn't exactly set the world on fire, but I had covered well over fifty assignments and most of them had been published. John, who held no particular friendship with my wife, had taken her to lunch one day—an action that had puzzled both of us. The conversation, she said, never got beyond the weather and the food. Nevertheless I would find out, much later, that I had been recalled because of her "tremendous unhappiness with Paris." *Life* magazine, it seemed, did not want to be held responsible for any family discord, and Jenkinson had felt a divorce was imminent for us if we stayed on in Paris. I never asked him about this. Natalie Kotchuobey accidentally came across a cable which said that Tom McAvoy, a photographer in the Washington bureau, was all set to replace me. Tom was godfather to Jenkinson's daughter.

I packed for home with remorse. Europe still held a lot of unfinished aspirations for me, but in the melancholy of those final days I prepared for the trip back. Strange thoughts kept dreaming in. There was some dark secret behind all this, I felt, but my depression prevented me from looking for it. Two days after Christmas we said goodbye to Paris, to its ancient buildings of towers and spires; to its beautiful river of boats and barges that pass one another year after year; to its ornate bridges and cathedrals; and to the lovely Place de la

Concorde spread out beneath my office window. Now we would return across the sea to a land where racial hatred and bigotry was still at work.

It wasn't that I forgot the gun I had left at Cherbourg; I remembered it well. I didn't reclaim it because I would be happier with the ocean between it and myself. Perhaps in time the customs officials would destroy it—at least I hoped so. It's off my hands forever, I remember thinking as we sailed from the embarkation port. We were aboard the Queen Mary again, on the same deck and only two cabins down from the one we had occupied on our first crossing. There was some secrecy about the occupants of that cabin now, and two men kept vigil outside its doors. One wore a derby, the other a grey fedora. Both observed us with hard, steely eyes when we passed.

An hour before dinner our telephone rang. It was Adam Clayton Powell; he, his wife, Hazel Scott, and their son, Skipper, were also aboard and on the same deck. We had dinner together that night, and David and Skipper, who were about the same age, struck up a friendship. For the next four days David, who knew the big liner from the boiler room to the captain's cabin, kept Skipper on the run. They would turn up after an afternoon romp as greasy as pigs. On New Year's Eve Hazel played the "ship's concert," and the place was packed. The first half was jazz; the last half classical, and I had never heard her play better.

The secrecy of the cabin down the corridor fell away on the third day when my steward handed me a cable from the New York bureau. It read: "Churchill and Eden are on board—try for pictures and interview." I tried, all that day and the next without any luck. The Prime Minister was seeing no one. I would have settled for just a photograph of him on deck, in the dining room—anyplace—but the old boy never left his cabin.

During the last morning out I took an early stroll on deck, hoping to get a glimpse of New York's harbor from the distance. At the far end of the ship, coming toward me, were three figures. Coming closer to them I could see it was Winston Churchill and Anthony Eden, but who was the small girl skipping between them, holding on to Eden's hand? In a moment or so it became clear; it was my daughter Toni chattering away to Eden's and Churchill's delight. I

was stunned—and without a camera handy. "This is my daddy," she said to them when we met. "What are your names?"

"A delightful child," Churchill said. "So she belongs to you?"

"Yes, and she has just scooped me. I've been trying to get a word with you for three days, and a picture for *Life* magazine, but without any luck."

Churchill chuckled and invited me into his cabin for a brandy. The two stern gentlemen in the derby and the fedora were taken aback when they saw me enter. Churchill, Eden, and I talked for a few minutes until the phone buzzed. Eden answered it, and his expression told me it was a very important call. As I got up to leave Churchill handed me one of his big cigars and bid me goodbye. Eden handed him the phone. Leaving the room I heard him say, "Good morning, Mr. President."

8

Preparing for the smoldering fire

There is a lot to remember about our return to America, but what struck me most was the change in our children's attitudes. It was immediate and complete. No longer did they come to kiss us good night before going to bed, or practice the little niceties they had come by in France—and they refused to speak another word of French. They were no less courteous or giving of themselves, but they were just a bit more hardboiled about everything. It was as though a curtain had descended between us.

Things had changed considerably at *Life* during my absence. There were new faces, new bosses, editors, and photographers to become acquainted with, and my circle of personal friends had dwindled to a pitiful few. My lonely island back home, it seemed, had grown even smaller, and I missed terribly the closely knit little group in our Paris bureau. Nor was our home quite the same; a land speculator had bought up most of the surrounding countryside and built an entirely new cluster of look-alike houses. We knew very few of our neighbors anymore; most of them were "blue-collar workers" and black, and perhaps because I was attached to *Life* magazine most

of them took a standoffish attitude toward us. The ice broke, for the children at least, when I built a swimming pool in the backyard. Their playmates tripled overnight. But to some neighbors that pool was a confirmation of the distance between us. One gentleman called a neighborhood meeting to discuss the possibility of my causing a water shortage in the area. Another lady who taught my daughter in public school began marking her grades to fit her dislike of me. Finally I called a meeting of my own, which the principal of the school attended. A few tempers flared, but we got matters straight—and my daughter's grades improved.

At times I found myself in a quandary, having been so many places and done so many things since I left Kansas. What had it all meant, those brutal winters in Minnesota, when at age sixteen many penniless, subzero nights had bent me to prayers; those Chicago flophouses I cleaned for shelter and hot dogs? Those big dreams that worked out somehow and sent me on to Washington and New York—Paris and beyond? I had returned an unlikely loner still driving failure from my dreams, still being pulled by something up ahead—something that hinted there was more luck in store, but that first I would have to pay for it. I recall hours in shadowy bars, drinking, searching the years for some connection to whatever it was that was moving me. It wasn't enough simply to be moving; I wanted to know what was making it happen.

Several things still bothered me. In escaping the mire, I had lost friends along the way. I was black, and I felt black, but I couldn't allow my work, or my aspirations, to be consumed with only blackness. Most of the scars on my body had been put there by whites, yet I resisted a show of the anger boiling inside me. I had a good job, respectable recognition, and a comfortable home in Westchester County—but hunger still gnawed at me. Finally I told myself these things didn't matter, that the future was the thing, that I would keep going without looking back. Still I couldn't understand why I felt so troubled, and so alone.

* * *

Life magazine was a citadel of newsgathering with bureaus in most principal cities of the world. In the more remote hamlets, villages, and towns, there were contract reporters and photographers known as "stringers," who covered local news breaks for the larger

bureaus. We photographers, especially, were constantly recording events of interest—big ones and small ones. A mother gave birth to quadruplets in Canada and we were there; Indians rioted in Calcutta; a plane went down over Iceland; civil strife flared in Spain. No matter what or where, we were rushed in by any means possible—and as quickly as possible—to get the story.

There were so many things to cover—art, theater, religion, sports, crime, war, disasters—and an inexhaustible number of situations in each category. It was impossible not to learn, not to be aware and well informed with so much happening around us. There was no special black man's corner for me. I was assigned to anything and everything, but if I could bring special significance to a story because I was black, it was given to me. When I did cover a situation involving black people, I went in as a *Life* reporter—not as *Life*'s "black" reporter. There was this distinction to be made, otherwise I would have been baiting my own trap. This same responsibility to objective reporting applied to all members of the staff, regardless of their racial heritage. With more and more stories to be covered concerning racial violence, I knew, as well as *Life*'s editors, that my rope would be a tight one to walk.

I would have been naive to think my editors could trust my sense of objectivity completely where racial issues were involved. Throughout the remainder of the 1950s, the tightrope grew tighter. Blacks wondered if I had arrived to say goodbye to them. *Life* wondered how I would behave in the heat of the black uprising ahead. Black militants wanted their voices heard, and what bigger vehicle was there to reach millions of people? The magazine needed the stories, but they wanted an impartial hand and eye to deliver them. In a certain way my position was enviable, and I began to prepare for the fire that was smoldering in the black, big city ghettos across the country.

A story on the black Metropolitan Baptist Church in Chicago in 1953 had helped set the pattern for my best work during the next fifteen years. The congregation was largely one of oppressed people who, according to their pastor, barely made ends meet each week. I remember they were a proud lot and, being mostly laborers, had fashioned their church into a remarkably beautiful place of worship. They worked at all sorts of menial jobs—maids, janitors, foundry

workers, and at whatever else they could find to do. One man made coffins on Chicago's South Side. I was particularly struck by the appearance of the ushers each Sunday morning. Dressed in swallowtail coats, starched white shirts, and black bow ties, they were a picture of sartorial elegance befitting the Easter-like atmosphere inherent in each Sabbath.

I covered the "moderate shouting Baptists," as they were called, with a young white reporter. He was a well-mannered young man with a pleasant disposition, but in all innocence made the mistake of entering church one day with his hat on. To a deacon who met us at the door this was just another case of the white man's disrespect, and he let us know it. The reporter apologized, but his apology was not fully accepted. Things got so uncomfortable he decided it was best I carry on alone, which meant I had to gather my own research.

The minister—a large, energetic, amiable man who dressed each day in a frock coat—spent his weekday hours visiting his flock on their jobs, at hospitals, and in their homes. "To kill their despair," he used up at least forty-eight hours a week—three prayer meetings and two days of preaching—"getting them fit to go back to work for the white man instead of killing him." That was his mission on earth, he said, and somehow I believed him.

To watch him preach a funeral was an unforgettable experience. As the choir sang the deceased to heaven, he strutted rhythmically about the pulpit smiling, wailing, and flinging his arms high "to touch God" in case he wasn't heard. Going to the coffin, he would exhort the congregation into a frenzy by laying his hands on those of the deceased and talking with "it's soul." It was more a celebration of death than a funeral.

At one hospital an aged woman held on to life until he arrived. He took her hand, raised it, and asked her to smile and accept God. She did what he requested. Five minutes later she was dead. George Hunt, the Chicago bureau chief, liked my research and recommended to the New York office that I write the story as well. The story never ran but I was on record as a writer. I had hopes now that my literary efforts in Paris might pay off.

I finished the piano concerto, with Henry Brant's help, in the winter of 1955. Dean Dixon was still in Europe and I notified him immediately. He called from Paris a week later to say that the work

was scheduled for a performance in Venice the following June. His wife Vivian would perform the piano part. Naturally I was extremely happy. Henry and I made a few revisions and sent the score off to Dean.

Sally couldn't bring herself to share my enthusiasm. When I gave her the news and expressed concern about the work's success she said dryly, "Don't worry, it will be a grand success. You always have success. Maybe that's your problem." She went on peeling potatoes for a chilly, silent supper.

As the time for the concert drew nearer she opposed my attending it, saying our bank account couldn't afford the trip. I didn't accept this as the truth but I agreed not to go, despite my longing to hear my first work performed—and in so romantic a city as Venice. There was a deeper reason stirring inside her, one she could never bring herself to explain. Unfortunately I suspected it was pure resentment, when actually it was just the gulf widening between us. So, I went about keeping a bitter silence, taking every opportunity to sound my anger and discontent. Our days became thick with depression and we abandoned all but the most necessary conversation.

Spring brought the final truth to our relationship. By then we could no longer understand one another, and all that we had shared for over twenty years was dead. It was a matter of marking time as we approached the end. There seemed to be nothing either of us could do about it, although we tried. So I began searching for new companionship.

I found it, for a while, with a lovely girl from South Africa. Nothing in the world, she thought, should prevent my going to Italy for the concert, and three days before it was to happen, she thrust a round-trip ticket into my hands, packed my bags, and drove me to the airport. At the hotel she had reserved, which overlooked the Grand Canal, two dozen red roses and a bottle of champagne awaited me, along with a cable wishing me luck and declaring her love. It was signed "M." For reasons best known to the both of us, "M" is how I shall refer to her.

Dean, Vivian, and I rode to the concert in a magnificent gondola, and along the way Venetians tossed flowers down to us from the bridges—shouting, I remember most pleasantly, "Good luck tonight, Maestro, good luck!"

"Wave your thanks," Dean instructed me. "The flowers are for you. Tonight is yours, Maestro."

I waved back as we drifted on the water, listening to our gondolier as he swayed to and fro singing an Italian love song.

The concert was held on a summer's night in the courtyard of the Doges' Palace, where a full moon cast its light upon Dixon and the large orchestra. The moment when the orchestra began to play was overpowering. The sound of it was nearly as foreign to me as the night itself. Each movement came dreaming in, and I was listening, hearing certainly, but so filled with inner excitement I couldn't connect what I was hearing with what I had spent two long years composing. I seemed to float apart from everyone around me, even from the chair that I squirmed about on.

Then suddenly, with one grand sweep of his baton, Dean Dixon brought the whole thing to a resounding climax. The entire performance had sort of flown by me. I was still dazed when Dixon motioned for me to stand and acknowledge the applause. Someone poked me in the ribs and I rose like a zombie to make an awkward bow. Then it was over.

Later that night I called Sally. She was out. I called M. She was relieved and happy that everything had gone well, and there was some exciting news but it would have to wait until I returned. I pressed, but she refused to give in, yet somehow I knew. M was expecting our child. Something in her voice refused to be hidden.

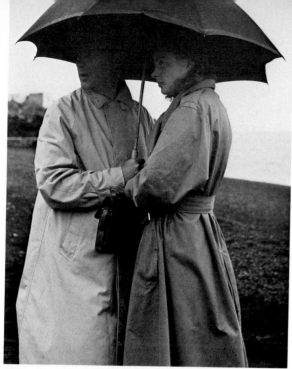

*Ingrid Bergman and
Roberto Rosellini on Stromboli, 1949.*
Photo: Gordon Parks.

Ingrid Bergman on Stromboli, 1949.
Photo: Gordon Parks.

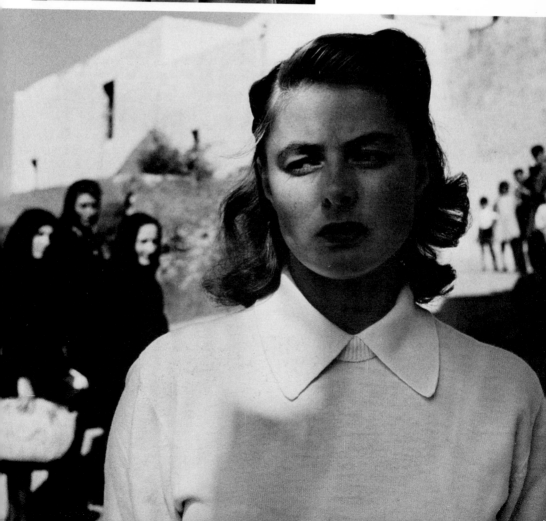

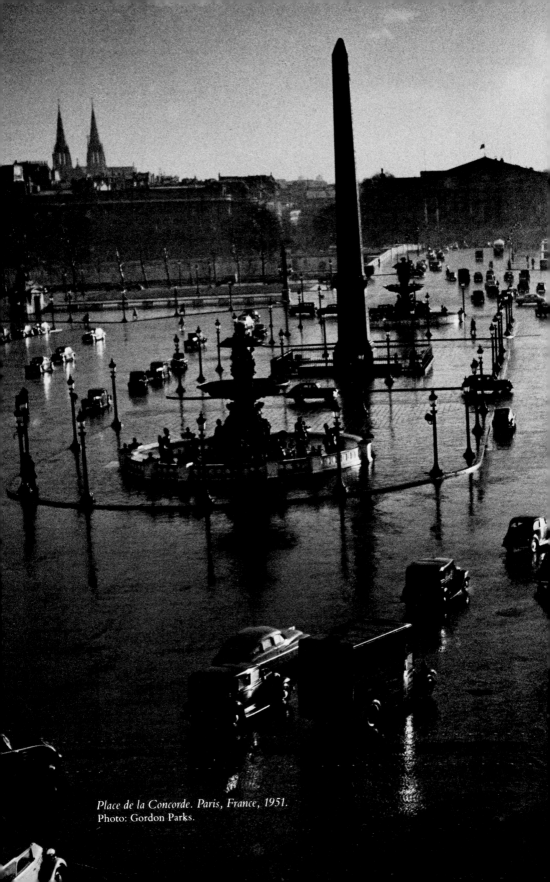

Place de la Concorde. Paris, France, 1951.
Photo: Gordon Parks.

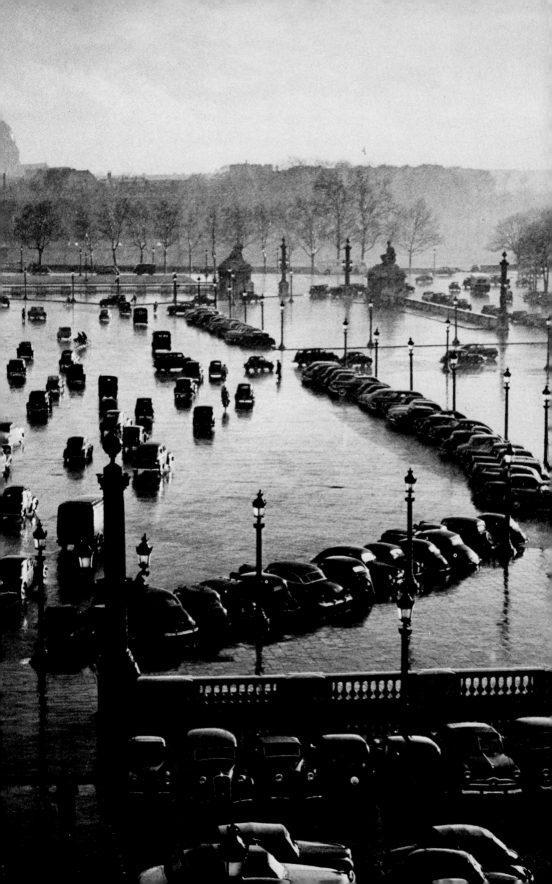

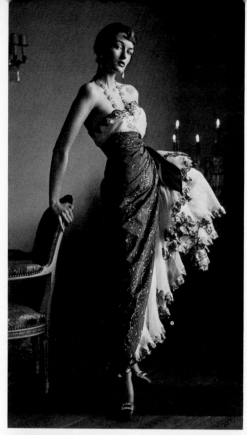

Maxine de la Falaise. 1949.
Photo: Gordon Parks—*Life*.

Clockwise:
*Bettina, Sophia Malgot, Jackie Stoloff,
and Janine Klein modeling evening gowns
from the French Collection, 1949.*
Photo: Gordon Parks—*Life*.

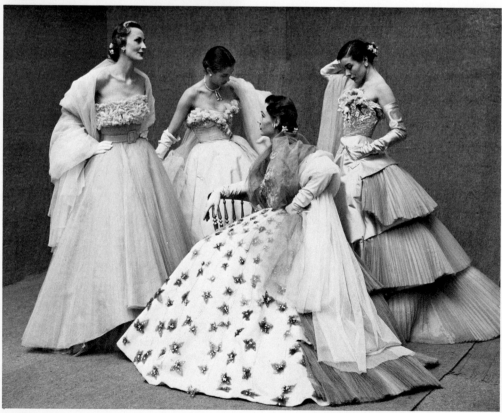

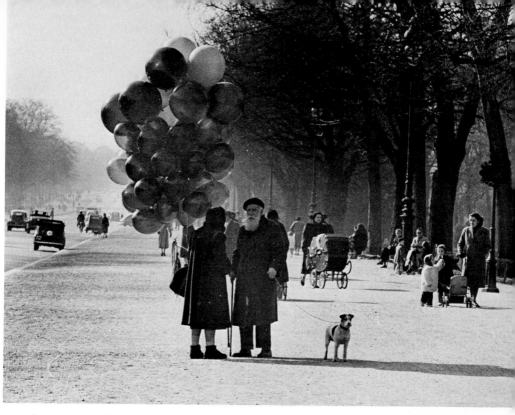

Paris, France, 1951. Photo: Gordon Parks.

Author at piano working on Concerto for Piano and Orchestra.
Photo: Bob Lucas.

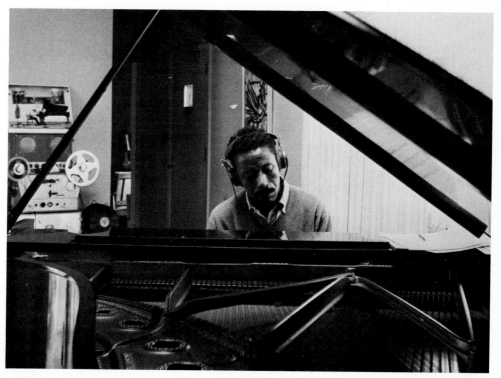

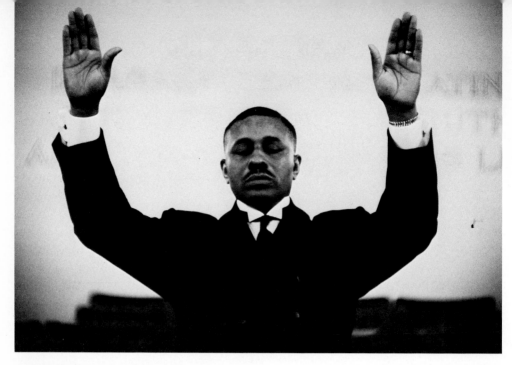

Pastor Ledbetter. Chicago, 1953. Photo: Gordon Parks.

facing page:
Baptism, Chicago, 1953.
Photo: Gordon Parks.

Pastor Ledbetter with dying woman. Chicago, 1953. Photo: Gordon Parks.

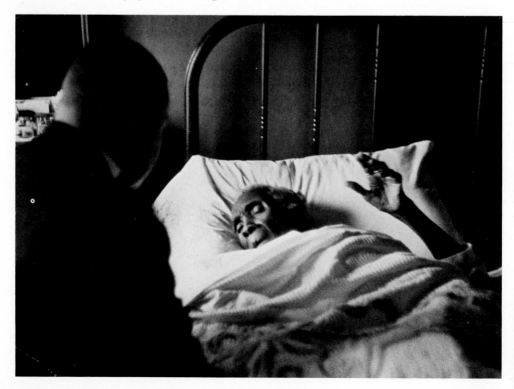

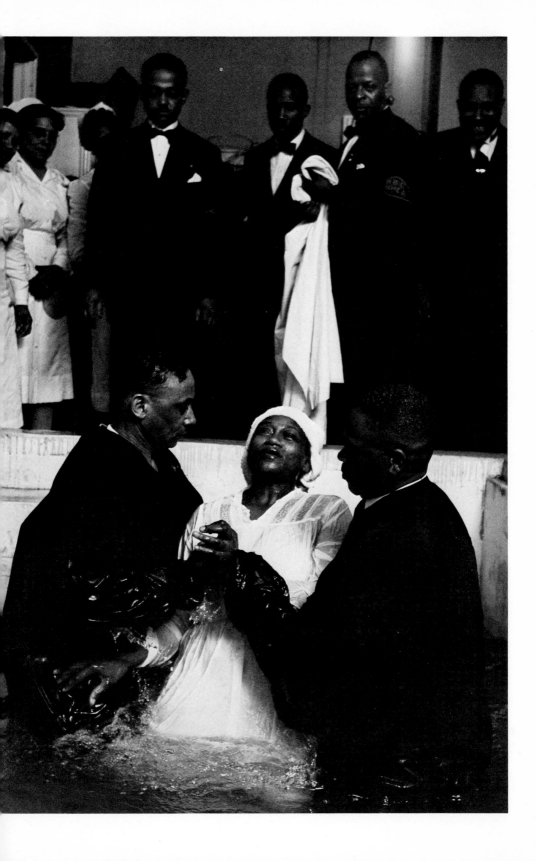

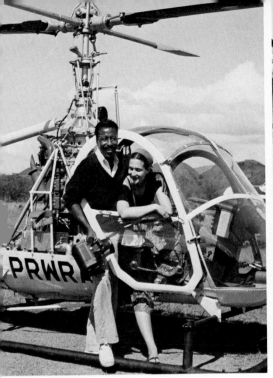

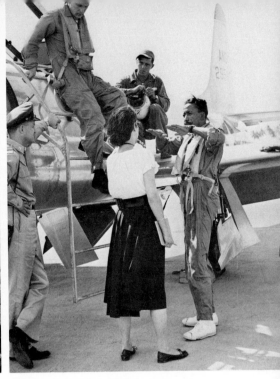

Author with Life *reporter, Patricia Blake.
San Juan, Puerto Rico, 1954.*
Photographer unknown.

*Author explaining jet fighter maneuvers
to* Life *reporter, Betty Baker. San Juan,
Puerto Rico, 1955.* Photo: J. Santana.

Fighter jets over Puerto Rico, 1955. Photo: Gordon Parks.

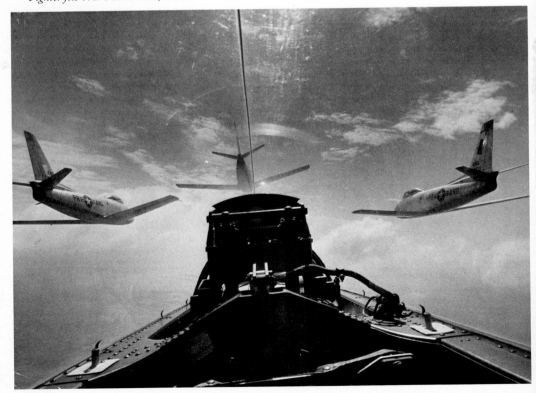

$\mathcal{9}$

Gloria Vanderbilt
and her dreams

\mathcal{I} *was* right about M's pregnancy, and both of us found an uneasy joy in it. She wanted so to have the child and we spent hours considering the reality of her doing so. In the end, confronted with so many sensible reasons against her going through with it, we reluctantly made what both of us felt was the right decision.

Unfortunately on the day a doctor was to take the child from her, I was sent on an assignment to Chicago. I would be gone for just a few hours, returning to New York that same afternoon. I remember now, with sadness, M's asking me not to go despite the importance *Life* attached to the assignment. I convinced her, so I thought, that everything would be all right since I would be waiting at her apartment when the nurse brought her back there. I had made sure that she was attended by a competent doctor as well as a private nurse. Then, feeling content, I went on to Chicago, completed the assignment, and got back to New York an hour earlier than expected. M's door was chain-locked from inside when I tried to open it. Peering through a crack in the door the nurse asked who I was. When I told her she asked me to wait, and then returned after a few

moments to say that M was doing fine but that she never intended to see me again. No amount of explaining changed things, and the door shut; M was closing me out of her life forever. A month's worth of telephone calls didn't alter anything; and a half dozen letters went unanswered.

Six years had passed when I saw her again, one summer's day, on Fifth Avenue. Her eyes met mine with cold contempt and held for a moment. We managed a hello, then passed on like strangers. I have never seen her since. For a long time I was tormented by the loss of this woman, by the few unimportant hours in Chicgo that destroyed our relationship, and by the hurt I obviously brought her.

* * *

Of the many women I've met, few have been steadier in their friendship than Gloria Vanderbilt. We were first introduced in the summer of 1954 at an exhibition of her paintings, and at that time we began a warm relationship that has managed to survive through the years. It was she who introduced me to poetry through notes, letters, scribblings, and an uninterrupted closeness. Perhaps if things had been different in this threatening society of ours, we might have married long ago. But I, much more than she, remained aware of the terrible distance between a black Kansas farm boy and a white heiress born to one of America's great families. Yet the truth is that in all these years, color never found its way into any of our conversations or our relationship. Both of the late columnists Dorothy Kilgallen and Walter Winchell stirred the fire with unsubtle hints of a love affair between us, but even then Gloria remained unswerving. I remember now, with mild astonishment, that not once did she ever so much as mention any of their gossip to me.

Through the years I have observed and felt for her as she's weathered the criticism of some theater people who resented her becoming an actress, of painters who frowned upon her for painting. After all, she was a millionairess. Why couldn't she be content with her fortune and leave art to the struggling artists? So few knew then, or know today, how deep her need was to accomplish things on her own. So few knew she spent weeks reading poetry and books to mental patients who didn't realize who she was, who didn't have the capacity to care about who she was. From a distance I observed her

throughout the troubles and loves of three marriages, watched as she went on living after a love had ended or a death had overtaken her. At times, it seems, she went on trying where others might have stopped. Things that wear out most people never seemed to exhaust her. I wondered sometimes what it was that drove her on to the tremendous success that she is today.

The night she parted from Leopold Stokowski, when the press was turning New York upside down in search of her, she was at my home up in Westchester County for my daughter's first piano recital. The recital turned out to be a disaster, however, when Frank Sinatra arrived. What teenager could have brought her fingers and mind together with this presence in the room? Francis, smart man that he is, realized this and remained in the kitchen most of the evening—devouring ribs that Rudolph, our cook, barbecued for the occasion. But Toni never played a note. The evening was saved by Vivian Rivkin, who had performed my piano work, and the fine cellist Bernard Greenhouse, who had also been at the concert in Venice.

What I admire most about Gloria is the way she went through that whole time turning out her dreams, as unruffled as a stone in a storm. She wrote a poem describing those days:

> he kissed me through a glass closed window
> I put my chin on the window's edge
> and tried to remember as the glass shattered
> that this was freedom instead of death

10

Breakup with Sally

ooking back, I remember certain things that were insistent in their need to impose meaning upon me. Poets, for instance. I read them by the dozens—T. S. Eliot, Langston Hughes, John Peale Bishop, Rilke, Auden, Aiken, Ciardi, Hart Crane, Robinson Jeffers, Pablo Neruda, and scores of others. I also involved myself in the writings of Richard Wright, Jean-Paul Sartre, Albert Camus, and Frantz Fanon, the black psychiatrist from Martinique who met death serving the Algerian revolutionaries. Perhaps I was subconsciously drowning myself in literature to make up for all the reading I missed during those early days in Kansas and Minnesota when, despairing of the Bible, we black youth turned to the funny papers.

I worked hard because I was secretly frightened about all I didn't know, everything I hadn't been taught during those formative years when good literature would have made all the difference. It wasn't enough that someone believed in me or saw promise in me. I knew my limits. At least recognizing those limits saved me from arrogance, an even greater ignorance. Down deep inside I knew I had nothing to be arrogant about. Even today when people ask if, back

then, I felt I had been blessed with extraordinary talent, I can honestly answer no. There was, of course, a reckoning of some sort, but my true feeling was simply a need to avoid searching in a garbage can for supper.

I write now as memory serves me, and I recall that during those days of intensive reading my children would measure my moods by the author I was currently immersed in or the composer I was listening to. When I heard the strains of my favorite Chopin Prelude (op. 28, no. 4) coming from downstairs, I knew Toni was at the piano trying to play the frown off my face, or was about to ask for a new dress. When Gordon and David heard me drowning myself in Rachmaninoff they would take off for the stable to curry the horses. On such days I was morose and uncommunicative.

*　　*　　*

Gordon, Jr. was called up by the army in May of 1957, and his final week at home had not been a good one. The unhappiness between Sally and me had drained our household of the love it once held. Perhaps it was her fear of losing her son, or a need to display her frustrations to him before he left, that she dumped a pitcher of ice water over my head as I knelt to help Gordon fasten his bag. Puzzled and angry, I wiped the water from my eyes and stared up at her. "The next time it will be boiling hot!" she said, and I believed her.

On the way to the station, Gordon and I discussed the situation frankly. Then, as he was about to board the train, he said, "Dad, Toni and David and I know it's all over between you and Mother. We've known it for a long time. We also know you're staying on because of us. She meant what she said about hot boiling water the next time."

"Just what are you saying?" I asked.

"I'm saying that all three of us kids will understand if you decide on a divorce. We wouldn't want to see either one of you hurt each other."

Gordon and I embraced; I wished him good luck and stood waving as his train pulled out.

Around three o'clock on the thirty-first day of August, I had a definite premonition of danger. I couldn't figure out why, since I was safe inside the Time–Life building enjoying a corned beef sand-

wich and a malted milk. But the feeling was there, and I sat for a moment sensing a chill running up the base of my spine to my neck. In a few moments it was all over, but that moment bothered me the rest of the day.

Two weeks later a letter from Gordon caused me to reflect on my anxiety. That same afternoon his convoy truck had broken down while escaping a radiation belt from an atomic test in Desert Rock, Nevada. Eventually he had been rescued by an emergency team. Perhaps the two incidents had nothing to do with one another, but their timing gave me cause for thought.

A terrible nightmare occurred not long afterwards. I dreamed there was a huge snake in my right arm that slithered about trying to find a hole through which it could escape. In desperation I dug my fingernails into my skin, grabbed its head, and jerked it from my arm; then I began to flail Sally with it. Awakening in terror, she jumped out of bed.

Coming at last to my senses, I felt my arm. There was no snake, but blood spotted the sheets; I had literally torn a hole in my skin. The uneasiness of that nightmare stayed with me until a psychiatrist friend told me it was time for Sally and me to consider a divorce.

The end came for us quietly one Sunday afternoon. I asked Sally if she would like to keep the house. No, it was too big and full of bad memories, she said. What about the children? It was best, she decided, that they stay with me since she now found herself unable to understand them. A week later I leased an apartment for her in New York.

On the final day I watched as she went to her car. Sadness was all over her, in her face, her shoulders, and her walk. Although I was tempted, I couldn't call out to her, to ask her to stay on. What, I wondered, had I done to this woman who had suffered three children into the world, three children she could not bring herself to understand? In the beginning my love for her had been measureless; now there was only regret. Yet I knew there were reasons for this moment of her departure—so many reasons, but so few that either of us fully understood. For so many years she had been the only woman for me; she had meant everything. I had loved so much the feel of her, her dimpled smile and soft brown hair, her innocent silence on those nights when she wanted love. Now, watching her go, I could

only mourn, not knowing even then what had left our love so tat-
tered, so beyond repair. I turned from the window before she drove
off, feeling hurt and alone.

* * *

Certain acquaintances of ours, especially those women who had
been close to Sally, came down hard on her for "deserting" her
children. I knew better. Hers was not desertion, but indeed an un-
selfish decision she truly felt was best for them. It was she, after all,
who would be alone now without a home or family, without the
voice of a child to go to sleep to or awaken to each morning. I felt
that way about it then, and I feel that way about it now, despite those
bridges that have burned since between us.

11

Freddie
"Segregation in the South"

I am concerned now with telling the truth about things, but there are times when truth must keep its silence—and so it must be with the real name of one person in the incident I am about to relate. I do this simply to prevent his wife and children from knowing something that he may have come to regret. I will call him Freddie.

Freddie was the chief of one of *Life*'s Southern bureaus, and he was white. The New York bureau had asked him to accompany Sam Yette, a young black reporter, and myself on a story titled "Segregation In the South." Sam was a Southern boy who was attending a Northern college. As it turned out, Freddie never accompanied us; he always went ahead to act as our "liaison," to ease things for us and sense any danger that might befall our mission in this unfriendly territory. Perhaps Freddie was the wrong man for this assignment in the first place. It was a rather dangerous situation for anyone—black or white—and all three of us could have wound up at a lynching party. Furthermore, Freddie had a wife and three children living in the South; they would still be there after the story was published and

Sam and I had returned to the safety of the North. Freddie persisted in his belief that there was not enough segregation in the South to warrant a *Life* story. That alone should have ruled him out, but for some reason I yet fail to understand, it didn't. At one point I became so concerned about Freddie's righteous Southern attitude that I telephoned New York. The next morning Kenneth MacLeish, a New York-based editor, flew down to meet us in Birmingham. After a talk with Freddie he patted my shoulder and assured me everything would be all right, that Freddie was now dedicated to the assignment.

Before turning in that night I met Freddie on a dark corner and got the name of a white man who would be our "protective source" in case there was trouble. Sam Yette looked at the name, scratched his head, and advised checking it out with the local NAACP. It was a good thing we did. The name belonged to the head man on the White Citizen's Council, a group as distinguished for their hatred of blacks as the Ku Klux Klan. Sam and I then did as the NAACP man advised. We got out of town in a hurry. Leaving Freddie a note, we asked him to meet us in Anniston, a town several miles from Birmingham. Freddie met us that night in a mild state of shock. The name he had passed on to me, he admitted, had been an "error." Sam and I remained dubious, but we accepted his "error" knowing full well that it might have cost us our lives.

We zeroed in on the family of a man named Willie Causey, a poor black man who cut wood for a living several miles out of Birmingham. Home for them was a two-room shack with a porch and a kitchen. It sat near the road's edge on a half acre of red clay that became slime in the hot Southern rains. A huge black metal cauldron sat in the center of the back yard for washing clothes. There was a shiny new frigidaire in the kitchen which would take them five years to pay for. Willie's wife taught black children in a one-room school that was heated on cold days by a pot-bellied wood stove. After giving the white man his share for the right to cut wood, Willie and his wife had about seventy-five dollars a month to feed themselves and their five children. They slept in one room; the children slept in the other. Sam and I spent a couple of weeks there photographing and writing about their struggle. We drove to Birmingham and the small

nearby towns, focusing on signs of bigotry and discrimination wherever we found them—and we found plenty.

Our story was nearly finished when the New York bureau instructed me to photograph the "separate but equal" facilities at the Birmingham train station. The day we were leaving I managed to do this with a hidden camera. Then placing my film and cameras in a bag, I gave them to a black redcap outside the station.

Interstate White/Intrastate Black. Catch 22 all over again.

"Come on, boss," Sam Yette quipped. "We're traveling interstate."

"And we're asking for real trouble," I said as we went in the white side. As we entered, three white men got out of a car and followed us. It was obvious they had been watching us all along. It was also obvious they had been tipped off and were waiting for us. Nervously we took seats and began reading a newspaper. Every eye in the place was glued to us, and the air was thick with white whispering. The three men also took seats—two of them in front of us and the other behind. They had a rather official look and, unlike most of the others in the place, wore coats and ties. "Might be the police," Sam mumbled under his breath.

"Might be the Ku Klux Klan in their Sunday clothes," I mumbled back. Now Sam, being young and brash, did a very uppity thing. He got up, strode over to the fountain "for whites only," and took a good healthy drink; every eye in the place followed him until he got back to his seat. Seconds later about ten big, rough-looking toughs entered through the back door. Their overalls were sooty and greasy from work. They stood silent, watching us.

"Here come the shit," Sam mumbled.

"Here go the shit," said I. "Oh, where is that protective source?"

The redcap reappeared and reminded us, nervously and too loudly, that we were on pullman car four—and that the train was arriving. The three men followed us and so did the scruffy-looking toughs—all the way to our car. They stood there staring and mumbling obscenities until we boarded the train. Sam had a lower berth. Smelling trouble, I advised him to share my compartment where we could take in the film and equipment and lock the door. But Sam,

uppity young black that he was, refused. We sat talking for a while after the train pulled off, convinced now that Freddie's liaison work was obviously misdirected. There was one more picture we had to take—and one last chance to catch Freddie at his game. A Fisk University professor would be boarding a bus in Nashville, Tennessee, beneath a sign reading, "Blacks Enter Here." Purposely we had asked Freddie to join us on the train to Nashville, but he had decided to fly on ahead—as we expected he would.

About an hour out of Birmingham I heard scuffling outside my compartment. Sam Yette was being attacked. I reached his side wielding a long flash gun as two men scrambled up, ran from our car, and out into the next one. They had been after our film, which they probably thought was beneath Sam's berth. Sam had discovered them in the process of looking for it, and set upon them. Their planning was well timed; the train pulled to a stop and they jumped off.

We set our trap. Instead of photographing the professor at two o'clock in the afternoon—as Freddie had proposed—we would do it at ten. A black university student volunteered to go to the station at two o'clock. If Freddie fell for our ruse, the student would be grabbed when he arrived an hour later. By that time we would have our pictures and be on a plane to New York. Everything went as planned; the student went in at two and was grabbed. They released him only after he was able to prove he was not a *Life* photographer.

When our plane set down in New York it was as though hell had come to an end. The experience had been even more horrifying than I realized; it was like awakening from a nightmare. Indeed, it was so unreal to me even then that after thinking things over I decided against giving the sordid details to the New York bureau. I did pass on the story of our ordeal to Alfred Eisenstaedt, one of *Life*'s most celebrated photographers, urging him not to repeat it. But Alfred was unable to contain the drama, and the following morning Irene Saint, chief of the domestic correspondents, called me into her office and took me to task. Freddie was a good friend of hers, she said; she would not allow such monstrous lies to be spread about him. I counted to ten, turned, and walked out of her office without saying a word.

For Willie Causey's sake, the story should have ended there. Because after it was published, the whites came down on him with

true Southern wrath. They took his truck and his home, and put the entire family to flight on a highway. After two days the Causeys reached Birmingham on foot and put through a collect call to me in New York. They were now with relatives, they told me. I asked if they had notified Freddie. Yes, indeed they had. He had promised help, but they hadn't heard from him. I rushed to Irene Saint's office, informed her of the Causey's plight, and asked if she had heard anything from Freddie. "No," she replied in distress. "Freddie and his family have gone on a month's vacation." Now the truth of it struck her like a hammer. Freddie had deserted and left Willie Causey and his family to their fate.

At least it is good to remember that *Life* relocated the Causeys and gave them a great deal of money for their trouble—more, perhaps, than the family would ever have seen in a lifetime. Hugh Moffet and Richard Stolley, two *Life* editors, even flew down there, went out to the little community, and tried—unsuccessfully—to get the Causes' truck and land back. When they walked into the "head lady's" front yard, several men were sitting around with rifles and a shotgun. "What are the weapons for, boys?" Hugh had asked with a smile.

"Rabbit huntin'," was the terse reply.

"If we'da got that nigger who took them pictures we'da tarred and feathered him and set him to fire," declared the "head lady." I would have been the last to not believe her. A voice so charged with venom could order death with the same calm it might order a hamburger.

This was the way things were in the South, before and after the strife brought on by the great Civil War.

But rebellion brewed in the backlands and big Southern cities. Tired now of even remembering our awful past, we blacks began looking through different eyes toward a new equality; preparing to put things in a different order for ourselves; determined to sentence Jim Crow to death. Encouraged by the 1954 Supreme Court ruling that segregation in public schools was unconstitutional, we stacked ourselves together like cordwood, hardened our hearts against legal segregation, and waited.

The spark that lit the fire was struck in Montgomery, Alabama, one Thursday evening, December 1, 1955; Mrs. Rosa Parks, a black

seamstress, refused to budge when a white bus driver ordered, "Niggers move to the back." From her arrest and eventual conviction grew Montgomery's famous and successful bus boycott by blacks. And from it, too, emerged Martin Luther King, Jr., who was chosen from a group of twenty-five black ministers to support Rosa Parks's gesture of defiance in their pulpits. This young, charismatic black man would keep us together and lead us in other boycotts, sit-ins, and marches in a way that would dramatically interrupt the flow of American history. As we marched against the snarling dogs, lawmen's clubs, and fire hoses, we threatened ourselves with death. But Martin, preaching endless love for the price of what some of us felt was a terrible peace, made us unafraid to die.

I worked on, sharpening those weapons with which I could fight most effectively, weapons I had chosen from those cubbyholes that stretched along the corridors of my own early life. The time had come to use them.

12

Execution at San Quentin

From a diary:

CHICAGO. CRIME *August, 1960*

Hank Suydam and I have been riding with narcotic and homicide
police squads for over a week now. Both of us wish we were home
with our families. The world of crime is a depressing one—for
those who deal in it as well as for those who fight it. Each day or
night gets more sordid than the next. Crime to the lawman is like
cancer to a doctor—always there presenting a challenge each morn-
ing. At times you don't quite know who to side with—the cop or
the crook. Certainly the two detectives we ride with are no shining
examples of law enforcers. Two nights ago, Jimmy (the fat one)
shot a guy in an alley, and while the guy lay dying, Jimmy stood
eating a corned beef on rye that Chip, his partner, got at a soup
joint on the corner. As the victim expired, Jimmy grumbled at Chip
for not bringing a sour pickle. The ambulance came and before it
pulled away with the corpse, Jimmy wiped the grease from his
hands on the stretcher blanket.

August 12, 1960

At times I wonder if most wrongdoers have to be black. Eighty
percent of the shootings, knifings, burglaries, and dope busts in-
volve black people and it is disheartening.

August 14, 1960

Last night we busted a place Chip and Jimmy had been staking out
for two weeks. A stool pigeon was sent in first to make a marijuana
buy. If he was successful, he was to light a cigarette and walk away
free. If not, he was to come back to the laundry truck, from which
the cops would be watching.

 When the stool came out smoking, we went in over the roof.
Reaching the apartment, I stood beside Chip and looked into a win-
dow. Three black children, a little boy and two girls, aged from
about three to nine, sat watching a Mickey Mouse cartoon on an
ancient T.V. set. A man, their father, sat half naked in an armchair
drinking beer. From a few feet away Jimmy whispered, "Let's go!"
Then eight cops with pistols and sawed-off shotguns were crashing
through the windows and breaking down doors. The children,
frightened and screaming, ran to their father. When he jumped up,
Chip sent him down with a brutal right and put the barrel of the
gun to his forehead. "All right! Where's the stuff you black son-of-
a-bitch? Where's the stuff?" The children were screaming now, and
I pulled them aside and took them into an adjoining room. I asked
them where their mother was. "We ain't got none," the eldest girl
sobbed. "We ain't got none."

 The father claimed innocence for a half hour while the cops tore
the place apart. Jimmy, frustrated and cursing the "lying stool,"
was about to give up the search when another cop hollered from the
hallway, "Here it is!" We found a hall closet filled from the floor to
the ceiling with neatly cellophaned packages. Jimmy smiled, threw
a hard right into the man's belly, and then handcuffed him. Before
hauling him off to jail, the cops left the three children with a neigh-
bor. The kids were still sobbing when we left.

August 17, 1960

A gruesome one two nights ago. One man caught another man in
bed with his wife. He beat him to unconsciousness with a car jack
and then cut off his penis. Both Jimmy and Chip seemed to find a

lot of humor in the incident, but Suydam looked at the sight and
rushed to the bathroom.

We'll be leaving for San Francisco tomorrow morning, and we
can't wait to take off. At another raid last night Jimmy offered to
"plug somebody for a good picture."

"No thanks," I said.

"Not to kill. I'll just nick him in the arm or leg."

"No thanks," I repeated. He seemed terribly disappointed.

SAN QUENTIN PRISON. *August 28, 1960*

There is something indescribably sad about all these men locked up
in this big prison. Each day for them—without a woman, without
love, without freedom—must be exhausting in its loneliness. Every-
thing has been shorn from them—their normal clothes, their hope,
their pride. They are like the walking dead, moving about in a time-
less darkness with silence eating up their years. I'm not asking par-
don for whatever put them here. Most of them, I'm sure, somehow
deserve to live in this cold, shadowed place. Nevertheless I sorrow
for them—enclosed, living out their lives like sightless zombies. I
talked with about twenty of them today and found that sorrowing
for some of them was time wasted. One little man with horn-
rimmed glasses and a shaved head said coldly, "I killed my wife and
kid. I should have done it sooner."

"Why did you do it?"

"They were sleeping together."

"His own mother?"

"No, I strangled his real mother. This one was my third wife."

And there are those who claim they were railroaded, swearing
their innocence despite the evidence stacked up against them. One
man goes to the gas chamber in two days. He's white. I sat with
him for over an hour discussing his life and the death awaiting him.
He seems like a gentle man who regrets very much what he has
done and is resigned to his fate. His circumstances, however, are
disturbing. He should have been—at least it seemed to me—in a
hospital. For a number of years he had been an apprentice to an un-
dertaker, he explained, but had never been allowed to work on a
body. A frustration set in, something he couldn't really understand,
so one afternoon he quit. That same night he read a book which de-
scribed Eskimos pulling seals from the water by hooking knives
into their eyes. "I went to a movie a week later," he explained fur-

ther. "After it was over I went to the men's room. There was a young kid standing beside me using a urinal. We were alone and something came over me, like a bad dream. I reached into my pocket and took out my knife, and with all my might I started hooking him in the eye—one after the other I kept hooking and stabbing, hooking and stabbing until he was dead in a pool of blood. I had nothing against that kid. My God, I'd never seen him before. Then the dream was gone, and seeing what I had done I ran up the stairs screaming that I had killed this kid. I sat down on the floor until the police came to take me away."

We sat silent for several minutes. Then I told him the warden had asked me to witness his execution. "Will you come?" he asked.

"Would you like for me to be there?"

"You're doing a story about criminals. You might as well see how one ends." I asked him if he was afraid. He thought for a long moment and said, "It's the awful thought of dying that I'm afraid of, not death itself."

"Do you feel you deserve to die?"

"I've given it a lot of thought. At last I feel that I took a life and that it's only fair they should take mine." I got up, thanked him, and bid him goodbye. He asked me to say a prayer for him. I promised I would, for I had already intended to do that much for him.

August 31, 1960

Neither Hank nor I wanted to be there this morning to see a life burned out, but the warden, who was a nice enough man, eventually persuaded us. He didn't like what he had to do either. It was his arm, after all, that would signal the drop of the lethal pellet that would put another death on the San Quentin record books.

Shortly after dawn we were informed of the procedures. "Don't move around, don't gesture, don't talk, obey commands promptly," said the cocky young guard who herded twelve of us into the safe side of the green gas chamber. He had given me an unfriendly smile when I appeared. A glint of mischief played at the corner of his lips. A few seconds before the doomed man was to enter, he motioned me down front, to within a foot of where the man would die. I moved down, knowing that in his own sickness he was hoping to frighten me, a black man, into another kind of

death. Perhaps his ignoble motive helped me face the tragic ceremony gathering before us. I became a camera; my eyes crystallized into lenses. Make it one long ten-second exposure, I told myself, then let your mind trip the shutter. The quiet was heavy and I damned myself for being there, but it was too late; the doomed man was on his way.

He came into the death cubicle ashen and shaking, flanked by three beefy guards. He was dressed in fresh blue prison denim and gray flannel bedroom slippers. Our eyes met and held for a second, his asking if I remembered to pray, mine assuring him that I had not forgotten. Then he began to turn slowly, using up each precious second before surrendering his body to the chair, knowing he would never, through his own strength, rise again. The minister behind me started his prayers. *"Then said Pilate unto them, Take ye him, and judge him according to your own law. The Jews therefore said unto him, it is not lawful for us to put a man to death."* The guards were straining to secure the straps around his sagging belly. To oblige them he inhaled deeply and they snapped the buckle that strapped down his shoulders and legs. Then they adjusted the stethoscope over his heart and left. One guard turned back to pat his shoulder and advise him to inhale "it" quick and get it over with. Then, at the last second, the condemned man asked for a Bible. There was a flurry of movement behind the Venetian blind where the warden stood. One was brought in and placed firmly in the man's hands.

Death was getting impatient. He sat alone now, with tears in his eyes, his head bowed—waiting for it, thumbing through Samuel, Kings, Chronicles, Ezra, Esther, Job, Psalms. The warden's arm was slowly rising. *"Yea, though I walk through the valley of the shadow of death, I will fear no evil; for Thou art with me; Thy rod and Thy staff they comfort me. . . ."* The warden's arm dropped. The pellet dropped. The gas was rising. The man's head snapped back and his thumb dug into Lamentations as the Bible fell free, hit the floor, and snapped shut. Now there was intense quivering from the top of his head to the base of his neck as the gas ate his nervous system away. *"Thou preparest a table before me in the presence of mine enemies; Thou anointest my head with oil; my cup runneth over."* The quivering raced through his belly, his hips, his knees, his legs; and as it reached his toes his body gave one final spasm of protest. Then he was still, slumped there in death, his judgment served up as dispassionately as he had served up his crime. I have yet to distinguish the

profanity of one act from the profanity of the other. I thought then, as I think now, that one evil, cloaked in cold, judicial morality, had just fed upon another.

The young guard seemed pleased with the pain on my face. He wanted to know if I enjoyed the show. Never in my life had I been so tempted to spit on anyone; but perhaps the look I gave served the purpose. He hung on as we filed out. "Two colored guys went together about a week ago. One cut his jugular with a razor before we could strap him down and blood was all over the place—guards, windows, chairs, and everything. He was hollering, 'Don't kill me, don't kill me!' and the other one was laughing, saying, 'Don't let whitey think you're scared, man.'"

I stopped and faced him; I looked down upon him. "Little mister guard," I said, "I prayed for that dead man back there. Tonight I'm going to say a prayer for you."

Hank and I crossed over the bridge into San Francisco in absolute silence. When we reached our hotel he patted my shoulder and said that he couldn't go on; I would have to finish the assignment alone, because he was taking the first plane home. Within an hour he had packed and was gone. After I was alone, I remembered thinking for a moment as that man died that it could have been me sitting there instead. Twice in my early life a conspiracy of evil beckoned me toward such an end. Remembering makes me tremble.

Duke Ellington: "Big Red"

JAZZ *(according to The*
Oxford Universal Dictionary
 on
Historical Principles)
Is a kind of music
In syncopated time
 as played
By Negro bands in the U.S.
 and
Music. Is a fine art concerned
With the beauty of form
And the expression of thought
 and feeling.
Negro. (also nigger, esp. a male)
Is one distinguished by
Black skin
Woolly hair
Flat nose
 and
Thick protruding lips.

> *(Thus defined in*
> *This same eminent tome*
> *Edited by C. T. Onions C.B.E., F.B.A.*
> *and*
> *Other corresponding fellows*
> *Of the Mediaeval Academy*
> *of America.)*
> *Well,*
> *Question not those lettered*
> *Fellows of Oxford.*
> *Jazz,*
> *The meaning of it,*
> *Is as evasive as silence.*
> *Name one who could*
> *Accurately define this*
> *Passional art that slices*
> *And churns one's senses*
> *Into so many delicate*
> *barbarous*
> *And uncountable patterns.*
> *But alas for me*
> *One definition would suffice.*
> *Jazz (n). Edward Kennedy Ellington.*
> *Also known as Duke, Big Red, Monster,*
> *duc, duk, ducem.*

After the gloom-ridden world of crime, going on the road with Duke Ellington was like a trip through paradise. I had been seventeen when I first saw Duke in back of the Orpheum Theater in Minneapolis, Minnesota. He had arrived in a cream-colored LaSalle convertible driven by Big Nate, a racketeer off the Northside. Elegantly attired, Ellington alighted and began making his way through a bunch of admirers. I scrambled up and shoved a piece of paper into his face for an autograph. Big Nate shoved me back, saying, "Get the hell out of here, kid!"

Ellington had gently reprimanded him. "We don't treat our public like that, Nate." He motioned me forward, asked my name, and signed my paper. He had dubbed me "Sir Gordon," and I went about addressing myself with that title for weeks.

Ellington had always been my hero. Unlike other black Hollywood stereotypes he never grinned, he smiled; he never shuffled, he strode. It was always, "Good evening, ladies and gentlemen"; never

"How y'all doing?" At his performances we young blacks sat high in our seats, wanting the whites to see us; to know that this handsome, elegant, sharply dressed man playing that beautiful, sophisticated music, was one of us.

Now he had invited me to tour with his band. And what a band! Traveling with it was a journey of sweet madness: standing offstage each night, watching the curtain go up, overpowered by that stomping, riveting sound as Duke strode onstage waving, chirping, "We love you madly!" Then he would slide gracefully under the keyboard, his fingers thumping a staccato beat, bringing the band rocking to their feet. I remember Sammy Woodyard drumming the brass section to frenzied madness, and Johnny Hodges stepping out front—legs akimbo, alto sax deadcenter of his soul, infuriating the trumpets and trombones with that arrogant, elegant sound. The brass would scream back and Cootie Williams's trumpet would growl as Hodges contemptuously booted out his last arrogant note to applause, applause, applause, and more applause. Then Ellington would rise, shouting, "Johnny Hodges! Johnny Hodges! Thank you, ladies and gentlemen. That was 'Things Ain't What They Used To Be,' written especially for me by my forty-year-old son Mercer on my sixteenth birthday—about four years ago." It was like that every night.

Ellington was soul. Ellington was music as it had never been played before or since. Ellington was greatness. He called himself the piano player in the band. But his real instrument was the band itself, and each night he put every fiber of himself into it, and that instrument could unfold as a flower or explode like a bomb.

I was with him back in 1956 at the Newport Festival when his extraordinary performance of "Diminuendo and Crescendo" burned that event into jazz history. It seemed, then, that the entire universe was there; a vast sea of humanity stretched as far as the eye could see. Duke opened up with an instrumental on the piano. After four choruses the rhythm section picked up his rocking beat. He leaned back, smiled, whipped up two more choruses, and then nodded at Paul Gonsalves. With his tenor sax between his legs, his eyes soulfully closed, Paul rose and began to play what would become the longest and most inspiring series of solos ever to grace that or any other band. Duke's impish fingering urged Paul on. About the sev-

enth chorus, excitement began building in the band and in the crowd. A shapely blonde, caught up in the mounting frenzy, jumped to her feet and began dancing. Her savage movements soon had the crowd on its feet screaming, cheering, clapping their hands, and stomping. Newport was gradually turning into a volcano—erupting with uncontrolled joy. As Paul drove on, the reeds and rhythm section began swinging beneath him, Sammy Woodyard sweating, pounding his drums, and beating the place into madness. The audience was now taking to the aisles and pressing down toward the stage. By Paul's twenty-fifth chorus the police and management were becoming concerned, trying to signal Duke to close it out. But Duke, knowing that to have done so at that moment might have brought on a riot, began easing Paul off, calling in the low-register clarinets and the phalanx of brass. By the time Cat Anderson's trumpet finally blasted the whole piece to a climax, Paul Gonsalves had played twenty-seven straight memorable choruses. For those of us fortunate to have been there, it was a July night to be remembered forever.

When I was still a young dude visiting a Kansas City whorehouse, Ellington, without knowing it, had favored me once again. His recording of "Sophisticated Lady" obviously inspired the *lady-in-waiting* more than I did; his music had driven her to the most remorseful thoughts and tears. After playing the record for the tenth time she gave me back my money, which she knew I needed badly, and then treated me to a midnight supper of pig knuckles, collard greens, and corn bread. When I told Duke the story years later and thanked him for the warm body and soulful supper he had granted me, he laughed. "That, my friend, was Ellington generosity touching you. You can now repay me with a big steak."

"And the warm body?" I asked.

"Mention it not. I'm submerged in them. Come on, let's find a good steak house."

If a telephone rang within ten yards of him, he went for it. "I'm a telephone freak. It's the greatest invention since peanut brittle. The only way to keep me from answering one is to padlock my lips. Even then I'll try sign language."

Early one morning I called his room, distressed because my

daughter was threatening to quit school and marry a Frenchman. (Later I was to find out that the "Frenchman" was Jean Luc Brouillaud, the little boy David had made friends with that first morning after we arrived in Paris.) "I have to find some way to stop her," I complained to Duke.

"Stop her? Come, come my friend. Why should you expect a lovely young lass like that to be practical and grammatic—when she is so rightfully inclined to the romantic. Forget it. Order the champagne and the flowers, then call your favorite preacher." It was questionable advice, but I took it. The marriage would take place in the fall of 1960.

Duke was somewhat of a mystery at times, even to himself. That's the way he wanted it. He didn't like being thoroughly understood. Those who knew him didn't try. They just sat back and enjoyed him, and there was plenty to enjoy. He was generous, kind, intelligent, and extremely entertaining. His inner life was as personal to him as his music, and he guarded it with a passion. Anyone who pried too deeply got politely and cleverly rebuffed. How did he get that scar on his cheek? "At my sixth bullfight in lower Spanishotozfol. No, in all seriousness, I got it umpiring a duel between a pink baboon and a three-legged giraffe in back of a Japanese supermarket in eastern Turkey." Ask him why he didn't indulge in outdoor sports and you were told that he feared fresh-air poisoning. Press him to evaluate jazz and he would lament having stopped using the term at his Bar Mitzvah. He would admit, under duress, that jazz spelled backwards was zzaj, or Zajj as in "Madame Zajj." Who did he admire most as a child? "My mother, of course. Only my sister had a mother as fine as mine." He hated flying. "I don't like pushing my luck. If God had intended me to fly, he would have leased me some wings." The others went by bus or plane. Harry Carney, who had been with Duke longer than anyone else in the band, became his driving companion—or better, his private chauffeur.

The three of us were approaching San Francisco early one morning. Far off, rising above the bay, the Golden Gate Bridge floated eerily in the dawn mist. Harry called to Duke, who was asleep in the back seat. "Hey, Big Red, wake up and look over yonder. Looks like something you might want to write music about." Duke stirred

awake, wiped the sleep from his eyes, yawned, and looked at the great bridge. "Majestic. Majestic. Damn, those white people are so smart," he mumbled, and fell back to sleep.

When we reached our hotel Paul Gonsalves was stumbling out, stoned out of his mind. Sleepily, Duke looked him over. "Where are you headed so early in the morn, my good man?"

"Fishing," Paul answered without stopping.

"Fishing? You're not dressed for fishing, man."

"Hell, Duke, I ain't trying to impress no fish. I just want to catch some of the bastards. See you later."

"Somebody's going to have to double on tenor tonight," Duke said. Carney agreed. Inside the lobby we ran into Ray Nance, the trumpet player. He was disheveled and seemed to have been awake all night. He approached Duke quietly, very quietly. "Hey, Big Red, let me hold fifty bills until payday. I just lost my damned wallet."

"Where'd you lose it?"

"Hell, if I knew I'd go find it."

"You guys got a crapshoot going?"

"Yeah, a little one up in Cootie's room. Why?"

"That's where you lost your wallet, sweetheart." He dug into his pockets and gave Ray the money. That same afternoon Ray bought me a drink at the bar. He was loaded now. Several hundred dollars bills graced his palms. Some other unlucky band member had lost his wallet by now.

14

The Learning Tree
and Elizabeth

Often, between assignments, we photographers sat around in our quarters at *Life* "chewing the fat" to kill time. I did a lot of my chewing with Carl Mydans, a photo-journalist I admire very much. For some curious reason he invariably dug into my past. He seemed fascinated with the tales of my early childhood, wondering how, from those soiled years, I had managed to glean some kind of happiness. After one particular session Carl asked me when I was going to write about it. Such a thought had never occurred to me. "It would take a book, and I can't write a book," I answered.

"Why not?"

Why not? I thought it over for a few weeks. On New Year's day, 1962, I sat down and wrote seven triple-spaced pages, and I read and reread them dozens of times before getting up enough courage to show them to Carl. After a month of procrastinating I slipped them into his letter box. He read them that same night, called me, and asked if I minded his showing them to a friend. No, I didn't mind. His friend turned out to be Evan Thomas, the executive vice-president of Harper and Row. Before the week was out Evan had

called and invited me to lunch. I accepted, not knowing what was on his mind.

Feeling insecure, I asked Carl to go to the meeting with me. Evan's first words, however, made both of us squirm. "I like your book very much," he said, "and I'd like to publish it. How long will it take you to finish it?"

Neither Carl nor I could believe what we were hearing. I looked over at him questioningly; and he looked back at me with astonishment covering his usually calm face.

"But, Mr. Thomas . . ."

"The other houses will be after you and they've got enough dough to outbid us, but we'll give you a good editor and look after you." He paused. "I'd like to offer you a five thousand dollar advance."

"But you don't understand. I . . ."

"Six thousand." Silence and bewilderment consumed me. "Okay," he said finally. "I'll go to seven thousand." I wasn't stalling. I was about to tell him I might not be able to write another word to back up what I had already written.

"Why don't you take a few days to think it over?" Carl suggested. I accepted his advice and began eating, but I didn't have much of an appetite.

There were other bids; Carl was an assiduous agent. Ken McCormack, a kindly and likeable man at Doubleday, offered twice the amount for an advance and invited me in to meet his staff, promising, "They'll be lending you every assistance."

At our next meeting Evan Thomas brought along a young lady whom he introduced as "your editor." Her name was Gene Young and I knew instantly that I would be working for Evan Thomas from that moment on. Years later, however, I found out she had told Evan he was out of his mind for accepting me with hardly any evidence I could actually write a book. "Furthermore," she'd said, "the guy scares me. He looks like a wild Indian about to attack." Evan had left us alone that day to get acquainted, but on the way to her train she had merely "tolerated" my presence. Two days later I started serious work on my first novel, *The Learning Tree*.

This tall and attractive woman of Chinese birth, who would from then on be my editor, had won me over easily and quickly to

Harper and Row. With a slightly heavy heart I accepted the news that she was married; and for that reason I saw as little of her as possible. Yet deep inside was the gnawing memory of her, the slow and painful awakening that I was falling in love. The few times I did see her only left me with a longing I knew I couldn't do anything about.

Elizabeth Ann Campbell, the daughter of my friends E. Simms and Vivian—and my daughter Toni's dearest friend—arrived from Switzerland in the midst of my confusion. When I last saw her she had been fifteen years old. Now, at twenty-one, she had returned lovely and fullblown, as beautiful a young woman as I had ever seen. She called me for lunch one day, and then gradually our lunches turned into dinners, and the dinners into parties, and suddenly there emerged the beginnings of a much closer friendship.

Then, one summer's day, Elizabeth arrived "to spend a weekend with Toni." I remember my heart quivered a bit as she alighted from the car and came down the driveway, radiant in a soft, beige linen dress. The weekend lengthened into another, and then bits of her wardrobe began arriving from New York. I pretended not to notice, although I made space in the downstairs closet and bought a new supply of hangers. It was the hospitable thing to do, I told myself. Soon after, through some thinly veiled misunderstanding, Elizabeth and I started living together.

In the beginning she was a most terrible cook. The eggs she served one morning seemed seasoned with brick dust and roasted between flatirons. I forced them down and resigned myself to compromise. Who, after all, could expect anyone so ravishingly beautiful to be a good cook? Nevertheless, I purchased several good cookbooks the following day.

One night I awoke in a cold sweat, elbowing Elizabeth to consciousness.

"What's wrong?" she asked, sitting up in bed.

"You know," I said, shaking my head, "neither of us have thought about what E. Simms Campbell will do when he finds out you're sharing my bed."

Elizabeth, endowed with an arresting humor that rivaled her father's, patted my brow and said very gently, "Don't worry, darling baby. He'll fume and cuss and threaten to blow your head off, but don't worry, lamb; all his shotguns are in a New York storage

house. Furthermore, the old boy's aim ain't what it used to be." She turned over and went back to sleep. In a little while she was purring softly but I still slept fitfully, dreaming of E. Simms pursuing me through inescapable woods, banging away at me with one of his double-barreled shotguns

The calls from Switzerland started at three o'clock in the morning about a month later. Vivian was on the upstairs phone in Zurich. E. Simms was on the downstairs phone in Zurich. Elizabeth was on the upstairs phone in White Plains. I was on the downstairs phone in White Plains. In a most motherly voice Vivian asked, "Do you love her, Gordon?" I, in a very weary voice, assured her I did.

"You're a goddamned liar, you bastard, and I'm going to blow your ass full of holes when I see you!" shouted E. Simms.

"Mother, shush Dad up! Gordon and I are deeply in love!"

"You and Gordon are goddamned fools!" E. Simms shouted. "The son-of-a—"

"Daddy!"

"Don't daddy me. I want you out of that house tonight!" It went on like that night after night. E. Simms ran up a twenty-five hundred dollar telephone bill the first month. Things had cooled somewhat when at four o'clock one morning another call came. It was E. Simms, crocked to the gills. The conversation was brief this time, very brief.

"You know, old boy, she's twenty-one and you, you bastard, are a hundred and twenty-one. Ha ha ha!" And the phone clicked off. Well, he had something there, I admitted, but it was too late. Liz had already found a marrying preacher and a nice little church. "Come on, dumpling," she had said, "we'll try it for a year. If it doesn't work, *tant pis.*" She got my best dark suit pressed and managed to get me away from *The Learning Tree* long enough for a blood test. When that test elapsed she hauled me down for another one. Finally, on one beautiful fall day, we took our vows. During the reception a case of good champagne arrived. It was from E. Simms, "with love, good wishes—and apologies."

15

Elijah Muhammad, Malcolm X, and "White Devils"

The nature of my work at *Life* would change drastically during the early 1960s. Blacks were now in full stride toward equality. The Supreme Court's doctrine of 1896 was no longer enough; we wanted full equality—and with all deliberate speed. For years I had waited for the moment when I could use my camera, heart, and eyes for what they had been trained for. The moment was now— while George Wallace stood pale and trembling in the doorway of the University of Alabama, blocking the entrance of two black students. I watched as the defiant little segregationist, playing his charade, backed down before the U.S. marshals, and I rejoiced when Vivian Malone and James Hood walked at last into their classrooms.

I also rejoiced when President Kennedy said, in a speech to the nation: "We preach freedom around the world, and we mean it. . . . Now the time has come for this nation to fulfill its promise." But soon it became clear that the Southern white was not about to give up his claim to racial supremacy without a desperate struggle. No sooner than the president's words died in the ceiling of his chambers, Senator Richard Russell declared, "I shall oppose his [the black

man's] civil rights with every means and resource at my command."
The good senator's words took on a more frightful meaning when
twenty- four hours later Medgar Evers, the black civil rights leader,
was ambushed in Jackson, Mississippi, and shot in the back by a
white man. But from the cortege that moved down the street behind
his coffin, a chorus sang out, "Freedom! Freedom! Freedom! No
more Jim Crow here, over here! I'm dead before I'll be a slave!" And
they marched on toward the heart of the city.

The police—with their clubs, guns, water hoses, and dogs—
were waiting and, spending their hatred on the mourners with mur-
derous vengeance, soon filled the jails. But as black Jackson, Missis-
sippi, seethed that night, so did other black communities all over the
nation.

A few years before, Medgar Evers's murder might have gone al-
most unnoticed. So many blacks had been killed in the South that
keeping an accurate count was impossible. The first year without a
single reported lynching was 1952. But now the Klan was on the
move again—shooting, burning, and bombing churches and
homes. Four black Sunday school students died in the bombing of a
Birmingham church. That city, being perhaps the South's most se-
gregated one, had become Martin Luther King's prime target, but
his peaceful marches had netted little progress. "Bull" Connors set
his burly policemen upon unarmed men, clubbed prostrate women,
knocked children to the ground with powerful fire hoses, turned
dogs upon them, and threw a record number of two thousand five
hundred into jail.

But the black wall of confrontation kept building. Besides Mar-
tin Luther King's Southern Christian Conference, there was Roy
Wilkins and the NAACP, with its powerful legal and moral force;
Whitney Young and the Urgan League; Floyd McKissick and
CORE; Elijah Muhammad and the Black Muslims; SNCC; the Pan-
thers; and men like Bayard Rustin and A. Phillip Randolph. Mean-
while, stirring in the shadows—eager to pick up the banner—were
young militants like Stokley Carmichael, Eldridge Cleaver, Mal-
colm X, Huey Newton, Bobby Seale, and others who would even-
tually radicalize the frustrations gripping the civil rights movements
during the 1960s. Despite the unbridgeable distance between the

methods they chose to fight with, all were making camp against the same enemy and the rush toward freedom had begun.

As blood flowed in the streets of Birmingham and black demonstrators filled the prisons all over the South, the cry of the Black Muslims rose to its highest pitch. Obscure and overlooked since they had banded together in the early 1930s, they swept into prominence as blacks became increasingly impatient. Elijah Muhammad, the leader of the sect, was the messenger of a black Allah with a bitter doctrine: expect hate and violence from the whites—and be ready to return it. He preached separation from the white man's world and demanded an all-black nation inside the United States. Now blacks were in a mood to respond to that credo; now, many who had shrugged off the movement for so long began to court it.

Life magazine had tried unsuccessfully to do a story on the Muslims for nearly three years—but they'd use white photographers and reporters. My objectivity toward such a story was, I'm sure, questionable to the editors; but now, having failed three times, they asked if I thought I could get inside the movement. I wasn't sure, but I answered in the affirmative.

The angry spokesman and trouble-shooter for the sect was Malcolm X; I first saw him on a Harlem street corner one winter night. Shouting over the heads of five hundred blacks, he pointed to a cordon of white policemen standing in the rear of the crowd. "You white devils know where the dope is! You know where the whores and pimps are! You know where the dope pushers and numbers racketeers are! You're a rotten part of them! You're the rotten white devils they pay to stay in business! We Muslims defy you! We blacks in the community are tired of you on our backs! Touch a Muslim and may Allah have mercy on your soul!"

I shot a glance at the cops. They stood silent, refusing even to look at their tormentor. But the hatred in their eyes matched the venom in Malcolm's voice and words. That's one crazy black man, I thought. He'll be lucky to live out the winter.

I didn't try to make contact with him that night, but a few days later I got a buddy of mine, Cecil Layne, to introduce us. When I told him I wanted to do a story on the Muslims, he informed me that only Elijah Muhammad could give that permission.

Together we flew to Arizona to see the "Messenger." As the plane banked for a landing I asked Malcolm what he thought my chances were. "Sir," he answered (it was always "Sir" in those early days), "it might be fatal to try and second-guess the 'Messenger.' We'll just have to wait and see."

Elijah Muhammad, looking more like a diminutive college professor than the leader of a violent sect, welcomed me with a bow of the head and a firm handshake, regarding me neither with favor nor scorn. Mainly, it seemed, he wished to expose me to his doctrine, which I was already familiar with. His manner and speech were subdued, as befitted his appearance, but his condemnation of the white man was ardent. "He can no longer be trusted; his ruling days are over. He was given six thousand years to rule. His time was up way back in 1914. Now he's worried about the black man getting his revenge after murdering black people by the hundreds of thousands. No, no black man can trust him. He's not fit to trust." He looked up at me and through me and said, "I worry about a black man like you working inside the devil's den. They tell me you're smart and talented. Well, don't let those white Christians blind you. You don't need them, and they're bound to do you evil."

Then, without saying whether he would allow me to do the story or not, he dismissed me. There was no attempt to convert me, but somehow I had been made to feel I was a black man walking about in white man's clothing. I was already out the door when he called, "Have a nice trip back to New York. I have to think over your request." I began to feel encouraged.

Chicago shone like a jewel as our plane flew far above it, but looking down I knew the hard life that so many blacks suffered in the infamous black belt of that city. I knew the rat-infested tenements, the fear, poverty, and bloodshed that came with the cold hawk of winter down there. And I wondered, knowing and feeling all this, if indeed I was capable of the kind of objectivity that the *Life* editors would expect. Elijah Muhammad's angry words had reminded me of how distanced I had become from the black life; of how much I missed the security of the black friends I once had around me; of the soft, easy laughter of Harlem. For a long time now I had not known where I belonged. In one world I was a social oddity. In the other I was almost a stranger.

Malcolm and I eventually made three trips to Phoenix. On the last one, Muhammad calmly suggested I do a film on the Muslims instead of the *Life* report. "We would finance you with five hundred thousand dollars." I told him I appreciated the offer, but would have to decline it.

"Why?" he asked.

"I'm sure you would expect to influence it."

Smiling, he said, "Indeed I would after investing that much money."

I smiled back. "I'm not interested in doing a propaganda film. As a reporter I must look for the truth in my subject. If what I find is the truth, and it serves your purposes, then that's fine with me."

"Do you practice that same philosophy in the white devil's den?"

"Absolutely. I wouldn't allow *Life* magazine to influence my report either."

He remained silent for a few moments, fingering a button on his jacket. Then, looking up, he said very softly and quite sternly, "All right, the nation of Islam accepts you. If we like your story, we'll send you a nice box of cigars. If we don't like it, we'll pay you a visit." He gave me a sly smile.

"I'm glad you find me worthy of your confidence," I said, returning his smile.

"Allah will watch you, and Brother Malcolm will guide you. Good luck."

For the next three months I was allowed to wander with my camera through the Muslim mosques in New York, Chicago, and Los Angeles; to attend rallies and secret ceremonies; to watch drill masters, dog handlers, and judo experts train the tough elite guard known as "The Fruit of Islam." Real guns were used to show a man how to disarm a policeman. Real dogs were used to show a man how to kill them with his bare hands if he were attacked. I also saw bright, neatly dressed Muslim children being educated in clean and orderly schools and universities. They were conveyed back and forth to classes each day in the sect's private buses, the boys standing patiently in line to let the girls enter first. I ate in their restaurants, visited their food markets and clothing stores. I stayed with one family for a week and was amazed at the warmth existing between the

parents and their children. When had I last heard a twelve-year-old boy, fresh from playing baseball, ask his mother if he could help with the cooking or clear the table or wash the dishes—without being pushed into it? It had never happened at my house. Everything was so pleasant that I couldn't help being suspicious. But no child could be rehearsed beyond showing his true colors now and then.

It was so strange each morning to see three small black boys, each facing East with their arms extended and heads bowed, praying to Allah—in a Harlem ghetto. I asked the parents many things about the children, their relationships, and their faith. There were two questions, I felt, in the light of Elijah Muhammad's teaching, that were loaded. Would the mother allow a white child in their home to play with her children?

"Yes, if they were well behaved."

I asked the father what he would do if his twelve-year-old son decided to renounce their Muslim faith?

"I would turn him from my door and never allow him to enter it again." Truth was in his eyes and in his voice as he said it, and I believed him.

On the journey through the Muslim world with Malcolm X, I began to realize that Elijah Muhammad had built it on the everyday needs of underprivileged people, people whom society—both black and white—had rejected. Dope addicts, thieves, murderers, prostitutes, pimps, and hustlers who had lain in prisons tasting the loneliness of the forgotten became respectable human beings in the Nation of Islam. Most of Elijah Muhammad's converts, it seemed, came from prisons. But once a Muslim, the clothes they wore as well as the food they ate reflected the cleanliness that the "Messenger" demanded. Cursing, smoking, drinking, or coveting a neighbor's home was cause for banishment from the sect.

But, I began to ask myself, what were Elijah Muhammad's real goals? And why was his voice, barely audible in person, drowning out the more conservative voices of the NAACP, the Urgan League, CORE, and other respected civil rights organizations? Malcolm X, in his firebrand speeches, claimed the only answer: "The thinking Negro realizes that only Elijah Muhammad offers him a solid united front! He is tired of the unfilled promises of these lethargic, so-called Negro leaders who have been brainwashed by the whites! 'Have patience' they say, 'everything is going to be all right.' Black people are

tired of sitting on a hot stove with their behinds burning, listening to some Uncle Tom whispering 'patience!' The black man has died under the flag. His women have been raped under it! He has been oppressed, starved, and beaten under it—and still after what happened to Medgar Evers down in Mississippi those devils have the nerve to ask the black man to fight their enemies under it! We Muslims will do our own fighting right here at home, where the enemy looks us in the eye every day of our life! I'm not talking against the flag! I'm talking *about* it!"

The Muslim creed was not concerned with an afterlife. Rewards were guaranteed only in its own world, a world sternly puritanical yet surrounded by the constant threat of violence. The police were its openly declared enemies. What then was the Muslims' meaning for the black struggle?

One day, at a Muslim restaurant over a quiet cup of tea, I asked Malcolm to be more specific about Muhammad's aims. Perhaps the tone of my voice suggested that I wasn't asking for a speech. There were no devils or police around, only the two of us. His voice grew gentle as he explained. "Muhammad teaches that black people cannot afford, especially at this time, the luxury of economic, religious, or political differences. We must sit in council if we are to attain our freedom. He intends to unite every American black man, whether Muslims, Methodist, or Catholic. To try and go it alone is to doom ourselves to failure. If I have a bowl of soup, then you have a bowl of soup. If you die fighting for what is right, then I must die beside you—for I am your brother. You are a black man."

I was in Los Angeles with a young Muslim, Ronald Stokes, shortly before he and fourteen other sect members had a confrontation with the police. Later that night, when police entered the Muslim temple, fighting erupted and seven unarmed young Muslims were shot down; Stokes, among them, was killed instantly.

The remaining fourteen were brought in and charged with "assault and interfering with an officer." During their trial I sat in the front row with Malcolm X, directly across from the all-white jury. Malcolm's eyes never left Officer Donald Weese, the killer of Stokes, from the moment the policeman took the stand until he finished testifying. It had been established that Weese, though he knew the young men were unarmed, shot at least four others and beat another one down with the butt of his gun. The following questions by At-

torney Earl Broady and answers from Officer Weese are from the
court records.

> *Question:* Mr. Weese, when you fired at Stokes, did you intend to
> hit him?
> *Answer:* Yes, I did.
> *Q.:* Did you intend to hit him and kill him?
> *A.:* Yes. The fact that I shot to stop and the fact that I shot to kill
> is one and the same, sir. I am not Hopalong Cassidy. I cannot
> distinguish between hitting an arm and so forth, sir. I aimed
> dead center and I hoped I hit.
> *Q.:* You are saying, sir, to shoot to stop and to shoot to kill is one
> and the same thing in your mind?
> *A.:* That is correct.
> *Q.:* Did you feel that to protect yourself and your partner it was
> necessary to kill these men?
> *A.:* That is correct, sir.

Twelve of the fourteen blacks were convicted and got long-term
sentences.

Just before the story closed, *Life*'s editors decided we needed a
photograph of all the Muslim leaders together. Elijah Muhammad
agreed to it and I suggested to Malcolm X that we fly out together to
meet the others in Phoenix. He advised my calling Herbert Muham-
mad in Chicago about that. Herbert was one of Elijah's older sons.
He and the others would of course be there, he promised, but it
wouldn't be necessary for Brother Malcolm to fly out.

"But we want a photograph of all the Muslim heads," I insisted.

"Then it *isn't* necessary for Brother Malcolm to be there," Her-
bert repeated, with unmistakable clarity. His decision confused me;
it had never crossed my mind that Malcolm X was not considered a
leader in Elijah's nation of Islam.

In the story *Life* eventually published I sympathized with much
of what Elijah Muhammad had to say, but I also disagreed with
much of it. Certainly a separate state within the United States was
not my idea of the ultimate goal for blacks, and not all of Muham-
mad's motives and aims ever became clear to me. Even some of the
sect members were not living up to the promise set forth by their
"Messenger." And speaking about the trial and confrontation with
the police, Muhammad had said, with more emotional intensity than

I had ever seen him show: "Every one of the Muslims should have died before they allowed an aggressor to come into their mosque. That's the last retreat they have. They were fearless but they didn't trust Allah completely. If they had it would have been a different story. A true Muslim must completely trust in Allah."

More than once I had heard Malcolm deride the "passive resistance" preached by Martin Luther King, Jr.: "There is no philosophy more befitting the white man's tactics for keeping his foot on the black man's neck. He's following Gandhi's tactics. But Gandhi was a big dark elephant sitting on a little white mouse. King is a little black mouse sitting on top of a big white elephant."

I concluded, nevertheless, that King's passiveness had stirred the black rebellion to life, compelling the Muslims, the NAACP, the Urban League, Black Nationalist groups, the sit-inners, sit-downers, and the Freedom Riders into a vortex of common protest. Blacks who had been speaking with polite moderation earlier were suddenly demanding unbridled freedom. I did admit, however, that the black leaders had lost control, that instead of leading the black people they were being pulled along after them like leaves caught up in the wake of a speeding car. Even Martin Luther King was witnessing his non-violence movement hopelessly swept into a long-fomenting universal revolt, while the resistance of the Deep South stiffened.

But to the Muslims I acknowledged that the circumstance of common struggle had willed us brothers, that if violence did erupt this same circumstance would place me beside them. The story ran big but Elijah Muhammad didn't send cigars, nor did he pay me a visit. Malcolm did inform me that he thought it was a "fairly impartial story." Shortly afterwards I flew with Malcolm from Los Angeles to New York. During the flight he called me "brother" for the first time. I sensed I had made a friend.

*　　*　　*

Anger was growing all over the land now. A few weeks later Malcolm and I walked through Harlem, and I was jolted into a new appreciation of what three hundred and fifty years of oppression had done to my people. The black ghetto had always swarmed with pain, poverty, despair, and resentment, but now there was an exultant anger—clearly capable of erupting into open violence. The restless

inhabitants, no longer afraid, no longer passively awaiting divine deliverance, crowded the street corners listening to impassioned voices screaming invectives.

In the midst of all this, disgruntled white policemen, sometimes fifty to a single square block—standing in doorways, hovering on rooftops, or poised with their backs against the tired tenement buildings—listened to the diatribes. One fiery little woman atop a soapbox was screaming: "We're on the move! We're crossing the line—even if it means death to some of us! We'll keep coming till you're ground to red dust under our black feet!" She screamed on relentlessly: "To hell with your love for us! To hell with your pity for us! We don't want nothing from you but a chance to live better than the rats that share our homes! Go find some way to make those rats share the rent with us!" The crowd rallied to her words, raising their hands and voices in approval.

"Tell 'em like it is, sister!"

"Give 'em hell, baby!"

"Preach on! Preach on!"

I returned to my home in Westchester, moved by the black temper of the time, by the courage of that old woman on the soapbox. I knew—and knowing made my heart pound—that history had caught up with us.

How often had I heard the white man suggest, "I know the Negro." Nobody knew the black man, not even the black man, because all our lives we had cloaked our feelings, bided our time, waited for the hour when we could look our oppressors squarely in the eye and tell them exactly what we thought, what we wanted and intended to get—and all this without fear.

Our young people were telling us boldly that they would not go on suffering while the white man insisted on slow surrender through law and time. If spoken to about new laws and legislation, they answered: "It's one thing to make a law and another thing to enforce it." If spoke to about well-intentioned whites, they answered: "If they are sincere, they will raise their fists and voices above those of the racists." When told that times were changing, they answered: "*We* are changing the *times.*" So, my generation yielded to them—and found pride.

16

Genevieve Young
and A Choice of Weapons

After The Learning Tree, Evan Thomas pushed me almost immediately into a sequel. The first book had been an autobiographic novel that had taken about a year to finish. The second would take twice the time. Vivian, Elizabeth's mother, had given her some questionable advice. "If you want to keep Gordon, get him a small apartment in the city where he can write." Elizabeth got me an apartment. I can't say whether or not this arrangement contributed to the marital bliss that carried us beyond those first doubtful years, but we seemed happy enough. I went home each weekend to a loving wife, good food, and a well-kept home. We seldom, if ever, argued; her way of handling our differences was very simple. If I raised hell about something, she would smile as I complained, place a rose on my desk, and kiss away my anger. More sage advice from Vivian, I suspected.

We were in Paris at the Hotel Crillon on the evening of November 22, 1963, preparing to go out for dinner, when I heard Elizabeth give a stifled cry. Half shaved, I ran from the bathroom and

found her near the radio, weeping. "What is it? What is it?" I demanded. "President Kennedy has been shot," she gasped.

Unexplainably, I reached for the light switch and threw the room into darkness. Then we prayed for Kennedy. We listened as the French radio announcer went on with his report; finally, near hysteria, he cried, "President Kennedy is dead!" For five minutes or more we stood there in the center of the room, silent, holding on to one another. What was America coming to? We passed up dinner and I spent the remainder of the evening trying to write Kennedy's murder out of my mind. That night the title of the new book came as I lay in bed. I got up, went to my manuscript and wrote down "A Choice of Weapons," underscored the words, and went back to bed.

Reaching the hotel lobby the next morning I found everyone stunned into silence. The sad-eyed concierge spoke softly. "Terrible news from your country, Monsieur—and for us here." "It is indeed," I replied. Then he brought me up short. "Tell me, what is this Mr. Johnson, your new president like?" My reaction must have seemed very curious to him. I nodded blankly and turned away without even answering. The concierge had awakened the shocking reality that, by now, was striking millions of other black Americans: a Southerner was now President of the United States. I shuddered.

That afternoon I cabled the title to Gene. She cabled back: "It's fine—just fine. Love, Gene."

Working on *A Choice of Weapons* brought Gene and me closer when I returned to New York. We lunched frequently now, finding in our growing friendship the warmth that time had nurtured. She always pushed for perfection and I tried to accommodate her. We were having dinner at the Palm Restaurant one night when I looked up from a steak I was finding hard to eat, and said, "Gene, you know, I think I've fallen in love with my editor."

She answered very evenly, "It's the wine. Authors do such things from time to time." She was right, of course, but after that it was never the same. Of all the women I had met she had been the one to give me the truest sense of myself, and of what I was capable of accomplishing. I felt close to her, and though I was confused at times by this closeness, I welcomed it. Now I used the slightest excuse for calling her or for being in her company.

One day at Evan Thomas's apartment the three of us drank to

the success we hoped for *A Choice of Weapons,* and as we drank, Gene and I looked at each other much too long. The next day, however, she burdened me with exactly ninety-four items of her personal criticism of the manuscript.

17

Malcolm X murdered. Parks next?

*I*t seemed incredible that Police Lieutenant Thomas Gilligan—veteran of sixteen years on New York's police force, recipient of several awards for disarming dangerous criminals—could not deal with or avoid shooting and killing James Powell, a fifteen-year-old black boy. But that was what had happened one hot, humid night in August.

Two nights later Harlem became a nightmare of violent protest that spread like wildfire through the main streets and on into the slum district of Brooklyn. Thousands of impassioned blacks stormed the Harlem police precincts, breaking store windows belonging to white merchants. From tenement rooftops came a hail of bricks, bottles, and garbage-can covers. Police reinforcements came pouring into Harlem firing guns into the air. With their helmets fastened tight they waded in with nightsticks, whaling away at every black skull they could find. Molotov cocktails, fashioned of bottles of gasoline and rag wicks, were lit and lobbed into the ranks of the pursuing cops.

The violence went on for a week. As it turned out, it wasn't as

bad as it could have been, and not half as bad as Harlem's riot of 1943 or the insurgencies at Oxford, Mississippi, or Birmingham, Alabama. Surprisingly, only one black man had been killed by the police. But one hundred and forty-eight people had been injured and five hundred and twenty imprisoned. Property damage ran into the hundreds of thousands. But, even so, it had been far less bloody than the Civil War draft riots in New York when rampaging whites lynched eighteen blacks, drowned five others, and burned down a black orphan asylum.

At the height of the fury I remember a white policeman, frustrated and tired, screaming through his bullhorn, "Go home, goddamn it! Go home!" A black man had shouted back, "We *are* home, honky! Get lost!"

Early one morning, looking at 125th Street littered with glass and garbage, the storefronts broken and boarded, I thought back to August 28, 1963. Hundreds of thousands of us had gone by foot, planes, buses, cars, and mule-drawn wagons to march on Washington; to join hands and peacefully sing "We Shall Overcome," to hear Martin Luther King in his beautiful, moving cadence cry "Freedom" in a way we had never heard before. I thought back to the night before when gunfire shook the night and black bodies surged forward screeming, "Kill 'em! Kill 'em!" And I knew that freedom was far away. Some of the white press had done a subtle job of mudslinging, using such invectives as "hate-preachers," "venomous demagogues," "leftists," "racists," and "hoodlums" when referring to some black pastors and leaders whom they held responsible for the rioting.

The long, hot summers—exploded in the heat of James Baldwin's prophecy, *The Fire Next Time*—had started.

For various reasons I had disliked and distrusted Vice-President Johnson. But somehow I respected his performance when, as president, he faced a national television audience and, with a modesty not born to him, promised, "I will do my best. That is all I can do." Were the tears manufactured? Was the sorrow counterfeit? I wondered, and instantly became annoyed with myself. Surely the man, despite his shortcomings, was above this.

Hope replaced despair when shortly afterwards he said before a joint session of Congress: ". . . we have talked enough in this

country about civil rights. We have talked for one hundred years or more. It is time now to write it in the lawbooks."

Millions of black people applauded that speech, but years of hollow promises still held our distrust. We had grown to doubt the hopeful songs of our fathers. We would wait. Johnson would have to show the real strength of his conscience. Our fears would remain, for these were fierce years for the black man, what with our leaders in confusion and Martin Luther's armor of truth and love beginning to wear thin. Racism still engulfed us. It would take more than love now to stay the increasing violence. But that summer, while arsonists' smoke darkened the air of several American cities, Johnson signed President Kennedy's sweeping civil rights bill into hard law. The breech seemed to be narrowing between what he claimed to believe and what he practiced. Our skepticism waned. It was a bill, a law, that governed America's most serious problem—those of a man's right to equality. Johnson was disobeying the law of his Southern upbringing.

A shocked country mourning the death of President Kennedy had been further shocked by Malcolm X's widely quoted statement that the assassination was "chickens coming home to roost." This statement was assumed to be the reason for Malcolm's expulsion from the Black Muslims some time later. According to Malcolm, the meaning of his words was blown far out of proportion. "I was saying that American whites, no longer content to kill the blacks, were now murdering each other—even their president." Soon after he had broken with the Muslims to form his own militant cadre, he told me: "It was a lie, a shallow pretense to get me out of the movement. It's simple; Elijah Muhammad is out to get me." For a long time Malcolm said he actually believed his reinstatement was imminent. "The permanence of the break," he said, "finally dawned on me when they fire-bombed my house."

I talked with him two days before his murder. He appeared calm and somewhat handsome with his new goatee and astrakhan hat. He was still confident, still full of fire, but he seemed less bitter, less hostile, than when he had spent his days and nights damning the white devil. "Those were hours of sickness and madness—I'm glad to be free of them. We need martyrs now—that's the only thing that can save this country. I learned it the hard way."

His change puzzled me. Could it be his disenchantment with Elijah Muhammad that had forced him into another type of role? Only a few months previously, at a Harlem rally, he had shouted, "We need a Mau Mau to win freedom and equality here in these United States!" Malcolm seemed caught up now in a new kind of idealism, and I never doubted his seriousness. He invited me to hear him speak the following day. His subject would be Brotherhood. "And brother, you won't see a lot of bodyguards fouling up the place, searching people," he said. "We must create an image that makes people feel at home."

"Is it really true," I asked, "that the Muslims are trying to get you?"

"They've tried it twice in the last couple of weeks."

"What about police protection?"

"Nobody can protect you from a Muslim but another Muslim. I know. I invented many of their tactics."

"Then you don't have any protection?"

He laughed. "There are hunters and there are those who hunt the hunters. The odds are with those most skilled at the game."

In the last year he had sent me postcards from Saudi Arabia, Kuwait, Ethiopia, Kenya, Nigeria, Ghana, and Tanganyika. I thanked him for these. "I went there to get closer to the orthodox religion of Islam—and the African leaders," he said. "Their problems are inseparable from ours, but Nasser, Ben Bella, and Nkrumah awakened me to the dangers of racism, that it's not just a black and white problem. The cords of bigotry and prejudice have to be cut with the same blade."

Before we parted, he placed his hand on my shoulder and said, "I did many things as a Muslim that I regret now. I was a real zombie then—like all Muslims—I was hypnotized, pointed in a certain direction and told to march. Well, I suppose a man's entitled to make a fool of himself if he's ready to pay the cost. It cost me twelve years." When he left he gave me the salutation, *"A salaam alaikem,* Brother."

"And may peace be with you, Brother Malcolm," I answered. Two days later he lay dying on the stage of a Manhattan auditorium, his life oozing out through gunshot wounds in his chest.

Despite his extremism, I had liked and admired Malcolm. A certain humility was wed to his arrogance. Although he helped create the violence that finally did him in, in private he was not a violent

man. His anger toward the whites, who had bludgeoned his father to death and burned his house to the ground, was justified. He was brilliant, ambitious, honest—and fearless. He said what most of us black people were afraid to say publicly. When he tongue-whipped the head-beating cops and the Harlem bosses, a ghetto full of "amens" could be heard richocheting off the squalid tenements. He was not after power in the Muslim movement, but his unquestioning belief in Elijah Muhammad, his personal charm, his remarkable ability to captivate an audience, brought him that power. With Elijah aging and ailing, Malcolm seemed to be the obvious choice as his successor. But his prominence and power also made him a marked man in this tightly disciplined society. With his "chickens come home to roost" statement about Kennedy's assassination he unwittingly made himself more vulnerable.

I sat with Betty, his wife, on the night of his death. With us, watching a television review of his stormy life, were his two oldest children—sixteen-year-old Attallah and Qubilah, now my four-year-old godchild—and a group of his stunned followers. Atallah took her mother's hand. "Is Daddy coming back after his speech?" she asked.

Betty put her arms around the child, but when she spoke it was to herself. "He tried to prepare me for this—I couldn't bring myself to listen. I'd just walk away from him. Only after they tried to bomb us out did I begin to understand. Then I closed my eyes, hung on to every word he said, and got myself prepared. I'm ashamed that I cried when he was lying there all shot up." Qubilah seemed to understand that her father wouldn't come home again. She tugged at her mother's skirt. "Don't go out, Momma, please don't go out." Betty gently pressed the child's head against her stomach and told her to go to sleep. Inside of her, in her womb, were unborn twins.

The man who broke one of the assassin's legs rode back to mid-Manhattan with me. He was distraught with guilt. "We could have saved him, we could have saved him," he kept mumbling to himself.

"What happens now?" I asked.

"Six brothers go looking for the main Zombie—wherever he's at."

I thought back to Phoenix, of Muhammad and Malcolm warmly embracing, their cheeks touching in farewell. I felt empty.

He showed me a list of names taken from Malcolm's body—

those who Malcolm thought were trying to kill him. "They know who they are," he said. "They will be dealt with."

The following morning *Life* called to ask me to do a piece on Malcolm's death. I accepted, with only three days left to write. At four o'clock on the morning we were closing the story I got the first word that several bomb warnings had been sent to the magazine. If my article was published the Time-Life building would be blown up. I had included the list of names but, for legal reasons, the company lawyers advised that it should be deleted from the manuscript. George Hunt, the managing editor, insisted on running it. In the end, when the decision was left up to me, I followed the advice of the lawyers; I also heeded their suggestion that I take my entire family out of the country, returning only when the whole thing had blown over. We took a plane to a secluded island on the Caribbean Sea in the West Indies.

While we were away things became more serious. The FBI notified *Life* that there was a plan afoot to murder me. Five men were involved and a photograph of the alleged leader was forwarded to our offices in New York. When he boarded the plane in Chicago, two FBI agents boarded with him. When the agents asked him why he was going to New York, the man got off the plane. Twice he tried and twice they covered him.

Aware of this, I decided to return to New York alone. If something was going to happen to me, I didn't want it to happen around my family, especially around my grandson Alain, whom Jean Luc and Toni had blessed me with. I lied to Elizabeth, saying I had to go back to have a tooth pulled, and cabled to Dick Pollard, my immediate superior, that I was returning. From the moment my plane set down at Kennedy Airport, I was to start living an unreal existence. The magazine surrounded me with a squad of detectives and moved me from my apartment to a suite in the Plaza Hotel. Anyone entering that suite from either side had to reckon with four trigger-happy plainclothesmen. I dreaded walking the streets, not because of the threat made upon my life, but for fear that one of my friends might rush up to shake my hand—and probably lose his life.

This was a difficult time. It's one thing to know that, during a war, a bomb might drop on your building. But it's quite another to know that someone might be gunning for you personally when you walk out your door each day.

I was beginning to grow weary of seeing men with guns every-day; I was weary of listening to them playing poker during the nights. After a month and a half, when I'd had enough, I decided to return to Paris for a while. If Elizabeth wanted to come she could. She chose to come along.

When I met her and the rest of the family at the airport, no less than twelve detectives lined the corridors. Liz, numb from champagne, hardly noticed them. With the rest of the family comfortably ensconced at our Westchester house—and surrounded with guards—we took off again for Paris. I dread, even now, to think of what all this maneuvering must have cost the magazine, but at the time cost was the least of my worries.

A couple of months later we returned to New York. The men with the guns surrounded us again. Then, one day, to end it all one way or the other I slipped away from them, got into my car, and drove up to the Muslim Restaurant in Harlem. "Where's Brother Joseph?" I asked when I walked in.

"What do you want with him?" someone asked back.

"A cup of tea—just a cup of tea."

A door opened in the rear, Brother Joseph came out, and we had our tea. That was the end of it.

18

Unfaithful to my emotions?

I had chosen my camera as a tool of social consciousness. Common sense told me I had to have sufficient understanding of what was right or wrong, otherwise that camera could eventually become my own enemy. I tried to keep my own consciousness alert—and at the highest level of integrity—to those things I would be committing myself to.

The problem was clearly defined from the very beginning. It would be hard not to betray myself, to remain faithful to my emotions when facing the controversial issues of Black and White. I was a journalist first, but I would have to remain aware that being true to my own beliefs counted even more. I would have to bear the anguish of objectivity, and try to avoid those intellectual biases that subjectivity can impose upon a reporter. I was a journalist and expected to fulfill the commitment, like all journalists are *supposed* to, of unemotional detachment. The succeeding years would test my ability to retain that detachment.

March 1965 saw the black man's struggle for the right to vote explode into another orgy of police brutality. Sit-ins and protest

parades in scores of American cities were met with tear gas, whips, dogs, clubs, and deliberate murder. But during the chaotic violence of that time, the main issue of voting rights seemed all but forgotten—especially in Selma, Alabama, where things hadn't changed much since an ordinance of 1852 declared: "Any Negro found upon the streets of the city smoking a cigar or a pipe or carrying a walking cane must be on conviction punished with thirty-nine lashes."

Now this "uppity nigger," Martin Luther King, was rounding up black folks and marching them down to Selma's courthouse to register. Again and again King and his followers marched, but always Selma's super-segregationist, Sheriff Jim Clark, and his mounted posse—many of whom were Ku Klux Klansmen—rode up to arrest and jail them. But King kept marching until the jails were filled to overflowing with two thousand black people whose voices filled the prison halls with "We shall overcome."

Selma's blacks finally got themselves a martyr when, in nearby Marion, state troopers and a mob of rednecks attacked four hundred black demonstrators; Jimmie Lee Jackson was shot in the stomach and died eight days later. Jackson's killing urged King on and he called for a fifty-mile march to Montgomery, Alabama's state capital, crying: "I can't promise you that it won't get your house bombed! I can't promise you that you won't get scarred up a bit! But we must stand up for what is right!"

The march to Montgomery was on, but King, for the sake of his own safety, was persuaded to remain at his Atlanta headquarters. John Lewis, head of the Student Nonviolent Coordinating Committee, and Hosea Williams, of King's Southern Christian Leadership Conference, led the march despite Governor George Wallace's order forbidding it.

On the afternoon of March 7 an incensed nation watched the inevitable conflict on television. Wearing gas masks, Alabama state troopers and Jim Clark's mounted posse surrounded the marchers swinging clubs and lashing bullwhips, their horses trampling the fallen. Then gas cannisters were fired as the marchers—dazed, beaten, and bloodied—staggered off in all directions. The scene was so chillingly brutal it was at times unbelievable. I sat with Elizabeth and two of my children, Toni and David, watching it on the evening

news. Elizabeth was angered to tears. David paced the floor, using profanity in my presence for the first time in his life. "Those dirty sons of bitches! Oh how I'd like to mow them down with a machine gun!" And suddenly I was ashamed, sitting there watching the slaughter from the safety of my living room.

Public reaction was spontaneous and furious. Thousands of protestors streamed into the streets in scores of American cities from Chicago to California, blocking traffic and shouting their rage. Michigan's Governor George Romney and Detroit's Mayor Jerome Cananaugh led ten thousand people in a protest parade. President Johnson declared publicly that he "deplored the brutality," and Martin Luther King's conscience compelled him to lead another march on Montgomery; over four hundred white churchmen plus an impressive number of blacks hurried down to Selma to join him. Three of the white churchmen were severely beaten and one, the Reverend James Rees, died. Congressmen from all over the nation took Wallace to task. Twelve blacks even got into the White House and staged a sit-in, hoping the president would take more drastic action. King, with all his supporters, marched again, but because of court injunctions and a deal with the courts, which wounded King's conscience even more, the march ended at the point of its last confrontation. But within hours the rage smouldering in the hearts of black people flared again—this time in Los Angeles. There—under skies filled with smoke from ransacked and burning buildings, amid the chilling, crackling fire of National Guardsmen's M-1 rifles and .50 caliber machine- gun fire—black people exploded into the worst protest in the nation's history. The Guardsmen had been called in to contain the fury, but at week's end property damage was well over one hundred million dollars, and seventeen hundred people had been arrested. Again the police disclaimed any acts of brutality; nevertheless, nearly seven hundred blacks were injured and twenty-seven lay dead. And this, we knew, was just the beginning. Across the nation the fires would burn on.

19

A son goes to war

By November 1965 the bitter ordeal of Vietnam had escalated to a large-scale undeclared war, and as we plunged deeper into the futility of it, my youngest son David was drafted.

He was scheduled to leave on November 17. Several draftee friends of his—undecided whether they'd fight or not—had begun gathering at our place to discuss the situation. Overhearing them from my den, measuring the passion in their voices, I tried to decide who, in the end, would go and who would not. Besides David there was Morton and Arnold, two Jewish brothers; Joseph and Harold, two blacks; Johnny, an Irishman; Jimi, a West Indian; and Bruce, a young man from Pennsylvania. The Jewish brothers seemed hopelessly split on the issue, as were the two blacks. The Irishman and the West Indian were reluctant, but they vacillated with the stronger course of the argument, not knowing which way to go. David seldom ventured an opinion, but Bruce was definitely gung ho. "Those Commie bastards need their asses kicked real good, and I'm for getting it over with!"

MORTON: You're beginning to sound like McCarthy.

BRUCE: It's got nothing to do with him. I'm talking about Communist aggression.

JOSEPH: The Communists haven't done anything to me. I don't have no reason for picking up a gun against them. If the war was against Mississippi, Alabama, and Georgia, I'd sign up in a minute. Don't give me that crap about aggression.

ARNOLD: Remember Hitler, Joe.

JOSEPH: And you remember Medgar Evers, Selma, and the Ku Klux Klan!

JIMI: Man, I just don't know. It's twelve of one, half a dozen of the other.

HAROLD: If we blacks are going to have a voice at the peace table, we'll have to fight for it like everybody else.

JOSEPH: Bullshit! Why don't you get with history, man. Get with history!

MORTON: I'm going to be a Rabbi—I'm strictly against killing.

BRUCE: Even if somebody's out to kill you?

MORTON: This is not our war—we're making it ours. We're as much the aggressor as anyone else.

JOSEPH: Amen, Brother Rabbi. Amen.

JOHNNY: It doesn't matter who the aggressor is. We're in this mess either way. I don't want to kill anybody either; and I don't want anybody trying to kill me. But, well, this is my country and I suppose it's my responsibility to help defend it.

JOSEPH: You're white, baby. It's easy for you to think that way. Maybe you feel you owe this country something. I don't.

JOHNNY: Perhaps you're right, man. Hell, I just don't know. What's your thinking about all this, Parks? You've hardly said a word.

DAVID: I'm thinking, fellows—just thinking.

It went that way night after night, without my knowing what David was thinking, or of how the Selma, Mississippi, and Alabama incidents had affected him. But I knew he was turning it all over in his mind, deciding in his own stubborn way. That's how he was, how we had been since he was a small child. He never talked to me about it—just showed me his papers when they came, smiled, and shrugged his shoulders. I wasn't going to try and influence him one way or the other. It was his life and his decision to make. I was concerned, and I was prepared to back him up regardless of what he

decided. But, if necessary, I would remind him that those whites he had seen in Selma did not reflect the nature of the entire white society; that the blood of three white ministers, Reverend Reeb, Richard Morrisroe, and Donald Thompson—and many others—had been spilled in our behalf. Then, too, he had just finished reading *Choice of Weapons,* which had been published only a few months earlier.

I noticed he didn't pack any clothes the day before he was scheduled to go, and I slept very little that night. Elizabeth was equally concerned, but she held her silence. At dawn we heard David stumbling about. I got up and peered into the hallway, seeing only a pair of ski poles and some boots. Was he going skiing, or to the army? "What's up, David?" I hollered.

"My number!" he hollered back. "I'm getting ready to meet the man!"

I was relieved but unhappy. Before he left that morning I put a 35mm camera and a large supply of film into his bag, telling him, "Take some pictures in your spare time, keep a diary, and get it off to me whenever you can. Good luck, and remember—we're not anxious to have any heroes in the family." We embraced for a long moment and he was gone. Naturally, we were worried, and we prayed he would come back someday, but we were aware and frightened of the odds against it. Considering the mood of the country he was off to defend, we could only hope that if he lived he would not have to return to yet another battleground. But with twenty-one million black voices chanting even stronger, "We shall overcome," it seemed that the revolt would go on despite the white man's stiffening resistance.

What David was heading for would be far different from what he was leaving. My children had loved the White Plains house. It had been a small bungalow on two lots when I acquired it back in 1945, but after our return from France I had purchased some adjoining properties, and redesigned and expanded the place. Where a field of wild sumac once grew there now sprawled a forty-foot living room with a shed roof and an oval, bubble-shaped skylight. Surely he would miss those snowbound nights when stars jeweled the sky and, with a fire blazing in the huge fireplace, we'd sit in darkness, drowning in Rachmaninoff or Brahms.

There were three fireplaces altogether—the one in the living

room, another in the dining room, and a third in an upper bedroom. During the holidays we kept all three burning. It was a rambling place designed for pleasant living and thinking, for reading good books and listening to good music. The summers were equally pleasant. A great towering willow and an army of strong oaks lorded over the garden that nature and a flower-worshipping gardener had created. Nestled in the center was a swimming pool—blue and cool under the hot sun, black and glistening under soft moonlight.

The wild flowers of spring always started things off. Bursting up from the earth impatiently, they spread in armies of violets, pinks, and blues, shooting up everywhere, taking over before the larger plants could overshadow them. Trembling in the April rains and hugging the soil during high winds, they were so different from the tall, gangly sunflowers of my Kansas childhood.

Then came the heat of May, burning the colors one into another. Only the wizened morning-glory curled into itself to escape those melting noons, while the pink and white Azaleas opened their petals against the light. In June and July all the plants ripened to every hue and color imaginable. I used to wish for that Bougainvillaea that took over our place in the south of France—that stubborn, discriminating species that graces only climates of its own desire.

All this and more David would miss.

20

Muhammad Ali and Vietnam

At times, especially in the adolescence of my career, I allowed my camera to pass judgment upon people without first taking time to understand them. I took refuge in the erroneous adage that "a photograph never lies." Since then I have learned that what a man is, does not always show on the face he wears. Usually there's a deeper truth submerged inside, often imprisoned by his most constant enemy—himself. That truth, for better or for worse, is sometimes most difficult to find. So few of us manage even to know ourselves during a lifetime. Shifting from course to course we search for a hunger to keep us moving, frightened of whatever it is that keeps us so unsure of ourselves. Finally we fall exhausted, entangled in a bed of remarkable excuses from which we are unable to extricate ourselves.

My mother used to tell me that there is some good in everybody, and that I should always try to find it. I have tried and sometimes I have succeeded. But trying, in certain instances, has brought me dishonor among people who would bury a man they dislike, even before death catches up with him.

Muhammad Ali was on a multitude of burial lists when I first met him in the summer of 1966, just after he'd proclaimed, "I ain't got no quarrel with the Vietcong." His public image had hit rock-bottom. Bad feeling had built up against him when he became a Muslim back in 1964, and the press had accused him of being an antiwhite bigot. No longer was he just a loud-mouthed kid but a "shameless traitor," as one newspaper put it. Frankly, I liked him, knowing he would never have been given a shot at the title if he hadn't made a lot of noise. But now that he had made it, I hoped he would cool down. I wanted to be proud of him as I had been proud of Joe Louis. Ali was a great black fighter; I wanted him to be a black hero as well—and he wasn't making it.

He was in Miami now, preparing for his fight with Henry Cooper, which would take place in London. It was early evening; he had trained hard that particular day, and his mood was hardly a friendly one. After reading an article about himself he threw the magazine to the floor. "Bigot! Traitor! Bum! Those white devils can burn in hell. They ain't hurting me none, and they ain't hurting the gates none; just making it harder on their white hopes." He smiled for the first time. "What you doing down here in hot old Miami?"

"Trying to find out if you're as obnoxious as they say you are."

He laughed. "I'm worse, brother. I'm a bad, awful, terrible, cruel, black man who won't do what the white man wants me to do. That's why they're calling me all those names. I—I—, aw I don't want to talk about it now. Save my anger for Cooper. Get paid for my anger." He jumped up, motioning to me. "Come on, let's go see a good flick somewhere."

Sam Cooke wailed out his latest hit, "Shake," over the car radio as we drove along. Ali, pushing the big Cadillac at high speed and rocking to Sam's beat, looked happy at last. An announcer's voice cut in. "Cassius Clay is back in town training for his . . ." Ali twisted the dial, butting him off in mid-sentence.

"Cassius Clay! Cassius Clay! I'm on everybody's lips but they won't call me by my right name!" He smacked his fists together. "Pressure and strain. Pressure and strain. When you're controversial and successful like me everybody and his brother tries to burn you."

"Why set yourself up for it? You've got what you want now. Why not cool it?"

Either he ignored my suggestion or he didn't hear it. Squinting his eyes he scanned the bright lights. "What's all those signs say?"

"There's *Cast a Giant Shadow,* and there's Paul Newman in *Harper.*"

"Naw, naw, something rough—with no love or sex stuff. What's that up there? Yeh, that's it, *Goliath and the Vampires.* That's for me."

"This show's half over," I said as we went in.

"Come on. The last half's always the best anyhow." It was the most horrible horror show I had ever seen, but Ali loved every second of it.

There were days when, consumed with bitterness and feeling no one understood his misery, Ali seldom smiled. There was only the terrible glare he stalked his sparring partners with every morning. On some afternoons he would go driving or walking, seaching for what he needed most—greetings from black people. And, from their windows, doorways, and schoolyards, they gave them.

"Hi, Champ."

"Hi, baby. What's shakin'?"

"Ali! Who's the greatest?"

"Are you blind, man?"

"How many rounds for Cooper?"

"If he gets rough—one's enough."

"You're the greatest, baby—the greatest!"

He smiled. That last quip supplied enough juice to sustain him for another day. "My people love me," he said as we headed for another location, another world bigger than life and filled with smiles, admiration, flattery, and sycophantic chatter.

"Dance, baby, dance," Angelo Dundee, his trainer, purred from the center of the ring. Ali, floating, ducking, pounding his partners with a staccato of fast combinations, was training as he had never trained before. To show that he was fit, that he could take punishment, he let his mates spin and bull him about as Cooper might do. On the rubdown table he searched for more praise. "Could I have whipped Joe Louis and Jack Johnson in their time?"

"Baby, you could have whipped everybody in anybody's time," Angelo shot back. And that's the way it went day after day, night after night. Even at breakfast praise was as important as corn-

flakes; he needed it to drown out those cruel voices. But he was determined to refuse them his death. Those worshipful children in those schoolyards needed him to lead them; he was their Pied Piper in a Cadillac. At recess he would holler, "Come to Ali, all you beautiful black children!" And they would come running like he was handing out thousand dollar bills. On Saturdays and Sundays he herded them into his bungalow and showed them motion pictures of him "Whomping the bear (Liston) and the rabbit (Patterson)." The machine started whirring. "Watch close now 'cause the bear's goin' down so quick you won't see him drop. Now that's over and here comes the rabbit. He's the white folks' black hope. Listen to 'em cheer, 'ya ya ya ya ya.' Now look, here I come. Booooooo! Booooo! Booooo! I'm the awful villain who won't do what they want me to do, to go fight those poor people who's mad at them—not me. Watch! Rat-a-tat! Bop! Wham! There he goes down again and again! His breath smelled like saddle soap when I got through beatin' on him."

He intended it to sound funny, but there was too much sadness in his voice. Later that night he told me what I already knew. "I like Floyd Patterson—but he shouldn'ta gone around saying he was gonna bring the title 'back to America.' Shootin' his mouth off like that just got a lot of leather in it." His eyelids dropped for a few seconds. "Yeh, I like Floyd, but he oughta quit. He's made a pile of money." He rolled over then and went to sleep.

I looked down at him for a moment before turning out the lights and leaving his room. He looked as harmless as a baby now, with his muscled arms curled over his head, silence replacing his anger, and his frustration dreaming into a few hours of peace. When morning came, after mumbling prayers to Allah with his hands lifted and his body facing East, he would climb into the ring and beat the tar out of his sparring mates. Then he might be laughing, chattering, dancing, throwing punches around my head, and reeling about in high spirits. Or he might be meditative, morose, and quiet all day. It was hard to predict his moods.

One afternoon he went to see a young white hemophiliac and, before leaving the hospital, stood in the burning sun signing autographs for dozens of white patients. On leaving he concluded that there were a "few good white folks around." Then the sense of lone-

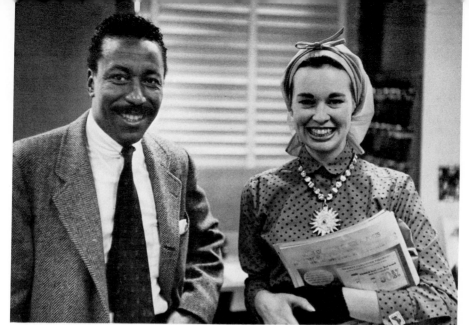

Author
and Gloria Vanderbilt.
New York, 1954.
Photo: Alfred Eisenstaedt.

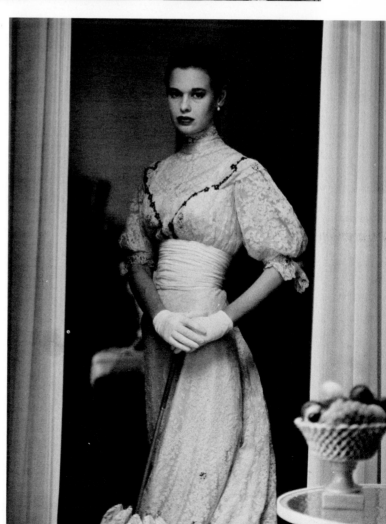

Author's portrait of
Gloria Vanderbilt, 1960.
Photo: Gordon Parks.

Duke Ellington, 1960. Photo: Gordon Parks—*Life*.

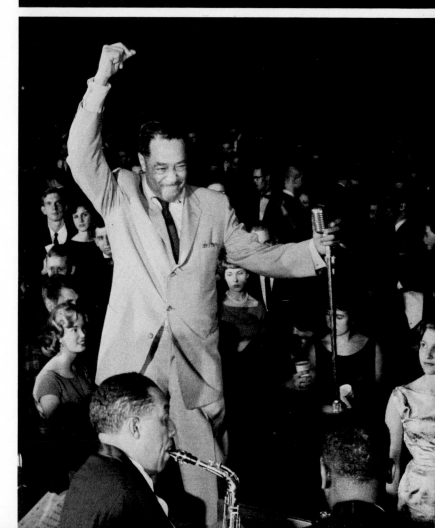

Author in New York.
Photo: Adelaide de Menil.

Author in Peru.
Photo: Josephine Ahern Zill.

Elizabeth Campbell Parks. Photo: Warner Brothers 7-Arts.

Elizabeth and Gordon enroute to their wedding. White Plains, New York.
Photo: Cecil Layne.

Elizabeth and Gordon talking to her parents in Switzerland immediately after their marriage ceremony. Photo: Cecil Layne.

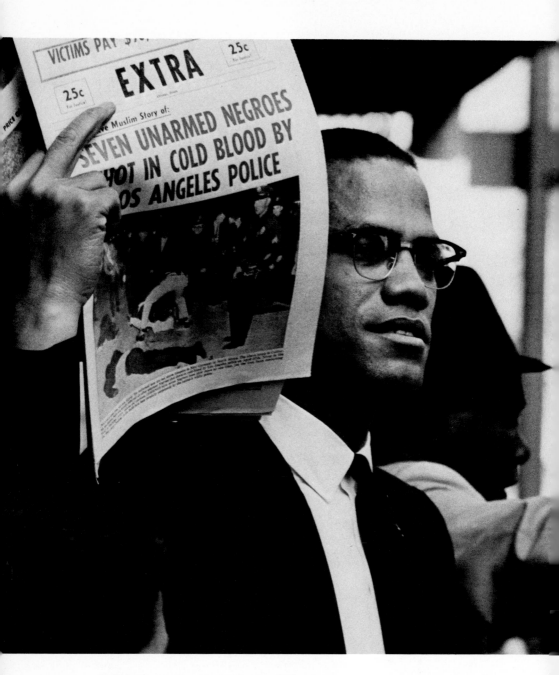

Malcolm X. Los Angeles, California, 1963.
Photo: Gordon Parks.

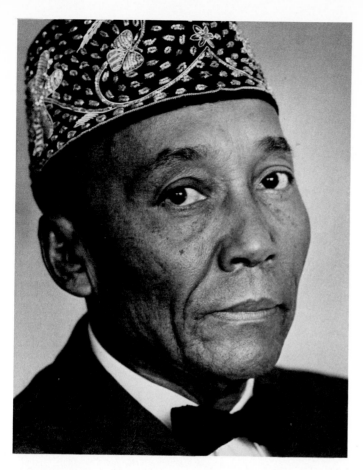

*Elijah Muhammad, leader
of the Muslim sect.
Phoenix, Arizona, 1963.*
Photo: Gordon Parks—*Life*.

*Harlem crowd listening to
Malcolm X. New York, 1963.*
Photo: Gordon Parks—*Life*.

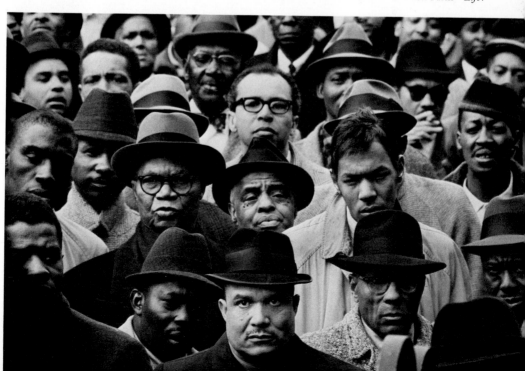

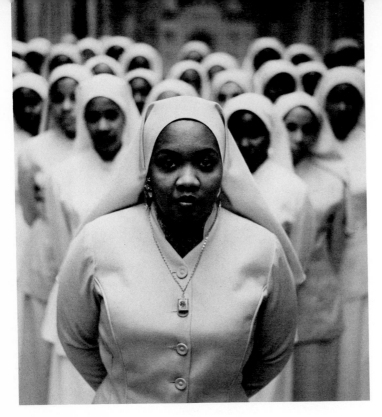

Ethel Shariff,
Elijah Muhammad's
daughter.
Chicago, 1963.
Photo: Gordon Parks—*Life*.

Muslim men. New York, 1963. Photo: Gordon Parks—*Life*.

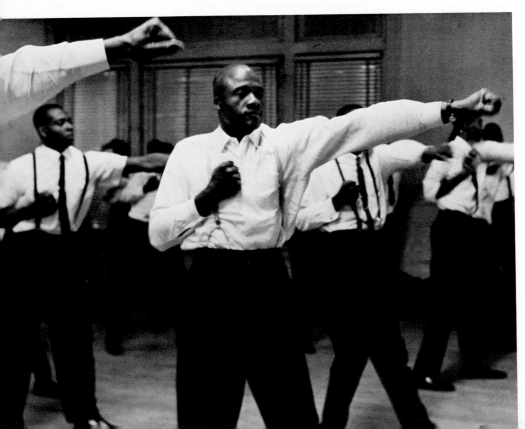

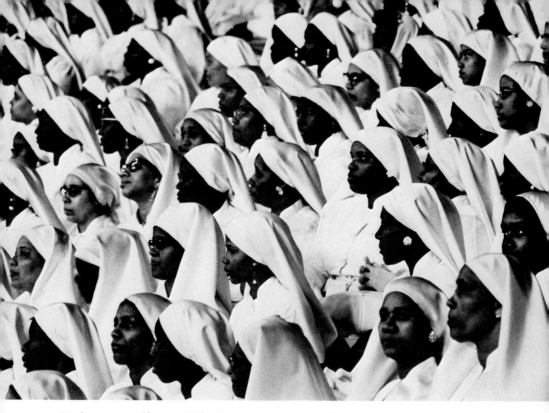

Muslim women. Chicago, 1963. Photo: Gordon Parks—*Life*.

A white newsman is frisked by Muslim.
Chicago, 1963. Photo: Gordon Parks—*Life*.

Brother Joseph X.

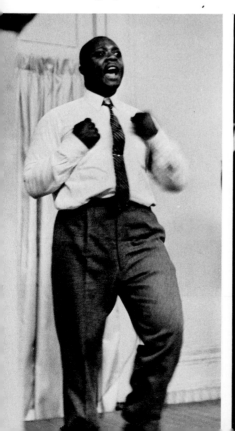

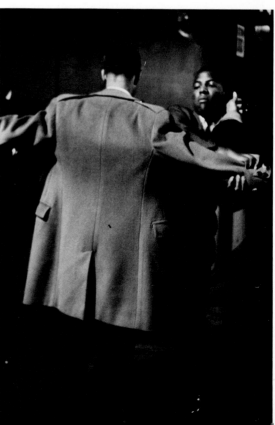

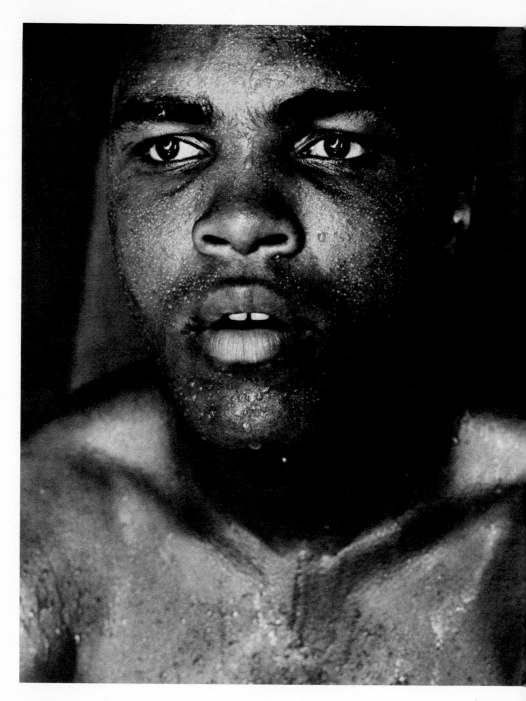

Muhammad Ali. Photo: Gordon Parks—*Life*.

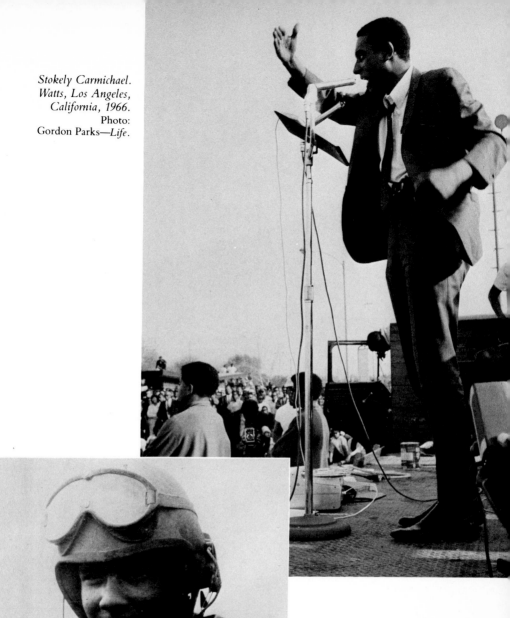

Stokely Carmichael.
Watts, Los Angeles,
California, 1966.
Photo:
Gordon Parks—*Life*.

David Parks.
Vietnam, 1967.
Photo: U. S. Army.

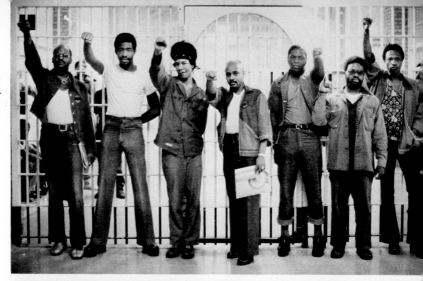

Activist inmates.
Photo: Gordon Parks.

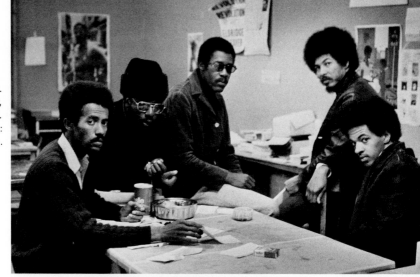

*Black Panthers.
Berkeley,
California, 1970.*
Photo:
Gordon Parks—*Life*.

Police raid. Chicago.
Photo:
Gordon Parks—*Life*.

*Bobby Seale and
Charles Garry,
his lawyer,
at San Francisco
prison, 1970.*
Photo:
Gordon Parks—*Life*.

Eldridge Cleaver and his wife, Kathleen, in exile. Algiers, 1970.
Photo: Gordon Parks—*Life*.

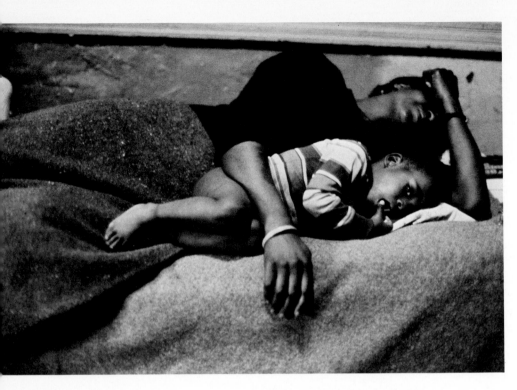

Bessie Fontenelle and son, Richard. New York, 1968. Photo: Gordon Parks—*Life*.

Norman Fontenelle and son, Norman, Jr. at hospital. New York, 1968. Photo: Gordon Parks—*Life*.

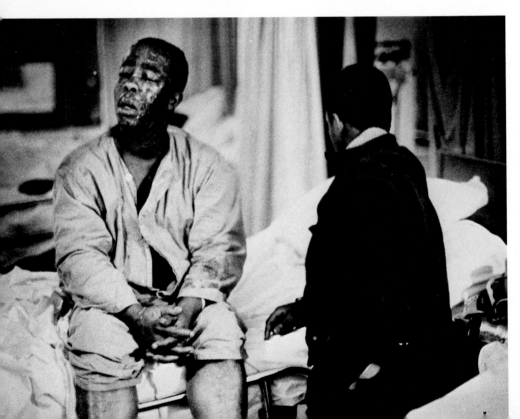

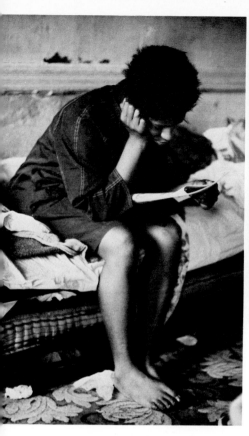

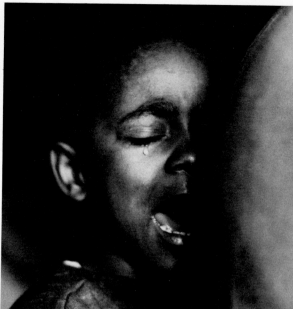

above:
Ellen Fontenelle. New York, 1968.
Photo: Gordon Parks—*Life*.

left:
Roseanna Fontenelle. New York, 1968.
Photo: Gordon Parks—*Life*.

below:
Bessie Fontenelle and children at welfare office. New York, 1968.
Photo: Gordon Parks—*Life*.

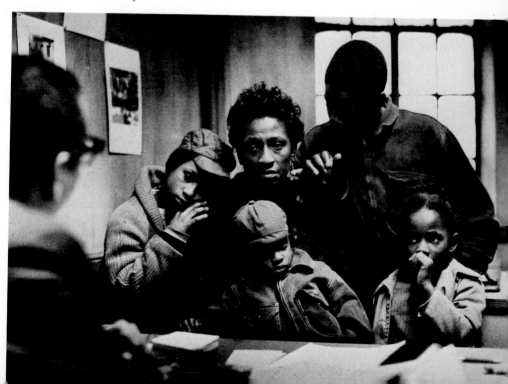

above:
*Author's daughter,
Leslie, with
Claude Picasso* left
and Author right.
*White Plains, New York
1978.*
Photos: Gordon Parks
and Claude Picasso.

*Leslie Parks.
Zurich, Switzerland, 1971.*
Photo: Dolf Schnebli.

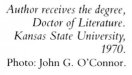

*Author receives the degree,
Doctor of Literature.
Kansas State University,
1970.*
Photo: John G. O'Connor.

liness reappeared. He volunteered that people didn't ask him to speak anymore; that Martin Luther King had been the only black leader who had sent him a telegram when he became champion. He had expected too much, he admitted. "I guess they don't like my telling it the way it is."

I tried to console him. "You're young yet. They'll come around."

"I aim to go on doing just like I'm doing and saying it the way I've been saying it. I don't owe nobody nothing except Elijah Muhammad, and I owe him my life."

That night we went to the local Muslim mosque, and Lucius Bey, the Miami Muslim minister, preached the doctrine of Elijah Muhammad for two solid hours; the next morning it was still burning inside Ali. Angelo, his sparring mates, and the white press who had come to watch him work out all got their lumps. I was leaving for New York the next day; it was now or never, so I stuck my neck out. "It's not only the whites. A lot of Negroes don't like the way you act, the way you go around preaching hate."

This cut him much deeper than I had expected. "Hate! Hate! Hate!" he cried. "I ain't spending my time hatin' white folks all day. They ain't worth it! I've got more important things to do, like teaching black kids the words of Elijah Muhammad, and getting myself ready to destroy Cooper! I don't hate tigers and lions either—but I know they'll bite. What's the white man worrying about my hatin' him for anyhow? Everything white that he's got is going good for him—White Swan Soap, White Owl Cigars, Snow White and her little white dwarfs—what's he worryin' about?"

"What about your draft situation?"

"Elijah Muhammad teaches us to fight only when we are attacked. I'll say it again, ain't no Vietcongs attacking me! Furthermore I'm a praying man. I pray to Allah five times a day. What time does that give me to kill somebody? The army shamed me, my Momma, and Poppa for two years, saying I was a nut of some kind. Now they've decided I'm smart, real smart—without even testing me again. I ain't scared of no gun or nothing else. Ain't no soldier in his right mind who will get in the ring with me. All these white kids around hollering 'Hey L.B.J., how many kids did you kill today?' I ain't said nothing half that bad. I don't even know where Vietnam is,

and I ain't about to go looking for it. I'm tellin' you like it is. I ain't killin' nobody unless they try to come over here and kill me."

He had made his point. But he was the heavyweight champion of the world. Did that give him a special responsibility to think or act differently? A lot of people thought it did. I wasn't too sure. I remembered now that I was ready to back up my son if *he* had decided to resist going to Vietnam. I left Ali that night, not expecting to see him again. But the following morning he got up early to take me to the airport. At the gate he said, "Hey champ, I don't want to do anything to hurt my people. I've been doing a lot of thinking since last night. I hope you'll be in London."

I was still searching for the truth in him. "Okay," I said, "see you in London." Then I ran for my plane.

* * *

At home, were three thick envelopes from David. The following are a few entries from the diary he sent me:

July 20, 1966

I've been transferred out of the nuclear Jeep group. I'm in the infantry now. They tell us we will train harder than we did in artillery and work longer into the night. They are getting us ready for the big trip. There is a rumor that we will be in Saigon by December. I'm in Company D, 56th Infantry.

July 26, 1966

Several more funerals this past week for Vietnam casualties who trained here. We're up at four and get into bed around one o'clock. They are working our tails off. I'm in a mortar unit and we stay in the field a lot. I thought my feet were tough but they are full of blisters. Oh to be home in that lovely swimming pool.

August 26, 1966

Three white guys in our unit are really bucking for rank. We call them the three stooges. They kiss the officers' asses all day. They're not the type I want to face death with. They'd break up in a tight spot. I can tell by their actions in the field when things get rough. I'm afraid of this entire unit. I don't like being a foot soldier. I'd rather ride to my death. This division is going to Vietnam, every-

one says. We're not ready. We got lost right here in Fort Riley, so
what the hell are we going to do in Nam? I don't think any of us
realize that we are about to go into battle, that the make-believe is
about done with. Sometimes I wonder how we will really take it.

September 15, 1966

All kinds of crazy operations now. We've been out in the field for
several days digging foxholes, fighting bugs, flies, and mosquitoes.
During the day the plains are burning hot. At night you freeze to
death. I'm a radio-telephone operator now. The guns can't fire
unless the forward observer (FO) sends a message. So you wait. If
the FO runs into trouble he calls for help from the guns in the rear.

September 25, 1966

Rained for hours last night. Cold sleeping after our tent got wet.
Had to get up and look for two guys who got lost. While we were
out we came across two guys crawling in the mud as punishment
for leaving their foxholes during the rain. They looked inhuman.

After reading those letters, I tried to remember David as a child
beyond this talk of foxholes, guns, and death—and trying was like
gathering in a fistful of fog. This once chubby and cheerful boy was
now a man preparing to kill or be killed—getting himself ready,
perhaps, for both. So clear in his words was the terrible uncertainty
of whatever awaited him at the other end. Oh, to have the luxury of
making a deal with fate; to somehow pay for the luck that would
bring him safely home; to be able to look through the transparency
of time and get all the worrying over with. I recall having such
thoughts, and of praying on as we tried to get used to his absence.

* * *

A few days before the big fight the *London Daily Telegraph* re-
ported: "Cassius Clay presented himself to an admiring British pub-
lic yesterday as Muhammad Ali, a heavyweight champion of cour-
tesy and charm." Ali read the article and smiled. "Wait 'til the folks
back home get a load of this," he beamed. He had taken the extra bed
in my room to get away from the miniskirts, mods, rockers, the tele-
phone, and the press, who were chasing him into exhaustion. So he
did care about what people back in the States were thinking?

"It's home. I still have to think about home." He reflected for several moments and then said, "When I was little I always wanted to help those poor black people who didn't have nothing. I felt sorry for them getting beat up and lynched and cheated out of everything. Those poor black people down there—maybe I can help them now by making them all proud of me. I'm the champion now—the black champion—and I want people to be proud of me."

He was slowly unwinding. "Momma always wanted me to be a lawyer. Guess I'd a been a good one since I talk so much. But I didn't get enough schooling for being a legal man or nothing like that. But I've got enough good common sense to get to where I'm at. Bought Mom and Pop a nice house and two cars down in Kentucky. I think they're proud of me."

"Everyone wants to be proud of you, Ali," I said, "the blacks, the Africans, the Americans—everyone. The English are sure giving you a good show. Just give people a chance."

He admitted the British were treating him very well ("better than they do back home") and he wondered why. Had they been in any big wars?

"Several," I said, realizing he wasn't born when Great Britain reeled under the awful Luftwaffe bombings of World War II.

Two nights later, sparkling with confidence and charm, Ali faced a battery of microphones and reporters. Then, reading notes he had scribbled in red ink, he thanked everybody, from a restaurant chef to the Prime Minister, for their kindness and understanding: "When I was campaigning for the championship, I said things and did things not becoming of a champion. But I'm champion now, and today I'm measuring my deeds. I'm measuring my thoughts. By the help of the Honorable Elijah Muhammad, this is the new Muhammad Ali."

He coughed and got to the heart of the matter. "And at last I want to mention something that is nearest to me—the country in which I was born. I thank the president of the United States and the officials of the government. And I thank my draft board for letting me come here to defend the title. Regardless of the right or wrong back there, that is where I was born. That is where I'm going to return."

I had read the speech two days before, but now—as he sat down amid the applause—I shivered with emotion, wondering just how

long this new resolve would last. It was left to those back home to extend their patience.

*　*　*

Another package of letters arrived soon afterwards from David.

On Board the Patch. December 18, 1966

We are on our way now. A lot of the guys have never been on the high seas before and we are swimming in vomit. A lot of it is the motion. A lot of it is nervousness. I haven't missed a meal . . . so far.

December 20, 1966

The sea is beautiful today even though it's very rough. The big waves come pounding down against the Patch, break, then drift slowly out to nowhere. A lot of the guys are depressed and home-sick. My buddy Cha Cha keeps telling me he's not coming back. He said today, "I'm scared. I've never been so goddamned scared in my whole life." I didn't say anything for a minute or so, then I told him that I was scared too—and I wasn't just being sympathetic.

Christmas, 1966

It's quiet as hell today; Santa didn't come down the smokestack last night. We're getting very close to Nam. Every now and then we see a ship or an island on the horizon. Some of the guys are already getting horny for the Vienamese women—me too.

December 31, 1966

It's about one o'clock and all you can hear is snoring and the creak-ing of the Patch. This just ain't a happy New Year for any of us.

January 1, 1967

At dawn, Vietnam came in sight on the starboard side, and you could hear a pin drop on deck. We just stood there and nobody said anything. It was fear and we all knew it.

*　*　*

One of the joys of being David's father had been to watch him grow into a fine young man. Almost from the day he was born his mother and I had suffered through the little sorrows and defeats with

him, and smothered him with admiration for his accomplishments. Then, with half our hopes for him fulfilled and things going well, war had stuck its ugly hand through the door and snatched him away. Now, from the Patch, he had looked out to where death had taken over—the land of war—where other frightened young men awaited dawn in the terrifying silence. He admitted his fear and I admired him for it. He knew that the casulaty list was growing and that the piper was hungry for more pay. All we could do was wait, to hope that this batch of letters would not be his last. There were twelve more months of waiting; and every day would seem like a year. Time becomes motionless when the life of someone you love hangs precariously inside it.

21

Love, War, and Confusion

*M*ore and more I was smitten by Gene, moved by the sight of her. We met for lunch one day and as she came down the avenue it seemed that she was all alone. "Hurry—please hurry," I kept repeating to myself. Then, no longer able to wait, I started walking toward her. In a few seconds we were rushing to one another, our hearts beating faster with every step. It was a glorious feeling, a flowered time, with certain longings yet to be fulfilled. She was the one I longed to see and touch; her voice was the voice I wanted most to hear. By now our love had grown into something warm and beautiful. Yet, for obvious reasons, we had serious problems. There were two good people to be considered whom neither of us wished to hurt. But, one soft summer's evening, we came to know that we were destined to spend our futures together. There would be a price to pay—a weighty price, mingled with hurt and despair. But surely we would pay it.

* * *

Three months passed before word came from David again. But until then no news had been good news. Now he was in the thick of it, as a few of his entries showed:

January 31, 1967

This being an FO (Forward Observer) is hairy business. The odds are against you. Sgt. Paulson hand-picks Negroes and Puerto Ricans for this job. After my experience with him you begin feeling that you should have been born white to escape all the shit he gives us. Somehow I thought things would be different over here, but whitey, with a few exceptions, is the same throughout this whole damn organization. All the soul brothers are beginning to gripe.

February 19, 1967

Snipers have knocked off a lot of our guys lately. A lot of the deaths result from stupidity. And a couple of times I've been stupid. Charlie hit a village near us about two this morning. We went in blasting away but Charlie was waiting for us. We were thirty-tracks strong and rounds were flying everywhere, making one hell of a racket. Civilians were screaming and falling on their children trying to protect them from the gunfire. God, it was a bad scene. White, our gunner, got it. I pulled him out of the way and blasted away at a tree holding two snipers. There was no more firing from their position. I must have got them, and it left me feeling sort of funny.

February 24, 1967

An ARVN [Army of the Republic of Vietnam] sergeant gunned down an old man who was standing by a tree today. The guy wasn't doing anything. But when the ARVN asked him a few questions and he began walking away, that was it. The carbine is a terrible weapon. In the next few seconds the guy's guts were in the mud and both of his legs were torn off. It was so awful I couldn't react. A few moments later we were eating C rations. The ARVN's are crazy.

March 7, 1967

We ambushed Charlie today and got several of them. Sgt. Young kicked a VC's body to be sure he was dead. He had to be; bullet holes were in him from head to toe. Young asked for my knife. He cut off the VC's finger and took his gold ring. I told him to keep the knife, and walked away. I'll be glad when this bloody mess is over. Everyday you go out looking for somebody to kill—and you're disappointed if you don't find them.

A letter to David somewhere in Vietnam (April, 1967):

Dear David,

I never thought that this war would hang around until you became a part of it. Sometimes I find myself wishing that you and Gordon would have been born at another time. But there has rarely been a time when men were not fighting one another.

As you know, we are having our troubles back here. The racial strife, especially in Alabama and Mississippi, is bad. But the televised performances of certain Southern lawmen are starting to fill the consciences of whites all over the land.

I mention this because it is something hopeful that might help you to tolerate one evil while we, back here, fight another one.

As for the prejudice you are finding there, understand that war does not always bring out the best in people. You surely know by now, that a bigot ambushed in a foxhole won't be a bit concerned about the color of the soldier who comes to save him. Danger tends to pull people together; after it has passed expect business as usual. There are bits of venom in some of your entries. You don't have time for it, and it doesn't fit you well. Do what you have to do and come home as quickly as possible.

Elizabeth is expecting, so you will have either a new brother or a sister when you return—maybe both. When Elizabeth does something she does it big. We are both astonished at the quiet of this place with you gone, although Elizabeth is not exactly the noiseless wonder. We miss you. Harper follows me around growling for those bones you used to save for him. Your ski boots yawn from boredom, and your empty bed looks like a fallen tree stripped of its bark.

That's about all. Try somehow to make peace with this miserable war you must fight. We love you and wish we could slice time off your absence.

> as ever,
> Dad

I had written about Elizabeth's pregnancy with an easy casualness. Yet on the morning she informed me of her condition, I had recoiled in astonishment. Then, suddenly realizing that shock covered my face, I tried to feign happiness. But it was too late; tears were already filling her eyes. "I want it so badly," she said, "so badly."

"But I thought we agreed we would never have a child."

"I want to have it."

"All right. All right, why not, darling," I said, shaking as my other world began falling away.

Gene reacted to the news exactly as I had expected. She clenched her teeth, burned a look of despair through me, and stalked off without a word. I stood alone for several minutes feeling foolish and sad. Only a few days before a future of happiness had been foremost in our hearts. Now, a fortnight later, with her refusing to see or speak to me, that happiness seemed forever lost. Her silence continued for nearly two months and I decided it was all over, then she called. Perhaps, despite what seemed to be an insurmountable problem, we could work things out. I agreed.

But for a while our love would have to be held together with letters, cablegrams, and overseas telephone calls. *Life* magazine had arranged an assignment for me that most photographers only dream of. I was issued an open ticket for a trip around the globe to photograph some of the finest restaurants and food markets in the world. Starting in Japan I was to work my way through the Far East, Africa, most of Europe, and finally wind up in Paris. There, after some delicate planning, I would meet Gene.

During my stay in Cairo a soothsayer had, for the sum of five dollars, informed me that all my talents would merge into fruition during 1968. Normally I don't put much stock in the mysterious mumblings of soothsayers. I did in fact forget most of the other things she told me, but I admit anticipating 1968 with extreme interest. Secretly I began preparing for it.

22

Stokely Carmichael,
"No more running!"

When I arrived back in the States from my round-the-world trip I was immediately sent to do a story on Stokely Carmichael. One scorchingly hot night in 1967 he and I found ourselves in an old ramshackle building just outside Watts, surrounded by a tough-looking bunch of black militants. They had gathered to discuss protection for Stokely hadn't asked for protection, but he was getting it whether he liked it or not. "We don't want another Malcolm X deal down here in Watts," was the only explanation given. Ron Karenga, of a group called US, was running things and not too well. Growls of dissent came from all corners of the dingy room.

"You brothers seem to be uptight about something," Karenga said.

"You jokers are talking bullshit and trying to take over." A great big fellow with a knife-slash across his cheek had spoken his piece.

Karenga nodded his head and a young tough sitting beside him got to his feet quickly. "Bastard," he snarled. "Call one of us a joker

again and I'll knock your goddamned teeth down your throat!" The big guy just stared hard at him. Then the door opened and the "Sons of Watts" began slowly filing in. They were veterans of the 1965 riots and looked it. About twenty of them, all with their pockets bulging, lined up against the wall.

Karenga cleared his throat. "We're talking security, brothers. Got any questions?"

The leader of the Sons spoke. "We ain't here for questions. Carmichael's in our territory. If any shit goes down, we don't aim to be out in left field directing traffic somewhere."

"Brother, there's such a thing as protocol and. . . ."

"Protocol my ass. We didn't come here for questions. We come here to tell you what we're gonna do—and we ain't gonna take shit off nobody." There was a lot of silence now, and a lot of staring between the different factions. Stokely spoke up very softly, but persuasively: "Brothers, let's not argue among ourselves. The leaders should get together—outside this room—and decide how each group will participate." As Stokely and I left, the leaders were filing out together.

Stokely, a man filled with humor, started beating the dashboard and laughing hysterically as we drove toward our hotel. "Now those are the brothers these crackers had better start worrying about. Lord! When those tough-looking dudes strolled in, I started up some prayers. Lordy, lordy, those was some bad brothers."

More than four thousand black people and a few whites jammed into the park the next afternoon. Stokely's protectors had fanned out around the speaker's platform, feet planted apart, arms folded, eyes cutting into the crowd. Signs of protest jabbed the hot air. The stern image of Malcolm X, stenciled on yellow sweatshirts, wriggled over the bosoms of several girls as they leaped about screaming like cheerleaders.

"All right! All right! Cool it!" a voice boomed over the loudspeaker. "All white newsmen and black newsmen with one-day contracts from the white press, and all TV men, move to the back of the crowd! Move quickly! We don't want to have to move you!" The orders were promptly obeyed. One big black man, for some reason I failed to understand, pushed his luck, bawling out, "You goddamned incendiaries! You punks! You . . ." Before he could say

anymore, four toughs grabbed him, flipped him upside down, dragged him off the field and threw him into a ditch.

Stokely started off by making a modest pitch for money. When the money came in faster than the small buckets could hold it, Cliff Vaughs, a SNCC worker, grabbed an old leather satchel off the platform just above my head. When he opened it his jaw dropped and he quickly snapped it shut. The satchel was full of guns. Stokely's speech, which I had heard several times in the past two weeks during my travels with him, was a fiery cry for Black Power and a vitriolic condemnation of the Vietnam war. "McNamara is trying to thin us out. Calls it 'black urban removal.' Well, I've got news for Mister Mac. Ain't no Vietcong ever called me nigger, and if I'm going to do any fighting, it's going to be right here at home! We will not fight in Vietnam and run in Georgia!" The crowd roared approval. Stokely—afire now, his finger knifing the air—went on. "The white man pulls out his hair when he hears the words Black Power. Think of it! Black Power has got to be good if the white man's against it. He screams that I'm going around preaching violence. I'm not advocating violence. I'm just telling whitey that he's kicked my behind and beat my head enough and I won't take any more. I'm telling him that White Power has been making the laws and that White Power, in the form of white cops with guns and night sticks, enforces those laws. If that's preaching violence, I'm going to my grave preaching!"

"Tell 'em like it is, Stokely! Preach on!"

"The white man says, 'Work hard, nigger, and you'll overcome.' Well, if that were true, the black man would be the richest man in the world. The white press out there equates Black Power with racism and separatism. We have no choice! The white man separated us a long, long time ago—and he intends to keep it that way! He doesn't have to worry about it as far as I'm concerned. Separation from him will forever and ever make me happy!"

"Preach on! Preach on!"

And Stokely preached on for another hour. In the end he shot his fist into the air and shouted, "Our fathers, our grandfathers, and great grandfathers had to run, run, run! My generation has run out of breath! We ain't running no more! Black Power! Black Power!"

"Black Power!" the crowd roared back.

On the way to his car, young black boys and girls surrounded

him; waved to him. He waved back, smiling. "Those same kids will be calling me Uncle Tom in a few years," he said with a touch of sadness in his voice. "People think I'm militant. Wait until those kids get some years on them. They'll make me look like a dove of peace."

Stokely had been "born smart" in Trinidad in 1941. He attended Bronx High School of Science and graduated, with honors, from Howard University. An early admirer of Martin Luther King and nonviolence, he had finally turned on the white society, his patience exhausted. Now at twenty-five, as leader of the Student Nonviolent Coordinating Committee (SNCC), he was lionized, damned, and discussed more than any black leader in the civil rights movement. An outgrowth of a militant mood rather than a creator of it, he had been propelled to the center of the Black Revolution by racism. The more conservative blacks were distrubed by him.

Cool, outwardly imperturbable, he gave me the impression that he would strut through Mississippi in broad daylight using the Confederate flag for a sweat rag. And, as I said before, he didn't lack a sense of humor. Once, when we had become hopelessly stuck in a snowdrift, he gunned the motor but the car wheels just spun in their tracks. The more he gunned, the deeper in we got. Suddenly, with the motor cut off and sitting there in defeat, the incongruity of the moment struck him. He raised his arms and, shaking both fists violently, shouted "Black Power! Black Power!" The situation became even more incongruous when a white farmer had to pull us from the drift with his team of white horses.

It was this great sense of humor, I feel, that saved him from absolute despair. Once, describing an experience that shouldn't have been funny, he had me cramped with laughter. It seems that he and some Freedom Riders had been thrown into prison near Parchman, Mississippi. "We're singing one night," he said, "and in comes this beloved cracker. 'Y'all niggers stop that damned noise or I'm gonna fix y'all.' We kept right on. Then he hollers, 'Take the black bastards' blankets! Freeze their asses off!" They grab Hank Thomas's first but he holds on like a leech. They finally give up trying to shake him off, and I started laughing. The cracker points at me. 'You goddmaned nigger—I'm gonna throw away the key on you. You ain't never gonna get outa here!' They clamped wrist-breakers on Freddie Leonard, hurting him so bad he twisted around on the floor

like a snake. The cracker said, 'You tryin' to hit me nigger?' 'Oh no!' says Freddie, 'I'm just politely waiting until you break my arm.' When we started singing, 'I'm gonna tell God how you treat me,' the cracker just stood there shaking his head and mopping his brow. 'Y'all is one bunch of crazy niggers,' he kept saying. He finally left, cursing to himself, and we sang all night long."

During serious moments he described things that had driven him close to a nervous breakdown; the beating of John Lewis, his predecessor, for instance, which had taken place during a march back in 1964. "I'll never forget those billy clubs cracking against John's head. Bam! Smack! Bam! 'You black son-of-a-bitch!' And he goes down time and again moaning, 'I love you. I love you.' And poor John, the true believer in nonviolence, sinks half conscious to the pavement."

When Stokely saw a pregnant black woman knocked head over heels by the jet from a fire hose in Birmingham, the horses trampling people and so many lying on the pavement with bleeding legs and ankles, "things blurred, and I started screaming and I didn't stop until they got me to the airport. That day I knew I could never be hit again—without hitting back."

Martin Luther King was the one outstanding exception—among the more moderate black leaders—who refused to denounce Stokely. And Stokely had great respect for Dr. King, who—at most—called Black Power a "confusing" phrase and joined with Stokely in linking the Vietnam protest to the civil rights issue. Presently Stokely had explained to me, "Black Power doesn't mean antiwhite, violence, separatism, or any other racist thing the white press makes it out to be. It's saying, 'Look buddy, we're not laying a vote on you unless you lay so many schools, hospitals, playgrounds, and jobs on us.' " Was he confusing the civil rights issue with the issues for peace in Vietnam?

"The people who support the war there are the same ones who keep their foot on the black man's neck in this country. Bigotry and death in Vietnam is no different from bigotry and death in Mississippi. The crackers will probably get me before the summer's over. But I'm not worried: there are too many others who believe as I do. I'm expendable. I'd rather die fighting in Alabama tomorrow than live twenty years fighting in Saigon. Racism, not love, got me in-

volved in this movement. Americans won't admit to their racism
and hate. But maybe we shouldn't be ashamed of hate. Like love, it's
a human emotion even if it has a dangerous energy."

Weary, angry, confused, and aware that his role was steadily
growing beyond his youthful experience, he said one night, "I don't
know where I'm headed. I'd like to go away and think things over
for awhile. Perhaps I've gone as far as I can go at this point. I finished
your book, *A Choice of Weapons,* this morning. Hell, I don't know.
Maybe that's the way." I felt he was groping for my advice, but
when I offered none he said, "Whatever happens, we've stirred the
consciousness of black people. We've got the black community on
the path to complete liberation. I suppose it's pride, more than color,
that binds me to my race. Blackness is necessary, but the concern has
to go further than that to reach anyone who needs it. Mississippi
taught me that one's life isn't too much to give to help rid a nation of
fascists. Camus says, 'In a revolutionary period it is always the best
who die. The law of sacrifice leaves the last word to the cowards and
the timorous, since the others have lost it by giving the best of them-
selves.' I dig Camus."

$\mathscr{28}$

"Why are Negroes looting and burning . . . ?"

\mathcal{A} *long* letter from David, one that bothered us:

I'm in the hospital and my buddy Greenfield is on his way back to the States in a coffin. We were on Operation Hammer, a search-and-destroy deal. Greenfield was sitting to my left just behind the driver of our track. Suddenly two shots whined over our heads. I called a sniper-fire report to the platoon leader, but choppers were ahead, so they had to hold mortar fire. We let go with our 50 and 60-cals. I heard a cease-fire order over the earphones, and the guns stopped. Then the snipers opened up again. There was a cracking sound to my left. I whirled around. Blood was gushing through Greenfield's helmet. Then his head disappeared beneath the top of the track. I jumped down beside him but Lt. Wyeth was already reaching for a bandage to try to stop the bleeding. Greenfield started choking on his blood and Wyeth stuck his fingers between his teeth so that the blood could run out. We kept telling Greenfield to hold on, that he was going to make it. His head was moving. Our guns were blasting the wood line again. I called in a chopper to carry Greenfield out. Wyeth tried to open a morphine can with a

key and it broke off. He cut himself bad trying to pull the top off with his bare hands. Now his blood was spurting all over the place. "Shit! Shit! Shit!" he kept hollering. I felt Greenfield's pulse and felt sick. He was dead. We started firing again. Then Wyeth ordered us to dismount, pursue, and to keep firing and moving. As we hit the water, we flushed out about fifteen Charlies at the edge of the wood. We shot them up like fish in a barrel—and I got my three kills. Poor Greenfield. He was a simple, nice guy who wanted to be a carpenter and marry a girl he was in love with.

On the way back to base our track hit a mine. Things blurred out for me when I heard the explosion, then I blacked out. When I came to, I found myself here bandaged up like a mummy. I caught shrapnel in my forehead and just above my left eye. It all happened so fast, I didn't have a chance to get scared. I'm thankful to be alive. They convoyed me down here to Sierra for treatment yesterday, and Charlie lobbed some mortars into here last night. I'm beginning to wonder if he's after me personally. Well, I've got something I could have done without—the Purple Heart.

* * *

I shuddered, thankful too that he was alive. But this from my son who once told me he would never be able to kill anybody? Yet, I realized, it was kill or be killed. Thinking back to Stokely, I wondered which boy was giving himself to a better cause. There was no immediate answer. But in the face of death, which was so possible for both of them, I couldn't help think that Stokely would be more certain of why he was about to die. "Remember," he had told me on a plane one night, "we fought three hundred years of American Negro history in a year and a half—organizing, bleeding, starving, and educating at the same time. We gave a nation hope."

That hope grew precariously thin during the violent summer of 1967. In mid-July the storm began to gather in Newark, New Jersey, where in less than a week that riot-torn city would account for over twenty-four deaths of blacks from the guns of National Guardsmen and state police. Then, just a few weeks later, big trouble started in Detroit, Michigan, when white police raided a black afterhours club called the "Blind Pig" and arrested seventy-three black customers and a bartender. As one of the squad cars pulled away with prisoners, a bottle shattered its window. Then stones, cans, and bottles rained on the other police cars. Crowds gathered quickly, then started on a

rampage through Detroit's west side and spilled rapidly across town to the east side—and the fire that was to happen next time was burning now, and burning out of control. The heat of it would plunge the nation into the greatest racial crisis since Reconstruction, and would throw the civil rights movement into chaotic disarray. The spirit that once had unified its leaders during triumphant marches against bigotry and segregation was withering. Poverty and despair in the black ghettos, instead of diminishing, had grown steadily. The arguments for political coalition—set forth by Bayard Rustin, the NAACP's Roy Wilkins, and the Urban League's Whitney Young— were crumbling. CORE's Floyd McKissick was bankrupt of ideas and money; SNCC and Stokely Carmichael's "Black Power" cry was growing faint in the wilderness of smoke, flames, and crackling gunfire, and Martin Luther King was pushing his way into the movement for peace in Vietnam. As bewildered and confused as the frightened whites, they could only watch and wait as Detroit burned into one of the bloodiest uprisings in U.S. history. Beneath the acrid smoke drifting over the city came the rattlings of police guns—now and then a bark of a sniper's rifle. And from this corridor of flame, sparks of anger leaped to places as far distant as Miami, New York, and Phoenix. It seemed the entire nation might explode into paroxysms of fire-bombings, lootings, and killings by nervous and trigger-happy police. By week's end large sections of the country's fifth largest city, lying charred and smouldering, looked as if they had suffered a bombing from aircraft squadrons. In that city alone there were over forty people dead, three hundred forty-seven injured and three thousand eight hundred jailed. The homeless numbered five thousand and the damage estimates had soared to over five hundred million dollars.

At a private luncheon with two of *Life*'s top editors I was asked, "Why are Negroes looting and burning like this, and what can *Life* do about it?" I felt I knew the answer. Certainly by now I was in a good position to know from my own personal experience. I had suffered the squalor and despair of the black ghetto, and I had celebrated the luxury and good life of the white world. I knew, in other words, how people lived on both ends of town. It was Friday. I would take the weekend to think things over and give them my answer on the following Monday.

I didn't go home to Westchester that weekend. I went instead to Harlem and spent two days walking the streets filled with garbage, watching black people standing in hot doorways, hanging from tenement windows for a breath of fetid air. I revisited the old building I used to live in, and was told that the rats still gnawed the walls all night. Had things changed? Yes—but for the worse.

There were a few new apartment buildings, but they stood like lonely sentinels against the backdrop of despair. Other areas seemed to have been bombed out. Young men and women roamed the desolate blocks—slowly going nowhere. Others hung out on corners with trash swirling about their feet—hungry, jobless, and sullen with defeat. A bearded young junkie lounged in a doorway, knife drawn, the blade glinting in the sun, lounging there nodding, his thoughts obviously filled with another kind of world. And around him was the stench of urine on hot stone. Harlem, a prison of crumbling squares, seemed to be sinking into itself. Its inhabitants were a long way from the premise of the American dream.

I was no longer trapped there because I had been determined to get out, and because somebody concerned had helped me out. If Harlem, and other big city ghettos like it, was going to get the help it needed, white Americans would have to reach across the gulf of fear and anger. And we blacks, who were able, would somehow have to help create a climate that would encourage them to do it.

Roy Stryker, a white man, probably altered the course of my life more than any other person. He assumed a huge problem when he took me on the Farm Security staff in Washington, D.C. The laboratory that processed my work was peopled with white Southerners who resented my presence and color. Years later I asked him why he had accepted me, knowing what each of us was up against.

"It was a tough decision to make," he admitted. "But the easy problems are usually easy to solve. It's the hard ones that test the metal in us."

"Poverty and racism," I gave as my answer that following Monday to *Life*'s editors, and I suggested that I spend a couple of months with a typical poverty-stricken family to show how they coped with life from sunup to sundown.

They agreed and it was decided that I go to Harlem and find a family that fitted our needs for such a story. I set only one condi-

tion—I would wait until the cold hawk of winter was over the ghetto again. It was not a startling conclusion I had arrived at. I was only reaffirming what I knew all along—that we Americans, black and white, who have made it, must face up to the human misery of people in the black ghetto. Otherwise the summers would get hotter and longer with even more burning and rioting.

24

Leslie Campbell Parks is born

*E*lizabeth's beauty glowed even more as she swelled with the presence of our child, and I kept closer to her these days. The excitement brought on by the eventual birth was matched only by the confusion building in my affair with Gene—who became more irritable as the delivery day approached. Aside from my fatal attraction to Gene, I couldn't figure out what had gone wrong between Elizabeth and myself. She was beautiful, amiable, had a great sense of humor, and was a pleasure to be with—and I feel the same about her now as I felt then. Yet there was something stronger pulling me beyond the control I needed to straighten things out.

To know that Elizabeth was trying hard in her own way served to increase my confusion. Peace, and it was a strange peace, came only when I thought about the child.

CHILD COMING

You are child-seed swelling now,
Stirring in the mother warmth,
Between some frantic sunup
 or panicky moondown,

183

You will bolt the womb to
A nippled, milk-full world.
Your length will be measured,
 not by infant inches,
But by seasons—
 when spring is in your tears
When summer is in your cheeks
 when autumn is in your voice
When winter is in your walk.
Your weight will be taken,
 not in common pounds,
But in heartbreak points of coming time
 when the moon is black
And stars melt in flames of brother-terror.
 But
You are only child-seed swelling now.
 Strength
Awaits you in the expectant breast.

Gene had absented herself from me as much as possible. She did send one letter, however; it was cold and impersonal. She even refused to address me by name. Terse and to the point, the letter offered advice about the *Life* piece I was about to do on the Harlem family.

You will take an ordinary black family and put their innermost thoughts and emotions into words. You will probably have to find the words, because they will not have them. Like the majority of human beings, they will not be accustomed to articulating their complex thoughts and emotions.

More than that you will have to find a way of communicating all this to a middle-class white audience. There are few, if any, points of contact between the inhabitants of a ghetto and the white community. The ghetto is truly a foreign country to your readers, and its people more incomprehensible than a foreigner. You must bridge this gap; and you are uniquely equipped to do so by your color, background, and sensibility.

The camera can show, with unparalleled vividness, the facts, the present, the tangible. But only words can convey the web of thought and emotion, the influence of the past and the fears and hopes for the future—all the things that go into the way an individual faces his world. At the end of the text piece, having seen the

photographs, I would, as a reader, like to have felt that I had been in the minds of your family, and have seen the world through their eyes.

Remember, as always, to show, not to tell, to dramatize, not lecture. No one, black or white, can presume to speak for the Negro in the collective sense. All you can do is to show through a piling up of telling detail, incidents, and snatches of talk, what the existence of a single Negro ghetto family is like. From them the reader will make his own extension, will generalize it to cover, in some way, all the inhabitants of all Northern black ghettos. You must trust him to do that. And if you portray the individuals of this family vividly enough, if you can engage the reader's emotions, you can be sure that he will.

The note was unsigned. When I called to thank her for it she replied very cooly, "It isn't necessary. I am still your editor."

The letter we had been waiting so long for came one autumn morning. It was from David and dated September 9, 1967:

Dear Liz and Dad,

I am at Bravo packing to come home. I fly out of here tonight, and it is hard to believe I will be seeing you again. So many of them won't make it back. Now that I'm out, all the mud, blood, and death out there seems unreal. It's even hard to realize that I've taken other men's lives. I'm not proud of it, but out there it's either him or you, and you always want it to be him. The strange thing about all this is I never really got to hate Charlie, simply because I never saw him until he was dead. It was what he did to Greenfield, Gurney, Harris, and the others, that I hated.

All my buddies are out on the wood line patrolling, so I won't see them before I take off. I'm glad I'm not out there with them tonight.

The camera you gave me is still in good shape, and I hope you'll like my pictures. The film is safely packed in my duffle bag. Well, buy a big turkey and lots of sweet potatoes. I'll bring the wine. I can't wait to put my tired feet under the dining-room table and eat some of Liz's great cooking.

> Love to all of you,
> David

* * *

Four days later David called from the San Francisco airport—and we were glad to hear his voice once again. "Well, how do you feel?" I asked.

"Oh fine, fine—just a little pissed off. The white guy who sold me my ticket gave me some Stateside crap, wanted to know if I missed eating chitterlings and pig's feet while I was away. I looked at him and said, 'Of course not, boy. Your mammy kept me well supplied in those care packages she sent me every week.' " I laughed and urged him to go catch his plane.

* * *

On November 24, 1967, Elizabeth gave birth to Leslie Campbell Parks, a gorgeous, fat, roly-poly baby with soft brown skin and big, inquisitive black eyes. With her cooing in her crib and my youngest son back from the war, it seemed I had every reason to be happy.

25

Diary of a Harlem family

In October I went in search of the Harlem family. There were plenty to choose from; the antipoverty board that served the area confronted me with a formidable list. The problem was consent; one after the other refused because they were ashamed of their plight. One woman, however, seemed to understand what I was attempting to do as well as the eventual good such a report might mean for other blacks. Her name was Bessie Fontenelle, a strong and personable woman who had a deep love for her family. After talking things over with her husband and wrestling with her own conscience, she agreed to be the subject of a *Life* story. The difficulties wouldn't cease there, however; the children would first have to accept me; to know that I was not an outsider who had come merely to exploit their despair. It was a matter of laying back, without even a camera or a notebook; of becoming someone who would honestly share and understand their condition.

I decided to keep a diary and make notes at home every night. Their problems made mine seem trifling. Their beatup icebox was all but bare; my frigidaire was crammed with food. Their youngest

child was surly, sore-ridden, and hungry; my youngest child was well-fed and gurgling with happiness. My son was back from Vietnam and enjoying life again; their oldest son was in prison on a dope cure.

From the diary:

November 3, 1968

Norman Fontenelle is a quiet, short, powerfully built man, but defeat is hanging off him. He has just been laid off from his part-time job as a railway section hand. He's broke and there's no food in the house and none of his children have winter clothing. They live four-flights up in an old brick tenement on Eighth Avenue. There's Norman, 38, and his wife, Bessie, 39; Phillip, 15; Roseanna, 14; Norman, Jr., 13; Riel, 12; Lette, 9; Kenneth, 8; Ellen, 5; and Richard, 3. And a bad-tempered dog named Toe-boy and a cat, who are there mainly to keep the rats and roaches in check. Until last night they had goldfish, but this morning when I got there the three fish were floating on the surface—dead from the cold. The heat had gone off during the night. Little Richard pointed them out to me. "Fishes dead, fishes dead," he kept mumbling.

Bessie Fontenelle looks even younger than thirty-nine during the first part of the day. As the day wears on, she ages with it. By nightfall she is crumpled into herself. "All this needing and wanting is about to drive me crazy," she said today. "Norman's a good enough man, but when he's out of work he takes it out on me and the kids. Gets his bottle and starts nipping. By the time he nips to the bottom, he's mad with the whole world. Him and Norman, Jr., don't get along one bit. That boy keeps telling him he'll kill him if he keeps beating up on me. I wouldn't be surprised if some day he didn't up and do it."

The house is a prison of filth, cluttered with rags and broken furniture. Bessie has given up trying to keep it clean although she tries. Her efforts show in the soiled, shapeless curtains; the dimestore paintings; the shredded scatter rugs that cover the cracked linoleum; the wax flowers and outdated magazines. It still remains a losing battle.

November 6, 1968

I've been with the family for three days now but I haven't taken out the small camera I keep in my pocket. I talk a lot with the little kids

before they go to bed, then I sit around with the older ones, trying to find out how I can help them solve their problems. None of them seem very interested in school. They don't see any need for it. Norman, Jr., has the most trouble. The teachers have sent him home to stay several times this year. His problems are deep ones. I bring in a little food now and then. Not much—if I do I've started something I can't finish. Furthermore, my purpose is to show their misery. It's hard, knowing I could fill their icebox so easily.

Not once have I seen them all sit down and eat together. When one of the small kids cries from hunger Bessie scrounges up something—scraps of meat or anything left over from the day before. Norman, Jr., loves seven-cent sweet potato pies he begs out of the grocer now and then. Little Richard was eating a raw potato today. I have seen four of them share one apple.

November 10, 1968

Hunger more than anything else stirs the kids into little violent acts. Day by day it gets worse. I'm constantly breaking up a scrap. I've been shooting pictures for several days now. The kids were curious about the camera on the first day. Each one had his turn holding it. Little Richard dropped it but my foot broke the impact.

Lette came to me crying this afternoon. Norman, Jr., had given her a hard thump on the head. I sent her off to buy a sweet potato pie. Norman's punishment was to sit and watch her eat it. Little Richard, his swollen lips cracked and bleeding, also had a hysterical crying spell. He's been eating plaster off the wall, poisoning himself little by little. Bessie spread ointment on the child's lips and then, weary and distraught, lay down moaning and wiping tears from her own eyes. Kenneth, a sensitive child, sat down beside her and put his arms around her. "You all right, Momma?" he asked. "You all right?"

November 13, 1968

Norman, Jr., stripped off a long piece of masking tape today and began covering a hole over his bed. I asked if he thought that was going to keep out the rat he had been trying to kill. "Naw," he said. "They eat right through the stuff. This is to keep out the wind tonight."

Going home each night is getting harder and harder for me. Their world in comparison is so futile, so despairing. It is a world of

gloom, hunger, and a thousand little violences each day of their lives. Today they were all shut in by a heavy, wet snowfall. But it seemed as cold inside as it did outside. The boys lay on their sheetless bunks, fully clothed and under blankets, fighting the cold and trying to do their homework. Roseanna read a comic book. Lette couldn't study; her glasses were broken. Welfare had promised her a new pair two weeks earlier, but the glasses haven't come yet. She gets dizzy spells if she tries to read without them. Bessie insists on homework. "Seems the most important thing is to try and get them some kind of education. I'm hoping that just one of them will make it someday. Just one of them. I'll be thankful."

The way the kids keep their books stacked so neatly in the rubble is amazing. During the rare quiet moments, the older ones help the others with their lessons. At times the house seems to be filled with love.

November 17, 1968

The severe cold, the rats, roaches, and hunger sent Bessie and four of her kids to the poverty office today. I caught up with her there, pleading with Bob Haggins for help. "The landlord looks at the broken windows and the holes in the walls and makes promises and nothing happens. Nothing happens but promises." "You have to keep faith," was all Haggins could tell her. He promised to try and get Norman some kind of job, something that would pay him two dollars an hour.

November 20, 1968

Roseanna wouldn't talk to me today when I arrived. She sat crying with her head buried in her hands, barefoot, with a black raincoat buttoned against the cold. I walked past her and into the kitchen. "Want to know what's wrong with Rosie?" Kenneth whispered. "Momma whipped her for being out all night last night." I asked Rosie about it later. "Us kids don't have no place to go. We were at a girlfriend's house, dancing and having fun. But it got so late we were afraid to go home. So we just hung out there till morning."

Later three of her friends came by—two boys and a girl. They sat in the darkness of Rosie's room on a bundle of rags and the unmade bed, their coats on, hardly speaking to one another, sharing a cigarette. It was as though they had come to escape the weather and share each other's misery.

I sat with Bessie in the front room. There is a picture of Christ on the wall; it hangs over the baby's crib. I asked her if they were a religious family. She was about to answer when Ellen screamed. Toe-boy had bitten her. Bessie sent the dog scurrying with a well-aimed kick. "Well, I guess we are—at least we used to be. We just don't go to church anymore. Nothing to wear. Nothing to put in the collection plate. You feel ashamed. But I have to be truthful. It's hard keeping faith when things are going so bad for you. I teach the kids their prayers, and that's about as good as I can do."

November 21, 1968

Today as I was leaving I ran into Norman, Jr., peering through the window of a fish and chips joint. "Want some chips?" he asked hopefully. I told him I'd love some. So we went in and filled our stomachs with greasy fish and chips. He is a strange mixture. He talks defiantly of the white policeman, the white butcher, or the white grocer clerk. His eyes have the hard glint of the older men in Harlem. At thirteen he is already primed for action. He is aggressive, determined, and powerfully built for his age. But his hostility is balanced by an overwhelming tenderness at times. He will suddenly lift little Richard off the floor and smother him with kisses. At times he stands beside his mother affectionately fingering her earrings. "You're pretty, Momma, real pretty," he'll say without smiling.

November 23, 1968

Today snowflakes were swirling down through an open skylight and piling up in the hallway by their door; and it was extremely cold. Bessie seems to have sunk into her deepest despair. "I can clean this place every hour and it still stays dirty. There's no place to put anything. If we just had some drawers of some kind, anything to put things in. I stay tired all the time. The hospital says it's my nerves. They want to open my throat and operate for some reason or another. Oh, I feel like jumping out that window."

November 24, 1968

Harry, the oldest boy, is in the Pilgrim State Hospital at Brentwood, about twenty-five miles from New York. The fare on the train is $4.50, too much for anyone in the family to go and see him, so today I drove Bessie and Norman, Sr., up there for a visit.

Their meeting was awkward. The narcotic ward where we met him was empty with the exception of a guard who stood nearby.

"How's the kids?" Harry asked.

"They're all fine and send their love," Bessie answered.

"They treating you all right?" asked Norman.

"Everything's okay. I should be out in another seven months."

"You're fat."

"Think so? They got heat in the house for you this year?"

"Oh yes," Bessie cut in. "Everything's just going fine at home." There was a pause. "I hope you come out good and clean, Harry. You've had enough trouble already."

"Oh, I'll be straight, Mom. Don't worry."

"I hope to God you never touch that stuff again."

His answer stunned all three of us. "Well, I don't know—I can't say for sure I'll never go back on it. Cocaine ain't so bad, Mom." Bessie moaned. Harry, sensing that he had hurt her, choked out a sob and covered his face.

"Time's up," the guard said rather gruffly. Bessie kissed her son and watched the guard take him back to his cell. "I'm almost sorry I come," she said as we got into the car.

November 26, 1968

There was no heat at all in the place today—none whatsoever. Bessie had turned the oven on and the stench of it covered the entire apartment. All of them had slept huddled together on a mattress in the kitchen the night before. Bessie and the children were still there when I arrived. They were sharing a warmed-over catfish for breakfast. Norman, Sr., was lying on a cot shivering in the front room. "How's it going?" I asked.

"Bad."

"Any hope for going back to work?"

"I was out for shape-up every day this week." He rubbed his head. "Nothing doing—nothing doing. You know a lot of guys would have pulled out and left their family by now. But I can't leave. All I want to be is a man—just a man, if they'd let me."

December 1, 1968

I ran into Norman, Jr., standing on a street corner tonight, warming over a garbage-can fire. The smell of snow was in the air. The boy wore tennis shoes with holes in them and a light windbreaker,

the heaviest coat he owned. I asked him what he was doing out so late in the cold.

"Poppa put me out."

"What for?"

"For nothing. He's mad about not having work, I guess."

"Do you want to go home with me?"

"Naw, thanks. Momma will get me in some way. I'll be all right."

I went upstairs. Bessie was stirring a large cauldron of water on the stove. The other kids were already in bed shivering under their army blankets. Norman, Sr., was asleep in a corner, smelling strongly of whiskey. I sat around for about an hour. Bessie went with me to the door. "Things are rough around here tonight," she said softly. "One of his friends gave him a bottle."

January 2, 1969

Bessie was lying on the cot groaning in misery when I got there this afternoon. Little Richard lay beneath her arm; her neck was bruised and swollen. She managed a half smile. "He gave me a good going over last night. My ribs feel like they're broken." She started crying. "I just can't take it anymore. It's too much for anybody to bear."

"Where's Norman, Sr.?" I asked.

"In the hospital."

"Hospital?"

"Yes. I sent him there. When he got through kicking me I got up and waited until he was asleep and then I poured that scalding water all over him—and it stuck because I put sugar and honey into it before I poured it onto him."

Norman, Jr., and I went over to the hospital. It was almost impossible for him to recognize his father. The honey and sugar still coated what skin was left on his face. His hands were horribly burned when they went up to shield his face. He sat on the side of the bed and daubed at his eyes. "I don't know why your mother did it, boy," he said. "I just don't know why." I took his picture and we left.

After their story was published in *Life,* the Fontenelles were able to move to a comfortable little house on Long Island with the help of the magazine and contributions from its readers. There was new fur-

niture, a front porch, grass, and fresh air, and a good school nearby. Harry left prison, swearing off dope forever, and Norman was promised a better job. An entirely new world had raced in and swept the Fontenelles away from the filth and chaos of that Harlem tenement. The entire family was happy; and I was happy for them.

Then, at three o'clock one morning several months later, fire destroyed the house, young Kenneth, and Norman, Sr. In less than one hour, horror had replaced their happiness.

Just a few Christmas Eves later, what remained of the family was somewhere back in Harlem, all except Harry, Norman, Jr., and another brother who were all in prison on dope charges. All the girls, even the youngest, were on the streets. Bessie hadn't seen them for months. Only little Richard was with her now. Even Toe-boy and the cat died in the fire. There wasn't much I could say to Bessie Fontenelle when I left her that night. She stood, I remember, at the top of the stairs waving goodbye. Finally she said what I could not bring myself to say: "Merry Christmas."

"And a happy New Year," I managed to call back.

I've often felt I shouldn't have touched that family. But I had gone looking for an answer—and they had given it wholly, and with the loss of two lives.

26

"I don't want a long funeral."
—*MARTIN LUTHER KING*

I loved loved the sound of Martin Luther King's voice, its eloquent, oratorical cadences. At the climax of the 1965 Montgomery march he had cried out, "How long will it take before my people achieve full equality?" Then, answering his own question, he shouted: "It will not take long because truth pressed to the earth will rise again. How long? Not long, because no lie can live forever. How long? Not long, because you still reap what you sow. How long? Not long, because the arm of the moral universe is long, but it bends toward peace."

I was just pulling into actor Marlon Brando's yard in the Hollywood hills when the news came over my car radio. "Martin Luther King, Jr., has just been fatally wounded in Memphis, Tennessee!" I stopped the car abruptly as if the announcer's voice had demanded it. "My God, my God," I said, over and over to myself. It was a bottomless moment. That voice I had loved so much had been stilled—forever. It was a terrible moment, without sound, without motion, without reason.

Brando was asleep on the couch when I walked in. I shook him awake and gave him the tragic news. "King is dead?" he asked, not yet comprehending.

"Yes."

"Martin Luther King—they shot him?"

"Yes. They shot him."

Marlon sat silent for several minutes, his eyes riveted on the window overlooking the city far below. Then he called in his secretary and, with remarkable calm, ordered her to call his gunsmith. He wanted to put in an order for ammunition and several rifles and pistols. Then he went into his bedroom and put a call through to the Black Panther office in Berkeley, California.

When he reentered the living room he went to the large window and stood for a long moment, gazing down at the city far below. And in a voice and manner he had used many times in scores of motion pictures, he said, "Well, my friend, this is it—we kill and kill and kill." Only this time he wasn't acting. Out of respect for the anger boiling inside him I waited for several minutes, then I asked, "But who do you kill, Marlon?"

"Who do you kill? People—that's who you kill."

We sat in absolute silence for a long while, listening to the radio crackling with all the details of the assassination. When I left him he was shaking with fury and as yet had not rescinded the order for the guns.

As I entered my hotel room the phone rang. It was my friend Philip Kunhardt, then an assistant managing editor at *Life,* calling from New York. There was sadness in his voice. "Well," he said, "I'm sure you have heard the news."

"Yes," I answered.

"This looks like one for you—if you want it."

"I want it."

"It's terrible, just terrible." He paused for a moment and then said in a quavering voice, "Get to Atlanta as quickly as you can. Loudon Wainwright will fly there to help in any way he can. And Gordon, all of us here are sorry, terribly sorry." We hung up and in a few minutes I was in a taxi and on my way.

* * *

The scratchy, taped voice of the man we sorrowed for echoed off the church walls and penetrated our hearts: ". . . and if you're around when I have to meet my day, I don't want a long funeral. And if you get somebody to deliver the eulogy, tell him not to talk too long." The quiet was heavy as the voice went on. "But I'd like somebody to mention that day, that Martin Luther King, Jr., tried to love somebody. And I want you to be able to say that day that I did try to feed the hungry. I want you to say that I tried to love and serve humanity."

Standing in the crush along the wall, I shut my eyes, remembering back, back past the sorrowing King children and their bereaved mother, through the odor of camphor and the swishing fans, back to the black funerals of my childhood. And here again was the stench of carnation sweetening the Southern closeness, the white-robed choir singing hymns so familiar to our down-home Sabbath. This time the coffin held one who had filled us with a sense of hope that seemed, at this despairing moment, shattered. As he lay dead in little Ebnezer Baptist Church in Atlanta, he made us know that we were still in the land of oppression and assassins.

Later, thousands upon thousands of us flowed like a river of solid blackness behind the brown mules and the old farm wagon that carried Martin Luther King to his grave. And as we mourned, the spring air of dozens of American cities was again darkening to the smoke of arsons—the black ghetto's answer to a white racist's deed. King had protested the way American whites preferred that he protest—nonviolently. But white racists had warned they would kill him, and they had kept their word.

On the plane back to New York I wrote things I knew would be a challenge for *Life* to print. This, indeed, was the ultimate test for the magazine, and for me. If, in this sad but historic instance, I failed to put down what I honestly felt, all that I had learned, trained, and lived for would have been to no avail. Truth looked hard at me and I was determined not to defile it with any fine excuses. These words were reality to me then, and remain so today:

He [Dr. King] spent the last dozen years of his life preaching love
to men of all colors. And for all this, a man, white like you, blasted
a bullet through his neck. And in doing so the madman has just

about eliminated the last symbol of peace between us. We must struggle to distinguish between his act and your conscience.

It is not enough anymore when you ask that all whites not be blamed for what one did. You must know how we really feel— before grass takes root over Dr. King's grave. We are angry. All of us. True, the burning and looting won't help, but how else could you expect the black ghetto dweller to express his frustration? Could he have called the cop who has given him the back of his hand—and often the end of his club—through all these years? Should he have called the mayor or the White House?

Dr. King's killer will remain a symbol of the white attitude toward blacks. We have grown to doubt the hopeful songs of our fathers. We wonder if we shall overcome our doubts about your promises. We have grown to lack the patience to wait for God's deliverance. We want a new life. Our youth refuse to sit and wait to share in the affluence that you surround them with. They will cross your line even if it means death. "A man must conquer the fear of death," Dr. King said, "otherwise he is lost already."

His only armor was truth and love. Now that he lies dead from a lower law, we begin to wonder if love is enough. Racism still engulfs us. The fires still smoulder and the extremists, black and white, are buying the guns. Everywhere—Army troops stand ready. Our President is warned against going to Atlanta. America is indeed in a state of shock. The white man, stricken, must stay firm in his conscience, and the black man must see that he does. If the death of this great man does not unite us, we are committing ourselves to suicide. If his lessons are not absorbed by the whites, by Congress, by my black brothers, by any who would use violence to dishonor his memory, that "dream" he had could vanish into a nightmare. You and I can fulfill his dream by observing his higher law of nonviolence to the echo of his drumbeat.

This was not the entire article, of course, but it was the part I was most concerned about, and that *Life*'s editors were concerned about. Philip Kundhardt, Loudon Wainwright, and I wrestled with our consciences, with the depth of our responsibility to the magazine and to its readers. At four o'clock in the morning we put the story on the wire to Chicago, had a stiff drink, and went home.

No doubt speeded by the murder of Martin Luther King, and perhaps by the burnings that followed it, the U.S. House of Repre-

sentatives passed a civil rights bill that made it a crime to refuse to sell a home to a man just because he was a black man. Martin would have liked to have realized that. It was part of his dream. Just a small part. Had he lived only two months more he would have been shocked, but not surprised, to hear that Robert F. Kennedy had been assassinated.

27

Gun Power
The Black Panthers

\mathcal{T}he black man's marching and sitting-in had sealed his dignity into law, but the cost was high. President Kennedy and Robert Kennedy, two men who had lent them hope, were dead. Medgar Evers, Malcolm X, and now Martin Luther King were dead, and Stokely Carmichael's great promise had been blighted. The surviving black leaders, their optimism waning, were just hanging on. The black masses were still hungry, and still angry. The cycle of their anger—along with the white backlash—had raced beyond control. The Muslims, caught up in the confusion of Malcolm's death, had quieted down. But the Black Panthers were replacing the cry for Black Power with something harder to deal with: gun power. And this would further stir the ragged tempers of the whites and the police. When *Life*'s editors asked me to cover the Panthers, I accepted.

The authorities' aims toward the Panthers were clear. Denver's police chief declared on national television that "they must be dissolved and banished." The FBI's J. Edgar Hoover wrote in a report: "Of all the violence-prone black extremist groups, the Black Panther

party is without question the greatest threat to the internal security of this country." In turn the Black Panthers accused the police of practicing genocide on black people. The police, through their actions in the ghettos, gave credence to that claim. The Panthers spoke gun-rhetoric to the police, and the police were taking that rhetoric at face value. By now, after twenty-eight Panther and four police deaths, both camps were gripped in a paranoiac state of fear—a fear that was spreading into panic and hysteria.

The trouble between the two factions started back in 1966 when a policeman had tried to stop Huey Newton, Bobby Seale, and several others as they emerged from the Panther headquarters carrying pistols and shotguns. As Huey, the Panther's leader, argued about their constitutional rights to carry weapons, more police arrived and a crowd of blacks gathered. The police tried to disperse them but Huey unlocked the Panther offices and let them in so they could watch from the windows.

One of the policemen asked Huey what he intended to do with the gun. Huey, in turn, asked him what he intended to do with his gun. "Because if you try to shoot me or take my gun," he said, "I'm going to unload this M-1 on all of you." The police backed down. The message went out; and that same morning a dozen young blacks, admiring Huey's boldness, joined the Panther party.

But when I entered their Berkeley headquarters in January the party was in deep trouble. Huey Newton was in a state prison near San Luis Obispo after being convicted of killing John Frey, an Oakland policeman. Bobby Seale, a cofounder of the party, was in a San Francisco jail fighting extradition to New Haven, Connecticut, where they wanted to prosecute him for the murder of Black Panther Alex Rackley. Twenty-one other members were in New York jails for alleged bombing plots, each under bonds of one hundred thousand dollars. Furthermore, the police had stepped up their raids on the Panther headquarters and homes.

It was dusk, and I sat in the upstairs kitchen of the headquarters where the Panthers lived a semicommunal existence. David Hilliard, the party's chief of staff, was serving rabbit stew to the men, women, and children congregated there for the evening. A mixed state of anger and fear prevailed—and for good reason, I thought, while reading from a piece of paper that Hilliard had handed me. The

contents sent shivers up my spine and I began wondering what I was doing there.

> The weapons to be employed: rifles, shotguns, 33mm gas guns, 37mm grenade launchers, and Thompson submachine guns. The assault plans: assign two man squad to front with shotgun (solid slugs) and armor-piercing rifle to blast armor plate off upper windows. . . . Upper windowshields to be shot out, and use oo buckshot to shoot out all lower windows. Use rifle slugs to try and knock open main front door . . . front and back guard lay down fire on the second floor. . . . Assault squad (three men) armed with submachine guns approach building from the south. . . . Squad enter building through front broken windows or doors. . . . Two men enter and move left to right center of ground floor. Fire thirty rounds each up through the second-story floor, and reload. . . . The entire building should be flooded with tear gas. The entire upper floor should be covered with intense fire. . . . Assault squad will then proceed upstairs and bring down the wounded and the dead.

The target: the Black Panther party headquarters on Shattuck Street in Berkeley. The task force ("In the event of a disturbance at the party office"): the Berkeley police.

I asked Hilliard if he thought the plans were authentic. Before he could answer, Donald Cox—the party's chief of staff—handed me a newspaper clipping in which Berkeley police chief Bruce Baker admitted the plans were probably the work of his sergeants. But he denied having known anything about them.

"Those plans are incredible," I said.

"The pig is incredible," Cox answered softly. "But if he comes tonight we're ready for him." I sincerely hoped he wouldn't come.

Cox wasn't just whistling Dixie. They were, in Eldridge Cleaver's words, "some bad mothers." They had first grabbed national attention when thirty of them—six women and twenty-four men—dressed in black leather jackets and black berets marched on the California State Capitol on May 2, 1967. Armed with .45s, 375 magnums, shotguns, and rifles, and draped in bandoliers, they walked up the steps of the Capitol building, and Bobby Seale read a statement by Newton protesting a bill then under debate making the carrying of firearms illegal. The bill was passed, but the Panthers

were on their way. Against a background of summer riots all over the country, many whites found the Panther image a frightening and intimidating one. On the other hand, to a multitude of black boys in the ghettos who suffered the white cop's billy club, the Panthers were "some beautiful, bad-ass brothers."

While some ate, others washed clothes and cleaned the rooms and hallways. Telephones rang continuously. Teenage girls kept several typewriters going at a fast clip; stencil machines cranked out propaganda sheets for distribution. The quiet chatter of the machines gave a businesslike atmosphere to the otherwise dreary floor. Above the workers on the walls were huge posters of Panther leaders and Panther martyrs, and of third-world leaders Mao Tse-Tung, Che Guevara, and Ho Chi Minh. A large portrait graced another wall. Overlooking it all was a poster of Huey Newton, sitting defiantly in a thronelike wicker chair—rifle in one hand, a spear in the other. A "Free Huey" poster still hung over the doorway—a throwback to those angry days when Newton was on trial in the Alameda County Courthouse, fighting a murder verdict and the gas chamber.

After the gun law was passed in California, the Panthers had shed their weapons and bandoliers, and street dress replaced the leather jacket uniform. They had, in effect, "cooled it."

But the calm didn't last. It couldn't last. Unprovoked raids on Panther headquarters continued in San Diego, Sacramento, and Berkeley. The Panthers were shot at and the Panthers shot back. Some days with Cox driving, and four or five others crammed into a Panther car, we tailed police cars, watching for any police brutality toward other blacks, whom they would then advise about legal action against their attackers. Some Panthers were wounded; some were killed. The mayor of Sacramento rebuked the police for their "wanton destruction" of food supplies the Panthers had assembled for their Children's Breakfast Program. "Not only did they destroy food but they pissed and crapped on the debris to be sure it could not be used again," charged Ed Cray of the American Civil Liberties Union.

In Chicago a team of fourteen State's Attorneys' cops shot up a Panther apartment, killing Fred Hampton and Mark Clark. Hampton, apparently asleep when the attacks came, never got out of his blood-drenched bed. Sergeant Daniel Growth, who led the raid, told

the coroner's jury that they had been fired upon when they entered the apartment. But the Panther's story, gleaned from interviews with the survivors of the fray and supported by an intensive ballistics investigation, held that the police burst in without warning and blasted away. Clark was killed in the first volley.

Later, Sergeant Growth was questioned by a special deputy coroner during the inquest. "Did you consider the use of tear gas for the raid?" he was asked.

"No, sir, I didn't see any need for it. I was going to execute a search warrant," he answered.

"Why did you consider the raid dangerous enough to carry extra weapons?"

"The fact that they were alleged to be Panthers. . . . They were known to shoot a police officer, sir."

Why, the coroner persisted, had they not brought tear gas along to avoid the possibility of gun play?

"There was . . ." Growth said, haltingly, "no tear gas available."

On another dawn the police had mounted a "frontal mission" on the Los Angeles Panther's headquarters, hurling everything into the two-story brick building from high velocity bullets to shotgun blasts, tear-gas grenades, and satchel bombs. The Panthers returned the fire. How the building stood after the onslaught remains a miracle. All the windows were blasted out and great chunks of bricks ripped away. Only one sign was left intact. It read: FREE HUEY. FEED HUNGRY CHILDREN. The shootout lasted nearly five hours. When the last clouds of tear gas and smoke cleared, thirteen Panthers—including two women—had stumbled out of the bullet-ridden building. The two women and six men were wounded. Two policemen were also wounded.

A month of riding with the Panthers, of hanging out in their headquarters and homes, was more than enough; by then my nerves were raw. I often wondered how they worked with such calm. To spend each hour of their lives in such a threatened atmosphere seemed to be courting insanity. But after awhile it became clear they were just doing what they felt they had to. The police were their enemy. And anyone who wished the police would wipe them out was their enemy as well; that someone, they felt, served as a reser-

voir for police brutality. All men want freedom; there are no excep-
tions. But it puzzled me that the Panthers embraced Marxist, Lenin-
ist, and Maoist dogmas. In retrospect, perhaps this was because they
were seeking a kind of moral support. But to me it was like hoisting
a red flag over a black revolution; and black people didn't need any-
one else in the world to teach them about trouble.

On my last night, when everyone was eating, the phone rang.
Cox answered, listened, and summoned Hilliard. "The pigs are giv-
ing a brother trouble over in Frisco." Hilliard stepped to the phone
and mumbled some questions. After listening again he ordered the
brother to "sit tight," then nodded to Cox and a few others, who
began eating faster. Since they were preparing to move out, I ate
faster, too. When they got up to go I grabbed my camera and waved
a hasty goodbye to the children playing on the floor—the floor where
sixty rounds of solid slugs were meant to burst through. I hoped it
wouldn't happen. I followed Hilliard and the others down to the car.
He paused when he saw me. As the others piled in he pulled me off
to the side. "Drop you off at your hotel if you like. Some private
business in Frisco and we have to pick up three more brothers. No
room," he said firmly. I accepted the ride. At my hotel we said a
quick goodbye, I wished them luck, and they roared off. That was
the last I saw of any of them.

Making my way through the elegant lobby of the Mark Hop-
kins Hotel—the odor of rabbit stew still clinging to me—I looked
around at the sumptuous restaurants, salons, and boutiques that
sharply defined the gap between the Panther's world and the world
they had set out to change. And for a few uncomfortable moments I
felt out of place, disloyal, even traitorous. Then the elevator door
opened and swallowed me, and up I went toward a hive of carpeted
floors, soft beds, and snow-white sheets. A white family of four got
on at the mezzanine. The teenage girl wanted to take in the wa-
terfront the next day; her older brother preferred a golf course. "We
have plenty of time," said their mother. "We'll see it all." I smiled as
I thought of asking how they'd like to go to Shattuck Street for rab-
bit stew. The father smiled back, I bade them good night, and got off
at my floor.

28

"We want you in the Black Panthers."

Eldridge Cleaver had fallen under Huey Newton's spell soon after he got out of prison; eventually he became the Panther's minister of information. When this brought him harassment by the state authorities, he fought back with vitriolic prose. One night he and seventeen-year-old Bobby Hutton were ambushed by the police, and Cleaver was shot in the leg. After the two surrendered, Little Bobby, as the Panthers called him, was shot and killed. Cleaver, hustled off to jail with a bullet-shattered leg, claimed the cops told the boy to run to the patrol car, and when he did they mowed him down. Later, having jumped parole, he had gone into exile in Algiers. *Life,* wanting the whole story, was sending me to track him down.

After a good deal of trouble I found him with his wife and their five-month-old son, Maceo, living in one of those yellowish white concrete houses that line the Mediterranean coast. It was wet, windy, and unusually cold for Algiers. I had brought an armload of packages for them—baby clothes, powders, and oils that were impossible to get there, sweaters and jeans for his wife Kathleen, and a new portable typewriter for Eldridge.

From his greeting you would have thought I had just come from next door. "Hey, brother. How's it going?" He took the packages and pushed them into a corner. Kathleen, her blue-green eyes smoldering beneath a great copper-colored bushy Afro, looked me over and said, "Hi." Little Maceo was sprawled on the floor, crying and kicking. Eldridge picked him up. "He's angry, born angry like a real Panther." Three other people wandered out to say hello—Emory Douglas and his wife, Judy; and Connie Matthews, who represented the party in Scandinavia. For the time being they were all staying at the Cleaver's house.

Kathleen tore open the packages and observed their contents. "Well, that's something at least," she said. "Lots of these mothers come through here and don't bring a damn thing." Cleaver gave the typewriter a very long look. He slumped down into a big chair, stretched out his legs, and slung the infant across his shoulder, gently massaging his back. "Angry little Panther—angry little Panther." In the soft, rain-filtered light from the sea, he looked like any other father trying to burp his child. But his mind was on a more violent thing: the killing of his fellow Panthers, Fred Hampton and Mark Clark, by Chicago police. "Murder, cold-blooded murder," he said in a low voice. I dug out some newspaper clippings about the ongoing investigation. After reading them carefully he handed them to Emory Douglas. "Crap, unadulterated crap. So we have to be murdered in our homes before people become indignant. We have charged the police with ambush and murder over and over again. Now, after twenty-eight murders, people are taking a look. What are we supposed to do, pray for deliverance?" He answered his own question in a soft, dispassionate voice. "The cops who murdered them must be punished in the same way they committed the crime."

"Right on, Papa Rage," Kathleen snapped.

And quietly he raged on. "That bullshit in there about Wilkins and Golberg forming an investigating committee of their own— what in hell are those dudes going to investigate? They'll wind up saying the pigs were justified in the killing. Anyway, it doesn't make much difference what they find. It's too late for their concern. The brothers are dead. All that is left is the problem. The Panther is the solution." He paused for a moment, handing the baby to its mother, and then went on. "So the black moderates are suddenly sympathetic. Hell, sympathy won't stop bullets. It's the brother's job to

defend his own home. There's only one way for him to do that—
when cops bust through your door, put a gun in their faces and say,
'Split, Mother!' Oh, there's alternatives. Call the U.N. or the civil
liberty boys or the police station and tell them you're being shot up.
Then wait."

Cleaver kept busy through the day attending all kinds of secre-
tive meetings with Algerian leftist groups from whom he got some
moral and financial support. But he seldom ventured out at night,
and we sat about the dinner table talking—mostly about his friends
back in the States, revolution, and death. There was very little laugh-
ter in the house—only Otis Redding's blues, Elaine Brown's protest
songs, and the soul stirrings of Aretha Franklin and James Brown.
The house was the cluttered, temporary shelter of a black man in
exile, where bags stayed packed and all precious things were por-
table.

So many times during his life Cleaver appeared to be a man
without a future. He had found himself behind prison walls; there he
had written *Soul on Ice,* a powerful and remarkably frank personal in-
sight. In and out of jail since he was sixteen, it was only when he'd
left prison, at age thirty-one, that he got involved in the black revo-
lution, politics, and the Black Panther party.

"And from then on," he said, "the parole authorities gave me
more trouble than they did when I was a robber. The cops were try-
ing to kill me that night they murdered Bobby Hutton. They
slammed me into Vacaville with a shot-up leg and revoked my
parole without a hearing."

I was in California when Judge Raymond Sherwin freed him on
a writ of habeas corpus, observing that Cleaver had been a model
parolee. And I had been surprised at that ruling, since all the authori-
ties from Reagan on down had lined up against him.

"That didn't stop them. They trumped up some more charges
and ordered me back to prison. I knew that if I went back I would be
killed. So I split."

"Are you ever going back?"

"Damn sure am. I'm going back home to San Francisco. No-
body is going to keep me away from it."

"Couldn't you do the party more good by writing from
Algiers?"

"You can't fight pigs with eloquence. I've got to commit myself

physically." He frowned. "I want to keep Reagan and his crowd in a constant state of nightmare."

Cleaver lit a cigarette, crossed his legs, and eyed me closely. "We want you in the Black Panther party. You could serve as minister of information. A lot of young cats would be glad to follow you in."

Totally unprepared, I spent an uncomfortable moment thinking that one over. "I'm honored," I finally said, "but—"

"We need you more than the establishment does."

"I'm a journalist. I'd lose objectivity. I have things I want to report."

"I'm more concerned about strong young cats following you into the party." His tone was uncompromising, intransigent.

"But my interests go beyond those of the Black Panthers, to other minorities and factions of the black movement who also want change."

Perhaps Cleaver realized he couldn't change my mind. Easing off, he suggested we leave the matter open. But he went on to stress that if guerilla warfare came, people would die. "But individual tragedy can't block liberation for the masses," he said. "We're out to tear down the system—not with fire, not with guns, but with solid political know-how."

"And what will you build in the rubble?"

"Social justice. We promise to replace racism with racial solidarity. There are no better weapons. We are disciplined revolutionaries who hate violence. That's why we aim to stop it at our front doors."

That night I left Cleaver on a wet, wind-swept street. It was strange that his last words were about social justice, irrespective of a man's color. I thought of our slain leaders and couldn't help but feel that Cleaver's promise, like their dreams, would go unfulfilled. Social justice, it seemed, was much more difficult to come by than martyrdom.

In retrospect, I find I have always been displeased with my answer when Cleaver invited me to join the Panther party. What I should have said is what I feel now about the small part I played during the 1960s. Both of us were caught up in the truth of the black man's ordeal. Both of us were possessed by that truth which we defined through separate experiences. How we chose to act it out

was the only difference. Certainly he recognized my scars and I ac-knowledged his. He was thirty-five at the time. I was fifty-seven. We had met over a deep chasm of time, the events of which forged different weapons for us. Perhaps if I had been twenty years old then I might have been a Panther—but maybe not. I do remember that as a kid I was taught to take the first lick before fighting back. But then a fist is not a bullet. I, too, would shoot a cop or anyone else who forced his way into my house to kill me or one of my family. He was going back, so Cleaver had said, to fight a system we both disliked. I would continue to fight also, but on my own terms. I have always preferred to change things without violence—providing violence is not thrust upon me. If this was Cleaver's position at the time, then our weapons were not as irreconcilable as either of us might have thought.

With the awful storm passed, I sometimes think of the black revolution as a great ship wrecked, lying abandoned on some peace-ful shore, being gnawed away by the waves of time and change; being looked upon with contempt by those of us who let it die.

The struggle against the punishing white sea was fierce. We saw our leaders, like masts on a battered ship, snap under the waves of hatred. In the end it was slaughter, fire, and human carnage. But there are stirrings in the wreck. Those martyred things lying in the rotting hulk keep giving off little signals of rebirth. If we forget how things were before the storm disappeared, next summer's children might witness what many of us hope will never happen again.

29

The Learning Tree *cameras roll*

Efforts to make my novel, *The Learning Tree,* into a motion picture had begun in 1965. Two Time-Incorporated employees, Alan Martin and Enfield Ford, having arranged for an option on the book's rights, spearheaded the attempt. They met with one failure after another, but encouraged by their faith in the project, they opened an office and started searching for a young actor to play the lead role. They had selected me as director; and perhaps this was their undoing. No major Hollywood studio had ever taken on a black director and it was generally assumed they never would.

After two or more years of disparaging effort, Martin and Ford threw in the towel and I tossed mine in as well. Then the nibbles started again. I remember in particular one astonishing offer of a considerable sum of money from a producer who insisted on changing all the black characters in the screenplay to whites. I refused. The most incredible suggestion, however, came from a produucer who thought Gloria Swanson should play the part of my mother.

John Cassavetes, after reading the book in the spring of 1968, came to New York and began stirring up interest again. Sensing that

this might be the vehicle to ease me into Hollywood, he advised me not to release the rights unless I was included in the contract as the director, although we had already gone that route without any success.

But there were two things that compelled Cassavetes: he loved *The Learning Tree,* and he wanted to see that barrier against blacks in Hollywood come down. He started thinking out loud. "There's one guy who's gutsy enough and ornery enough to do it—and he likes the book. But hell, he's mad at me. Oh hell, I'm flying back tonight and I'll talk to him anyway. Be prepared to fly out there fast as hell. Okay?"

Cassavetes called early the next day. "I can't say for sure what's going to happen," he said, "but take the first plane out here tomorrow morning and come straight to Warner Brothers Seven Arts in Burbank. I'll be waiting for you in Kenny Hyman's office."

"Who's Kenny Hyman?"

"The cat who runs the joint. Don't ask any more questions. I'm nervous, so just get your ass on a plane very fast like. Okay?"

* * *

Kenny Hyman sat smiling behind his big desk when I entered the room. Cassavetes paced the floor with a worried look on his face. After introducing me to Hyman, he said, "I've got to attend to some urgent business. I'm leaving my car for you at the front door." He was gone before I could say another word. Hyman tossed *A Choice of Weapons* across to me. "Is this what you want to make?" he asked.

"No," I said. "I want to make *The Learning Tree.*"

Hyman picked up my other book and glanced at it briefly. "Oh, this one?"

"Yes, that's the one."

"You want to direct it?"

"Yep."

"When do you want to start?"

(Was this guy kidding me?) "Right away."

"You wrote the book. Would you like to write the screenplay?"

"Well, I suppose so. Never thought of that." (This is crazy.)

"Who's your agent?"

"Robbie Lantz in New York."

"Okay, I'll call him—and you'd better think about getting a house out here so you can start work right away. Time's wasting."

I was dizzy with pleasure, unable to believe what had happened. In less than five minutes Kenny Hyman had accomplished what everyone, including myself, had thought was impossible: a major Hollywood studio was about to take on its first black director. The news fanned out across the nation like wildfire. The following Sunday Kenny had me in for brunch at his Beverly Hills home. He had just purchased a beautiful new piano. "Try it out," he said. I sat down and played something he had never heard before. "It's lovely—what is it?" he asked.

" 'The Learning Tree.' I wrote it two years ago."

"Well, Mr. Director, unless you object, I think we've found the composer for the filmscore." I had no objections. No feelings. No nothing. I was too numb with joy. Not until the middle of the week did I remember that soothsayer back in Cairo nearly three years before. Her prophecy, it seemed, was taking on full meaning. It was all coming together for me—and in the year 1968.

Burnett Guffey, a cameraman whose work I admired very much, had just retired. Nevertheless he agreed to take on the film after reading the book. My next problem was to employ some blacks to work behind the camera, and that was extremely difficult. In the light of the industry's attitude, so few blacks felt encouraged enough to prepare themselves. Again Kenny Hyman came to my aid and helped me scrounge up eleven blacks for the crew; Vincent Tubbs, a black publications expert, was added to my staff. Then suddenly Hyman put me in a mild state of shock. After very serious thought, he said, he had decided that to keep control I should produce the film as well.

Bill Conrad, a heavyset, gruff man, was assigned as an executive producer. Much later, when he became the star of the television series "Cannon," I realized that gruffness was his trademark. We didn't exactly develop a love affair, but I soon gained high regard for his judgment. He knew the business and generously imparted his knowledge of it to me, helping me make the transition from still-camera to motion picture techniques. I don't mean to suggest, however, that I found directing easy. It was, and still is, one of the most demanding jobs I have ever undertaken.

After strapping me with the extra burdens, Kenneth Hyman very simply explained the challenge. "The only two directors I recall taking on similar responsibilities," he said, "were Orson Welles and Charlie Chaplin." Then he gave me a mischievous smile. "But you, my friend, are not only the novelist—you are the film's screenwriter, its producer, its director, and the composer of the score."

Joel Freeman, a buddy of Hyman's, chuckled and quipped, "Kenny is a very sweet and generous man. He's gonna hand you the knife and let you slit your own throat, then you blacks can't say we bigots didn't give you a chance out here." We laughed, but a slight touch of paranoia set in, and for a moment I couldn't help but wonder about how much truth there was in Joel's remark. But each day, with Hyman solidly behind me, I gained in confidence.

Perhaps the most unnerving moments came when I faced, for the first time, the department heads of all the various groups that would be working with me: the grips, electricians, special effects, camera and sound men; the makeup, wardrobe, trucking, and prop crews. Their questions came at me fast and even. My answers, right or wrong, came back just as fast.

"Now the cyclone—how many wind machines will we need for that?"

"At least six, and very powerful ones."

"How many cameras will be going during the sequence?"

"Two, possibly three. It depends on the amount of force the fans can generate."

"Will there be any need for livestock during the storm?"

"Yes, plenty—herds of cows and four horsemen to control them."

"For your mother's funeral—will we have to construct a grave-yard?"

"No. We'll try to get permission to shoot where she's actually buried. If that isn't available we'll try for another one."

"How do you expect to shoot that scene with the two horsemen? They will be nearly a mile away."

"We'll have to have a thousand millimeter lens along—or at least an eight hundred millimeter."

"How will you talk to the actors?"

"Walkie-talkies. Be sure to have powerful units."

"What vintage cars will we be using, and what kind?"

"Early 1920s—Maxwells, Fords, and maybe Chevrolets if they were being sold by then. Somebody please check it out."

It went on like that for over two hours. Since it was "my first time out" I knew that every eye in the room was sizing me up, searching for the soft spots—or the toughness I'd need to survive those three grueling months on location in Southwest Kansas.

Although he hadn't said anything during the questioning, Bill Conrad had been at my side the whole time. As we walked back to his office he congratulated me on doing a good job. "Everyone has a lot of respect for you already," he said. I thanked him and began to breathe easier. A director without the loyalty of his crew has trouble on his hands. A long time ago my father gave me some good advice about handling a very sassy mare of ours called Gypsy. "Now don't be afraid to ride her," he'd told me. "Just keep your hands gentle but firm." Gentle but firm. That's the way my father would have advised me to handle the crew; and I had usually taken his advice. This time would be no exception.

The next few weeks were spent casting. When Kyle Johnson came into the room and read for me I knew we had the actor for the lead role of Newt Winger. The rest was a day to day search trying to find the other actors who would complement him. The most difficult would be the role of his antagonist, Marcus. This part called for an actor who could pull off the combination of sensitivity and a naturally mean disposition. Several had read for it but no one seemed quite right. Then one morning as I walked into the casting office, the man in charge was ushering a young man out the door. "I'm sorry," he was saying, "but I told you yesterday to bring along a photograph and a résumé."

"And I told you yesterday that I didn't have any," said the young man. "Now you're giving me this crap about not being able to audition. What kind of jive is that?" I stopped and looked at the complainant. A scar ran across his face at the right spot; he was built like a prizefighter, and he was blessed with a sullen appearance. "What's your name?" I asked.

"This guy's trying to tell me . . ."

"What's your name?"

He looked up with a scowl. "Alexander Clark!"

"Can you act?"

"I wouldn't be here if I couldn't. This man here . . ."

"Come into my office," I said. The casting director looked at me as if I had wrung his neck. I gave him a covert wink, followed Alexander Clark into my office, and handed him some lines to read—not the "young tough" lines but ones that required him to work up some compassion.

"Can I have a few minutes to read over this?"

"Take your time. I've got some reading of my own to do."

I watched as he rehearsed the lines in his mind, hearing his teeth grind as he reached the most gentle passage. He got up and walked around the room for a few moments. "Do you think I'm right for this part?" he asked finally.

"I don't know. It's the part you came to read for."

"Okay, I'll read for it." He read and the transformation was remarkable.

When he was finished I said, "Okay, Alexander Clark, for the next four months your name is Marcus. You've got the part." Then I saw his beautiful white teeth; with the smile he gave me, it would have been impossible not to have seen them.

The relationship between Bill Conrad and myself wavered dangerously one hot afternoon when, extremely busy with my staff, I had refused going into his office to meet an actor friend of his who wanted a part. Bill appeared suddenly in my office as I was explaining that during a storm sequence I needed water brought up to a certain hilltop.

"You won't get any water up there," he said with his usual gruffness.

Thinking he was joking, I said, "Oh yes we will, Billy boy."

"And I say you won't!" There was no humor in his voice.

Everything got quiet, very quiet. My staff turned toward me, probably wondering how I would handle the situation. I tried counting silently to ten, but by the time I reached six I heard myself beginning to shout. "I'm the director of this goddamned picture and you'd better goddamned well remember it! Now get the hell out of my office before I throw you out!" (Thinking back, that would have taken some mean throwing. Bill weighed close to three hundred

pounds.) He started shouting back but the heat of my voice sent him off.

I always regret losing my temper, even seconds after I've done it. Now was no exception. Bill, a real gentleman at heart, obviously felt the same; just as I was about to go to his office, he arrived at mine.

Apologies exchanged, the two of us had reached a most amicable state when Suzanne Crayson, a lovely young English lady who acted as my nanny, advisor, and mother confessor announced that "one Mr. Dana Elcar is outside insisting upon reading for the part of Kirky the cop."

"But a New York actor has been chosen for that part," I said.

"I've informed Mr. Elcar of that fact. But the gentleman insists—and I'm at the point of exasperation." I asked her to send him in, intending to tell him off in no uncertain terms. Dana, a big bull of a man, charged into the room sweating and spitting out Kirky's lines with pure venom, acting as if he were ready to shoot Bill and me on the spot. Then, capping off his show of anger, he shouted, "And you take this, you dirty bum!" With that he kicked Bill savagely in the shins. Yelping in pain, Bill cursed back at Dana.

Suddenly I realized this poor New York actor who we had hired was out of luck. As it turned out, Elcar's performance in my office had won him the job.

*　*　*

It was hardly peaches and cream when director, cast, and crew finally reached our Kansas location. The residents of Fort Scott were wary and suspicious of that book Jack Parks's boy had written about his hometown. Since there was no bookstore in the area, only a few of them had read it. One farmer, whose place we wanted to use, yelled, "Git off my property! I don't want nothing to do with that dirty, lying book about whites lynching Negro people. It's all a lie. Now git before I git my gun!" We got off his property.

Attitudes got progressively worse until finally we had to call on the mayor. Once he learned that nearly a quarter of a million dollars would be spent with local merchants—and that we were thinking of moving on to another town—he called the town fathers together

hastily and laid down a few simple laws of his own. Not only did we get cooperation from then on but the following Saturday was proclaimed "Gordon Parks Day."

As we approached our first morning of shooting I sought out Burney Guffey, the wizened veteran cameraman. Burney immediately sensed my nervousness, having been through it with scores of other beginning directors. "Listen," he advised me, "when you get up on that big crane tomorrow morning you probably won't know which way to go. Just don't let the crew know it. Go one way or the other. It won't matter as long as you get going. After that everything will be okay." I thanked him for his advice and went off to bed for a totally sleepless night.

The next morning I walked Kyle Johnson, who would play Newt Winger, far out into what had once been my father's cornfield. "Kyle," I said, "I lived it, I wrote it, and now I'm turning it all over to you."

Kyle, a sensitive young man of seventeen, smiled and patted my shoulder. "It's in good hands, Gordon; I'll do my very best."

Finally it was time. I walked over to the camera crane and sat down in the seat. The assistant director gave a signal and up it went, lifting me high into the air. Beyond me as far as I could see were the rolling green plains of Kansas where I'd spent those first sixteen years of my life. For my father, the cornfield beneath me had been the only means of keeping his family alive. Now, with close to three million dollars behind me, I had come back to recreate an experience long since passed. A few miles to the southwest was the graveyard where my mother and father lay side by side. How I wished they could have seen me; how proud they would have been. I looked down toward Kyle. He was smiling.

I signaled to my first assistant. "Cameras," he said softly.

"Cameras rolling." Burney Guffey's voice seemed to have a smile in it.

"Action!" I shouted.

Squinting hard against the blazing sun, his brown skin gleaming, Kyle started moving through the prairie grass which reached to his chin. *The Learning Tree* was on its way.

* * *

The shooting went well. Many major newspapers and magazines sent reporters and photographers. Swarms of television and newsreel cameramen visited the different locations to record the making of the film. I gave interviews at lunchtime or sometimes in the evening after watching the daily rushes that were flown in from Hollywood. What a joy it was to watch, day by day, *The Learning Tree* unfold right before our eyes. By this time the entire crew was caught up in the drama; it was as much their film as it was mine. To a great extent each of them had been picked with delicate care. For the first time blacks were working beside whites behind the camera; for the first time a black man was in charge as director. Much was at stake and we knew we were adding a new chapter to the annals of American film industry. The white crew members made great efforts to teach the black crew members as much as they possibly could. It was indeed a beautiful thing to experience. Although my book and my life was being filmed, as far as I was concerned *The Learning Tree* belonged to all those black technicians who, like me, had aspired so long to work behind a Hollywood camera.

Yet, despite the general state of happiness surrounding us, Vincent Tubbs, our public relations chief, seemed terribly upset about something. One morning I asked him what was wrong.

Frowning, he answered, "For the life of me I can't figure out why *Ebony, Jet,* or any of Johnny Johnson's publications haven't been out here."

"Were they invited?"

"Of course, just like everyone else."

I urged him not to worry about it. We were getting wide coverage from the media and *Life* magazine had commissioned my son, Gordon, Jr., to photograph everything happening on location. But Tubbs couldn't stop worrying; he put a call through to *Ebony*'s managing editor in Chicago. After dinner one night he played me a tape of the conversation which went something like this:

"Hey, aren't you guys coming out?"

"Nope. Sorry, Vinnie."

"Why?"

"Johnny's orders. The staff held a couple of meetings about it, but he won't budge."

"What's his trouble, man? This is the first time in history that a

black man is directing for a major Hollywood studio. Even if he hates the guy, it's his obligation as the owner of a responsible black journal to report the event."

"You're right. We argued that point with him, but his order stands. And anybody who goes against it is going to be fired."

"Has he got something against Parks?"

"He denies that. In fact he says he's quite fond of him. We're as puzzled as you are. All of us wish we could be there. It's a hell of a good story."

Vinnie had hung up in a quandary. "Well, what do you think of that?" he asked.

"Frankly, I'm shocked," I said. "But what the hell, he's obviously got his reasons; and whatever they are he must feel them strongly, so *tant pis.*"

But it wasn't that easy. Johnny and I had never shared a cross word with one another in our long friendship. Actually he had always been sort of a hero of mine—a black guy who had made it the hard way, a titan in the publishing industry. Back in the 1950s his first publication, the *Negro Digest,* had reprinted—without permission—a story about me that had first appeared in Tom Maloney's *U S Camera* magazine. Infuriated, Maloney had telephoned to ask if I had given Johnny permission.

"Of course not. How could I?" I answered.

"I'm going to sue him," Maloney said.

I spent nearly an hour on the phone trying to convince Maloney against such an action. "It's just a small magazine aimed at helping black people, Tom. Give the guy a break." Tom was still angry when he hung up, but eventually he pulled back.

Sometime later I journeyed to Haiti with Johnny and his wife, Eunice, and Ben Burns and his wife, Esther. Ben was, for a while, the managing editor at *Ebony* magazine. It was the Johnsons' first plane trip, and I remember Eunice gripping my hand in fear as we took off. All of us stayed at a lovely hotel up in Petionville. One afternoon I heard a terrifying scream erupt from the Johnsons' suite. Rushing in I found Eunice cringing in fear against the wall, pointing at a little green lizard on her dressing table mirror. She grew to hate those lizards, and I can't say I blamed her. They took liberties beyond their importance. That same night I found one curled up

comfortably on my pillow. All in all we had a wonderful stay in Haiti, and Johnny and I had grown even closer there. Later I would contribute to his most successful enterprise, *Ebony* magazine. In light of this, his strange attitude toward the film puzzled me, and still does today.

I tried to persuade Vinnie to forget the whole thing. He couldn't; he boarded a plane to Chicago to confront Johnson—and he got the same answers that had been given to him over the telephone.

Finally he had asked, "Johnny, is there something personal between you and Parks?"

"Absolutely not. I like the man very much. We've been good friends for a long time."

* * *

There were some very nostalgic moments during the filming of my childhood, and some traumatic ones. Particularly so, for the crew and myself, was the death and funeral of my mother. Estelle Evans, the actress who portrayed her, became somewhat reluctant about lying in the coffin. The crew, wanting to feel the real depth of the occasion, asked me to keep her off the set the day we filmed the burial scenes. Kyle Johnson was also becoming a little edgy—a little quieter by the hour. Finally he came to my quarters one night, troubled by the scene where he loses the fear of death by sleeping beside his mother's coffin.

"How did you actually feel that night?" he asked, staring out the window toward the dark prairie.

"I was sad and frightened," I said. "That's the most I can tell you." Kyle didn't seem satisfied with my answer; he wanted to know more. So I went to my work table, thumbed to the passage in the book, and handed it to him. "Read this tonight," I said. "It might help." He took the book and left. It was a passage I could almost recite by heart:

Reaching the parlor door, he [Newt Winger] stopped, breathing heavily. He felt that he had awaited this moment all his life, and now that it had arrived, he could not fail it. He pushed the door open gently, paused, then stepped in—leaving the door ajar behind him. In the dimness he could see the shape of his mother's coffin. His heart sank; and he wanted to run from the room; but he real-

ized that he had to go through with it after coming this far. Sweat dripped from his armpits, and he could feel the moisture in the palm of his hands. He made another small step toward the coffin (the lid's down), one more step—driplets of sweat coursed down the sides of his face. He gently eased up the lid, shivered, trembled, looked. The dark form of his mother lay deep in the cushion of crinkly white. Bracing himself, he took a final steady, teeth-grinding look, dropped the blanket to the floor, spread it, lay upon it, pulled it about him, closed his eyes tightly—sealing off all blackness except that inside him. After a while the heartbeat slowed, the trembling eased. He commenced the struggle with sleep. . . . Before long he was snoring softly.

Kyle was outstanding in his performance the next morning. Usually, for protection, a scene like this would call for at least two takes. But he had put so much of himself into it, I knew he was exhausted from emotion. I didn't have the heart to ask him to do it all over again. I did ask him if he was satisfied with his performance. He nodded. "And how was the camera, Burney?" I asked. He stuck his thumb in the air, and I called for an early lunch.

Two days before we were scheduled to finish, the studio requested we reshoot a scene that took place in an apple orchard. By now the temperature had dropped far below freezing, the grass was brown, and the trees were bare of apples and leaves. Furthermore, the boys would be practically naked and barefoot. I passed my problem on to the propman. He shrugged—no problem. Next morning the grass was a summer green; leaves and store-bought apples hung from tree limbs. The boys nearly froze (we sprayed sweat on their bodies) but they carried it off without a grumble. Two days later the cast and crew boarded a plane for Hollywood. We had "wrapped" one day ahead of schedule.

When *The Learning Tree* finally opened in New York in August of 1969 its reviews were mixed. Some called it beautiful and sensitive; some called it "too nostalgic." Rex Reed, however, came to my defense on that one. Said he: "That's like saying John O'Hara should write like Saul Bellow, or that Truman Capote should write like Norman Mailer. And why should nostalgia be reserved only for white writers?"

I'm told there were some verbal assaults from black militants

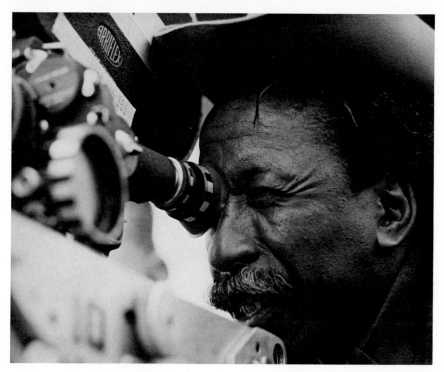

Author on set of The Learning Tree. *Fort Scott, Kansas, 1968.*
Photo: Gordon Parks, Jr.

Author with actors on set of The Learning Tree. (Left to right) *Bobby Goss,*
Carter Vinnegar, Kyle Johnson, Alex Clarke, and Stevie Perry. Photo: Steve Weaver.

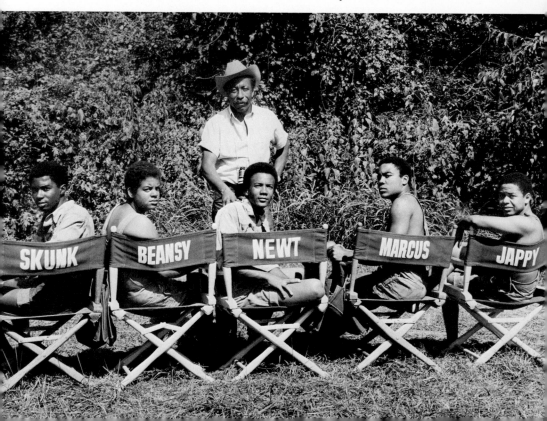

Top right:
Author with cameraman,
Burnett Guffey.
Photo: Steve Weaver.

below right:
Bill Conrad and author on set of
The Learning Tree.
Fort Scott, Kansas, 1968.
Photo: Steve Weaver.

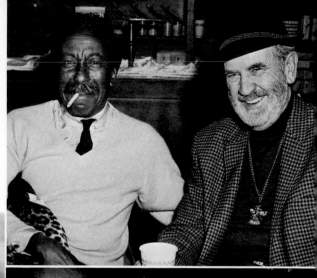

Author on set of
The Learning Tree.

Author with six
of the black crew
members on the set of
The Learning Tree.
Left to right:
Vincent Tubbs,
Gordon Parks, Jr.,
Keith Lundy,
Elizabeth Searcy,
Eugene Simpson,
and Kenny Taylor.
Photo: Steve Weaver.

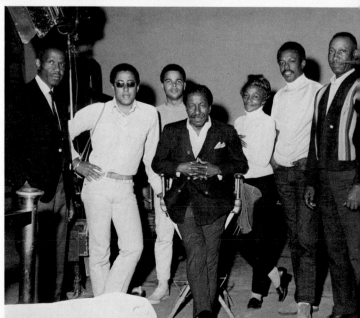

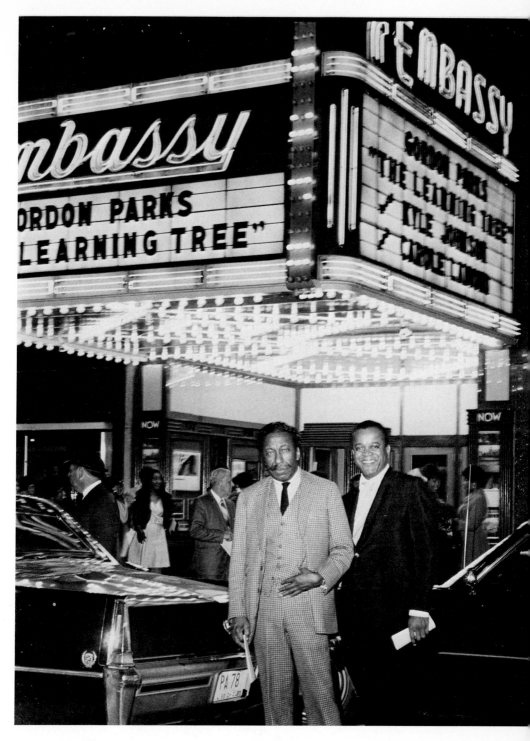

Author at The Learning Tree *premier in Cleveland, Ohio, 1968.*
Photographer unknown.

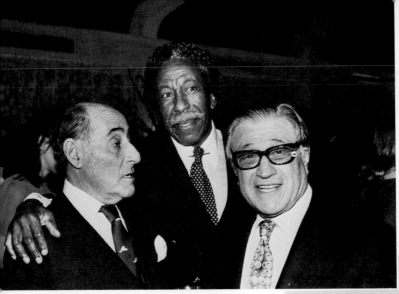

Life *photographers, Alfred Eisenstaedt* (left)
and Carl Mydans (right) *with author.*
New York, 1978. Photo: *Life*.

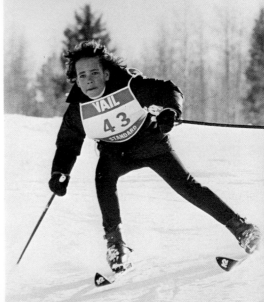

Alain Brouillaud,
author's grandson,
skiing at Vail, Colorado,
Christmas, 1974.

Pancho Gonzales, author,
and Arthur Ashe at Forest Hills,
New York, 1972.
Photo: Peter L. Gould.

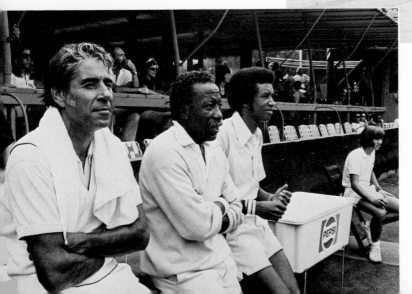

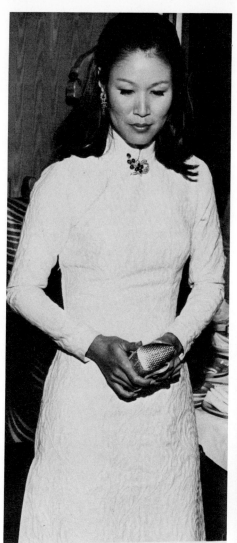

Genevieve Young.
New York, 1972.

Gene and Gordon leaving
the Arthur Ashes' wedding
ceremony in New York City.
Photo: Eisasi Zachariah Dais.

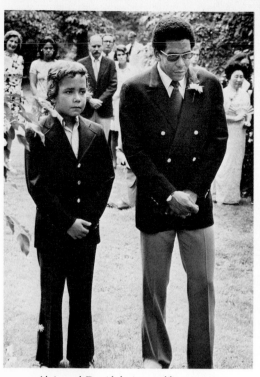

Alain and David during wedding ceremony.
Photo: © Jill Krementz.

Author dances with daughter, Leslie,
at wedding celebration. Photo: © Jill Krementz.

Gene and Gordon's wedding party, August 26, 1973. Pound Ridge, New York.
Photo: © Jill Krementz.

Gene and Gordon work at their respective manuscripts.
Photo: Alfred Eisenstaedt.

Gene Young Parks in the Parks' East Side
New York apartment. Photo: Gordon Parks.

The wedding bouquet, 1979.
Photo: Gordon Parks.

Gordon, Jr. and Gordon, Sr. White Plains, New York, 1977. Photo: Bob Lucas.

who thought I should have put "whitey" down harder. But all I ever heard from them personally was, "Right on! You did it, baby!" In any case, *The Learning Tree* was the truth of my own childhood. I would not have compromised that truth for the temper of the times. It was also the resolution of whatever it was that took me from that Kansas cornfield to that big camera crane in Hollywood—the crane that, for so long, had been reserved for whites. Now I hoped that other black men would take its long ride into the air. Meanwhile I could only wish that after viewing *The Learning Tree* a white bigot and a black bigot would emerge from the theater holding hands. That's what that piece of "nostalgia" was really all about.

When I first saw my name in bright lights on a Broadway marquee it was cheering but somehow intimidating. To some people it meant that I had "arrived." To me it meant that I would have to work all the harder. Success in films was now my vertigo. I'd always loathed failure. I didn't ever want to end where I'd begun. Now I would have to have faith in my faith, and ignore doubt in those things I still doubted.

I glanced again at the marquee. *The Learning Tree* was shining brightly. I thought back to all its misery and joy, shook my head, and walked on.

I met Johnny Johnson a couple of months later at a social gathering in New York. He smiled and said, "Gordon, I just loved *The Learning Tree*. I took my mother and Eunice to see it three times. It was a beautiful picture."

I smiled and looked at him, and for the lack of anything else to say, I replied, "Thank you, Johnny."

30

To open doors

Shaft, my second film, which I made for MGM, was a
financial success—one that gave black youths their first hero compa-
rable to a James Cagney or Humphrey Bogart. We practically raced
through it without any problems, but Jim Aubrey, the studio's head
at the time, gave us a few suspenseful days in the beginning. Hours
before we were to commence shooting in New York he called to say
that we would run into bad weather and go over budget. It was a
blow. Hollywood, despite its great set designers, could never match
the look of New York. We held up shooting but I held on to the
crew and actors. The next morning Joel Freeman, the producer,
David Golden, the production chief, and I took a plane to the West
Coast. Once there, it would be a matter of convincing Aubrey that
he was wrong. This was a heavy task. Aubrey was a hard man to
turn around once he made a decision.

At the conference table he eyed me coldly as I exaggerated the
possibilities of the lenses and cameras we had assembled. "Jim, it
could be sleeting, hailing or snowing, but I swear, with the equip-
ment I've lined up I can make it look like a hot summer day." The

discussion went on for an hour. In the end Aubrey either decided that I was a magician or the most persuasive liar he had ever encountered. In any case he gave in, and David, Joel, and I were on the next plane back to New York. Two days later those magical cameras were trained on Richard Roundtree, who had been picked to portray Shaft, the handsome, tough, black private eye. It was an enjoyable film to make, and we brought it in a quarter of a million dollars under budget.

For some reason I never quite understood, the studio sent me to London to preview the film for a group of British newsmen. It was a most disheartening experience. They didn't seem to understand anything about the film, especially the humor we had worked so hard to bring to it.

"I say, old boy, what does Shaft mean, really?" one asked.

I thrust my index finger into the air and twirled it around then upward.

He colored deeply. "Oh really! And he goes about calling these tough blokes 'mother.' What's that all about?"

There were several women reporters in the audience. Scratching my head, I replied, "Well, you're going to have to figure that one out for yourself, old boy."

In Beverly Hills several weeks later, Doug Netter, the second in command at the studio, asked me how it went. "It was disastrous," I told him. "Shaft should steer clear of the British Isles."

My telephone jarred me awake at three o'clock in the morning on the day the film opened in New York. David, my son, was calling. "Dad," he shouted excitedly, "get out of bed and come over here to the theater right away!"

"It's three o'clock in the morning, David," I complained.

"Get up, Dad," he insisted. "You've got to see this to believe it!"

When I arrived at the theater I immediately understood his sense of urgency. The line waiting to get inside wound completely around the block. Shaft was a hit, and in the months to follow it became a hit throughout the world—even in England. I attribute several things to its success: a fine screenplay, Richard Roundtree's performance, and without doubt, the great musical score by Isaac Hayes, which later won an Academy Award—the first for a black composer.

I was indeed pleased by it all, but extremely important to me was the number of blacks used on *Shaft*'s crew. The number had tripled since I made *The Learning Tree*. *Shaft* had given black youths their first big romantic hero, and MGM prospered mightily. Now, other Hollywood studios had the green light for black suspense films, and they exploited them to a merciless and quick demise with a rash of bad screenplays.

There was, and still is, much controversy about who was to blame—the black filmmakers or the studios. The situation is hardly arguable. The studios put up the money; the studios also decided what films should be made, but critics, both black and white, seemed to ignore that fact. Unfortunately, many blacks with means, offered a lot of rhetoric instead of money, whereas money was the only thing that could have given black filmmakers the independence to make better pictures.

I hope black directors and producers will not give in to this setback. Their hopes lie in their ability to channel their creativity into motion pictures that are more universally acceptable. (Right now I am writing a novel about an Irish family.) But I'm now saying to them, "Give up black films." I'm suggesting that they prepare themselves for any good film that comes along, regardless of whatever ethnic group it portrays. And, I know that the studios are not going to throw open their doors to a black director simply because he has a terrific screenplay about the secret life of Jane Fonda or Lauren Bacall. Hollywood still harbors the most racist industry in the country. The doors to its inner sanctum are big and tightly shut. The important thing is to be ready if one should accidentally open. The bigger the door, the harder you pound.

31

"... the Spingarn Medal will suffice."

*W*hen Frank Yablans, a former Paramount studio head, decided to put the life of Huddie Ledbetter—the legendary folk singer—on film I was assigned to it as director. David Frost was made executive producer and Marc Merson was the line producer. *Leadbelly,* as the picture came to be called, was filmed in Texas; and it got caught in what certain producers and directors have come to know as "the Hollywood shuffle." Before the picture was finished for release, Barry Diller replaced Yablans as head of the studio. So *Leadbelly* became one of Yablans's leftovers— "studio stepchild," in other words.

In Hollywood, where the game of musical chairs is constantly being played, this is not an unusual occurrence; any number of worthwhile films have suffered the same fate. When I previewed the rough cut for Diller, he told me that he liked it and would do everything within his power to push it. I believed him; he had no reason to lie to me, and I don't think he did. It's hard to say what happened after that; mysterious things take place in those big offices of Hollywood studio executives—sometimes for the better, sometimes for

the worse. *Leadbelly* was destined for the worse. After some stirring receptions at public previews—and top honors at the Dallas Film Festival—it was allowed, politely, to expire. I fought, and the press fought with me—but to no avail. *Leadbelly* died an early death; and, like it, the unpleasant situation that developed between Paramount and myself is dead. But an incident surrounding the ill-fated picture mystifies me more than its fate.

That mystery has to do, once again, with Johnny Johnson, whose earlier behavior concerning *The Learning Tree* puzzled me so. At the height of my problems with Paramount he invited me, through Dr. James Barringer, the studio's black minority marketing director, to bring the film to Chicago and preview it privately for him and his staff. Remembering *The Learning Tree,* I at first refused, giving Barringer my reasons for doing so. Barringer, a man whom I have grown to highly respect, convinced me that Johnson was perhaps trying to "bury the hatchet."

"Where?" I had asked, "in my back?" As far as I could see there was none to bury. For some reason he had declined to publicize *The Learning Tree.* His actions seemed strange, but that was fine with me. He still greeted me with his gentlemanly Southern charm; and I had no bones to pick with him. I buried the past, since there was no hatchet, and journeyed to Chicago with Dr. Barringer.

The relatively new multi-million dollar home of Johnson's publications is a monument to the man himself, as well as to the enterprise and hard work he obviously put into it. Imposing in its architectural design, and overlooking Lake Michigan, it is something that any man would have reason to be proud of. And Johnny took great pride in personally showing me every well-appointed foot of it. Later he showed me a most gracious evening—cocktails and dinner with his staff, and a visit to a gallery of fine paintings on one of the upper floors.

After *Leadbelly* was shown, Johnny, with his arm about my shoulder, talked of our old days together, that first plane ride to Haiti, praised the picture and promised to support it. "It's the kind that black filmmakers should be doing instead of the current junk." He was indeed so taken with it he suggested that Lerone Bennett, *Ebony*'s executive editor, accompany me to Haiti and research the possibility of doing a film on the great black revolutionary, Henri

Christophe; and assured me that he would lend his financial support of such a project.

Such talk warmed my heart. Together, years before, Johnny and I had visited the ruins of the citadel, La Ferrière. We had stood in the gloom of fog and low hanging clouds, speaking our awe of this formidable citadel and fortress that Christophe had erected on the precipitous cliffs of a North Haitian mountain. Now, together again, we stood inside his own monument, his own citadel; and I was suddenly warmed once more to this man—happy that he had extended the invitation and glad that I had accepted it.

Elated, Dr. Barringer carried the news back to Paramount's offices in New York. A week later the chief of the marketing division and two of his assistants journeyed to Chicago, again at Johnny's invitation, for cocktails and dinner. At cocktails the marketing head expressed his appreciaiton for Johnny's response to *Leadbelly*. I have been told, by at least three persons who were present, that Johnny turned to him and said, "I hated the picture, the music, and story, and everything about it. If Gordon hadn't been there I would have got up and walked out." He then added, "The next time you people at Paramount decide to make a black picture, ask me about it first."

The story sorrows me. I would like to have kept my silence about it; but I can no longer burden myself with the weight of such a silence. It had grown to feel like a sack of stones on my back—and was growing heavier, making me weary. In his poem, "A Certain Weariness," Pablo Neruda, the great poet, writes:

> *I have seen some monuments*
> *raised to titans,*
> *to donkeys of industry.*
> *They're there, motionless,*
> *with their swords in their hands*
> *on their gloomy horses.*
> *I'm tired of statues.*
> *Enough of all that stone.*

I hold no malice toward Johnny Johnson. He is, like many others I have met, stored in a little slot of my memory, indexed and categorized under God or the Devil. Some people come and go fleetingly; others emerge and remain, somehow, entwining and entan-

gling themselves in my life—and no matter how hard I try, I can't escape them. Others were like a darkness attempting to obliterate my only beckoning light. They scarred me with their soiled nailpoints and left me with a different set of eyes and a set of bifocal ears—and for me things were never quite the same. But, try as they might, they lacked the guile to steal the dream my mother had for me. I was determined to nourish that dream until it was finally fulfilled.

Most successful blacks swallow a suffering that is more bitter to them than any other—the kind that they know at the hands of other blacks. This is the sad truth of my own observation and personal experience. It is a truth that we older blacks admit to; a truth that our finest leaders, artists, writers—from Booker T. Washington through Paul Robeson to Martin Luther King—have had to silently endure. This is in no way meant to discredit those blacks who are pridefully supportive. They outnumber, by far, the ones with the wicked claws. For those who would lift themselves up it means keeping sight of the green light that others seem so eager to extinguish. They climb regardless of who attempts to stop them.

Langston Hughes, a good friend, and one of America's most prolific writers of poetry and prose, was a case in point. We met in the early 1940s during a cold wintry day on Chicago's South Side. "The hawk's flying mean and high today," I remember him saying as we struggled against the wind sweeping in off Lake Michigan. He was a sad man at times, and angry with the injustices and "ways of white folks," but I seldom saw a frown on his face. He expressed his wrath with moving, ironic prose, and softened the hard knocks by living life fully, while keeping a big space in it for wisdom. My favoriet poem of his is "The Negro Speaks of Rivers." He composed it on a train, on the back of an envelope while traveling South along the Mississippi.

> *I've known rivers:*
> *I've known rivers ancient as the world and older than the*
> *flow of human blood in human veins.*
>
> *My soul has grown deep like rivers.*
> *I bathed in the Euphrates when dawn was young.*
> *I built my hut near the Congo and it lulled me to sleep.*
> *I looked upon the Nile and raised the pyramids above it.*

I heard the singing of the Mississippi when Abe Lincoln
 went down to New Orleans, and I've seen its muddy
 bosom turn all golden in the sunset.
I've known rivers:
Ancient, dusky rivers.
My soul has grown deep like rivers.

Lang, as we called him, was the poetic, frolicking voice of the Negro Renaissance during the early 1920s, that age when well-heeled whites made Harlem their vogue, their "Café au lait Society." He was best when writing about streetwalkers, roustabouts, and black workers. Hailed by critics and reviewers, he mixed it all up—the prejudices of the whites along with those of the "cultivated" Negro. And he caught hell from both sides. Those of us who loved him referred to him as the "Shakespeare of Harlem." Those blacks who loathed him for his honesty, called him the "Poet Lowrate of Harlem." Lang could have cared less about what he was called. He knew for what he had been called, and for him that was the heart of the matter. He loved Africa. To him it was the motherland of the Negro and he never tired of talking about it. Yet he was puzzled by its reluctance to accept him as a true black—simply because he was born with a light skin. I suspect that he was equally puzzled by some American blacks for the same reason. Yet, he died loving black people. It is sad that he was unjustly maligned by certain members of his own race.

Fortunately this fault of ours is being corrected by our black youths. They are learning to swim uptide without fear. Their letters to me each year tell me that they know who they are, where they are going, and what it takes to get there. Unlike their father's textbooks, that were crammed with white heroes, theirs are beginning to spell out the importance of their own heritage. Their geography has become the world; their inspiration is drawn from those older blacks who died to give them blood and strength.

To any black person who falls short of the Nobel Prize, the coveted Spingarn Medal will suffice. Awarded annually by the National Association for the Advancement of Colored People, it is a handsome gold medallion engraved with the words "For Merit," and is considered to be the most distinguished honor a black organization can bestow. On May 17, 1972 a letter came to me saying that I

had been unanimously designated as the 57th Spingarn Medalist: "This year's award thus nourishes the continuing tradition of excellence which has encompassed, among others, Richard Wright, Langston Hughes, Martin Luther King, Paul Robeson, Ralph Bunche, Marion Anderson, and Leontyne Price."

That night I thought back, searching for whatever it was that had placed my name among these men and women of such outstanding accomplishment. Very quickly I realized that, more than talent or anything else, it was my need to be somebody; to save myself from early defeat. I remembered when, at sixteen—alone, frightened, and without equipment or tools—hard work had to become my law. From then on the quiet forces that worked inside me wouldn't accept my simply doing well. I had to do better each year of my life if I was to outdistance failure. Sometimes, realizing that I was running a little too fast, I stopped to catch my breath, finding myself hurrying toward nowhere. Now, after sixty years, this letter had caught up with me, and I exulted with joy and appreciation.

The award had come at a most auspicious time. Of the ten honorary degrees I'd received in literature, fine arts, and humane letters, all had been given by white colleges and universities. It was satisfying to realize that my own race had been watching me tread that tightrope of the 1960s, and that now its most prestigious body was telling me I had done so to its satisfaction.

On the fourth of July I went to Detroit, where I was to receive the award. Still smarting from the disunity I had witnessed between blacks during our revolution, I had written a speech about brotherhood. It was a subject that had gnawed at my conscience for a long time; one that seemed especially appropriate since the award was also meant as a stimulus to the ambition of colored youth.

Over three thousand black people and a smattering of whites filled the vast auditorium where the ceremony was held. A friend, after reading a copy of the speech I was about to give, seemed somewhat apprehensive. Pushing back a drape so that I could see the waiting audience, he said, "There's a thousand hardcore young militants sitting out there in the middle of the room."

Realizing what he was getting at, I replied, "All the better." Then I went out, accepted the honors, and began my speech. When I came to the part my friend was concerned about I glanced at him. He

stared toward the floor. Going on I explained how Malcolm X had refused to call me brother until we had traveled the fire together—the fire of police brutality, shootings, and murder. It had been the heat of this experience that, in the end, welded our relationship into something lasting and meaningful. With my eyes on the group of young militants, I said that there was a direct parallel in their honoring me with their presence on this night; that I wanted to feel that I had also traveled the fire with them, so that they might truly accept me as their brother. But they were to understand that I did not use the word "brother" loosely, that, with the exception of the word "love" it was the one we abused most. No, true brotherhood had to be earned through fire—as we black people knew fire—until it meant the same as love; it took more than a quick thumbgrip and a give-me-some-skin handslap, and more than a black face for it to qualify as love. It meant pushing someone up instead of pulling someone down. It meant reaching back for someone after escaping the hell in which we had been spawned.

I assured them that we all spelled brotherhood the same way we were taught to spell it in school. The trouble was not in the spelling, but in the day-to-day application of it in our lives. In the end I could only warn that the mirror of racism reflected both ways, but that the kind of racism that blacks practiced against blacks was the most destructive of all; that only when we gained respect for ourselves would we have the right to address each other as brothers.

After a moment of deafening silence there came, to my relief, a tremendous applause. The young "militants" had sprung to their feet chanting, "Brother! Brother!" It had been a difficult speech to make, but obviously the young blacks knew something of what I had grown to know. Profoundly moved, I stood waving to them as they continued to chant and applaud, and I hoped that they would shake off forever that nihilistic behavior toward one another that still persists among some of their elders. Nothing is so senseless as self destruction—and, there is no heart more fulfilled than one that beats with love. On the final line this, to me, is what living has been all about.

32

Genevieve:
"Ah, love, let us be true . . ."

In the end it was not a matter of leaving Elizabeth at the door in tears. We talked it over as intelligently as our emotions allowed, and decided to remain friends—for Leslie's sake and ours. And despite those agonizingly necessary moments when lawyers—with their legal meanderings—came to churn things up, we have remained good friends. When Leslie was old enough Elizabeth explained our breakup in a most admirable way, and she has insisted our child be with me whenever possible.

After a respectable wait beyond the divorce proceedings, Gene and I got married at her sister Frankie's country home in Pound Ridge, New York, on Aguust 26, 1973. On this occasion I had the rare pleasure of having two "best" men, my son David and my grandson Alain.

Leslie, who had just turned six, arrived in a lovely, short pink sundress—which I preferred she wear. However beneath her arm she carried a long ruffled dark dress—which she preferred to wear. Tempers quietly flared. The guests were already arriving, so I *demanded* that she obey me. Being an obedient child, she did, and hold-

ing her thoughts to herself, she put on my choice. But as she left the room she turned and said, "Heh, Dad, I know this is your wedding day, and I want you to be happy. But take it from me, in this outfit I won't be the least bit happy." Like a wise father I *demanded* that she wear what she wanted to wear.

It was a lovely wedding and took place on a sloping green lawn banked with flowers. Close relatives and friends from the publishing world attended, along with a sizable part of the Chinese community, some coming from as far away as the Orient. Although my own family had scattered and most of my brothers and sisters were dead, I suddenly had a host of wonderful new relatives. Most Chinese women are called aunts by the younger children, and most Chinese men are called uncle. In a few moments I had also become an "uncle." One of my presents was a Chinese "chop block" with my new name carved into it: *Kao Teng Pai,* which means high achiever. I also realized at the reception that a gathering of Chinese makes almost as much noise as a gathering of blacks; so at the large parties and dinners later on, I felt right at home.

Some of the children in Gene's family have had a few problems concerning me. Douglas, the six-year-old son of Gene's sister Shirley, recognized a photograph of me being used at a class lecture. "That's my Uncle Gordon!" he shouted.

"Quiet, Douglas," said the astonished teacher. "That's Gordon Parks and he couldn't be your uncle." He looked at Dougie, who looks more Chinese than most Chinese, and shook his head. The child must have been having illusions.

Naturally this got Dougie pretty upset. Reaching home in an angry state, he called and we arranged to straighten that teacher out the following day. When another nephew ran into the same kind of problem at a Westchester school, I armed him with a photograph of myself signed, "From your Uncle Gordon, better known to you as Kao Teng Pai." No more problems.

* * *

It is difficult to say what I remember most about our marriage. It seems now that we were always trying to shake free of our work so that we might fully enjoy one another. Gene spent a lot of time

organizing things and trying to pull my ragged existence together, what with my indulgences in photography, music, writing, and films. Not one for attending those details that keep life going—paying bills, balancing checkbooks, or minding the social calendar—I left most of that to her. She was a stickler for promptness (although she was forever late) and knew what we would have for dinner two months from any given Thursday.

She was a fine editor and worked hard at it. In one year she edited three best sellers. Nancy Mitford's *Zelda,* Stephen Birmingham's *The Grandees,* and Eric Segal's *Love Story.* I was proud of her, even awed by her quiet energy, although she probably never thought so; I seldom expressed my feelings about such things when perhaps she needed it most. But she very rarely talked about her work; she seemed, at times, almost secretive about it. This didn't bother me; I was content to admire her all the more.

We spent many pleasant weekends at Frankie and Oscar Tang's in Pound Ridge where we were married; skiied winters at Vail, and took occasional vacations with her family—usually on some Caribbean island. Then we made several business trips together to Europe and England. Ours was a smooth, almost dreamlike existence at times, laced with exotic Chinese dinners at Gene's mother's house.

My film work nevertheless kept us apart more than we liked, but I shot the two *Shaft* pictures in New York, and that helped. When I was editing on the West Coast we talked by telephone each night, and she would fly out to be with me now and then. But when we were apart, time went slowly. During these periods we seldom wrote, and the telephone never sufficed. There were always unromantic things like rug cleaning, piano tuning, or other domestic nothings that I would rather not have talked about.

At one low point Gene sent me a poem. Creased and time-soiled in my billfold, it traveled the world with me.

> *Ah, love, let us be true*
> *To one another! for the world which seems*
> *To lie before us like a land of dreams,*
> *So various, so beautiful, so new,*
> *Hath really neither joy, nor love, nor light,*
> *Nor certitude, nor peace, nor help for pain;*

And we are here as on a darkling plain
Swept with confused alarms of struggle and flight,
Where ignorant armies clash by night.
—MATTHEW ARNOLD, "Dover Beach"

Dear Gordon, I love you and miss you.
G.

In turn, I wrote this verse for her:

Before I took my mother's blood and breath
I loved you.
When you broke the silence of your first hour,
crying
Through ovaled eyes under some foreign sky,
I had already begun to guard your days.
Each moonfall after,
I tossed a lotus petal into my river of hopes
Until an endless bouquet covered the oceans
that parted us.
Through winter-locked and hungered days,
in
The trials of many doubtful years and over
Hourless and mistaken roads I searched for you.
If, as you say, during pillow-talk, you do not know me,
It is because I am you.
I have been you for a thousand years.
Our love is older than the air.

Gene had moved from Harper and Row to J. B. Lippincott Company in 1970 where, after two years, she was made a vice-president. The pressures from that job, along with my long absences in Hollywood, contributed to the bad cards that started falling for us three years into our marriage. Her work load and office responsibilities had doubled by now, and tension began mounting between us. Eventually, small things we would have normally settled easily, became big, irritable problems. The hasty, loving notes that used to await me on the bathroom mirror each morning, gradually turned into terse unsigned orders. She was displeased when I wasn't at the door to greet her when she arrived evenings. This displeasure was warranted, but most writers feel that the sentence they are momen-

tarily writing is the most important one of their literary career—although they strike a red line through it moments later.

Too, there were times when I might have had dinner ready when she arrived, and a warm towel to wipe the weariness from her face; but the typewriter usually claimed me at such moments. Something dangerous was happening that neither of us seemed able to understand or put an end to. The light, so rainbowed for nearly fifteen years, was clouding over. Our relationship was edging toward the precipice, although the thought of a breakup was disturbing to both of us.

Gene didn't have any illusions about me when we got married. She knew I was a hopeless romantic with a sense of adventure, and that I liked to live wide and free. She also knew that she would have to gather in those stray bits of me that floated about, harness them, and make them work for us in a practical way. This was a rather tough job for anyone. My zest for living had sprung from the kind of existence that *Life* magazine afforded me. I had already traveled more and experienced more than most men do in a lifetime. Gene, on the other hand, had led a rather sheltered life. Her problem was clear. She would have to keep her own career moving, to back up mine with the energy she had left.

She tried—helping to run my corporation and dealing with all those figures that are so nightmarish to me. But, in time, she began to crumble under the load. We argued now and then. I wasn't very good at it at first, but Gene, feeling that we had to deal with our angers, insisted that I learn to fight back. I learned quickly, and perhaps too well.

We tried applying Band-Aids after our scraps. They were all right for minor scratches but not for wounds that spread into angry, unhealable sores. During the height of the depression that was settling over us, Gene gave an interview to a magazine, one that hurt me more than I was willing to admit. Finally one night we argued violently about it. Tears came to her eyes. She got up and went to the bedroom and shut the door.

I turned out the living-room lights and sat in the darkness, ashamed of my anger. I sat there most of the night, remembering all the good things there were to remember, but feeling that we had lost something along the way that could not be found again. Our love

had grown dusty; perhaps we had outgrown it. Reclaiming the nectar of those first sweet springs was taking more effort than either of us seemed willing to give.

Our marriage wasn't working. We still loved one another, but understanding had taken leave of us. We turned back to the past we had shared, but even that seemed to deny us any hope. Then suddenly we knew that it was all over.

It is a cold February morning as I finish this memoir. The Azaleas I gave Gene one Valentine's Day are in bloom again, sitting in the window soaking up sun. Her wedding bouquet, once so pink, is still in my study—brown now and crumbling above its silver vase, refusing the ordinary death of bouquets. Only dry petals are left wasting on the brittle stems. I'm often tempted to do away with it, but it manages to stay on. That bouquet, the last vestige of our vows, has a sacred feel about it.

I sit now drowning in the music of Ravel, looking out on the slow-moving river. Jagged patches of ice—like parts of a huge broken white bird—float downstream to the sea. On the shore, a lone woman clad entirely in black dances crazily, stopping now and then to kick up snow in her fury. At first I thought she was expressing joy; she looked so happy. But now I don't know. Perhaps she dances out of some sort of madness. I watch, fascinated—yet a little fearful—as she moves closer to the waterside. The river flows, the woman dances—both to the rhythm of Ravel, which neither can hear. Now she is stopping, holding her arms akimbo, then slowly she stretches them skyward and begins a dreamlike waltz to the river's edge. She totters. I dial police emergency, hoping she's not about to end it all in the icy water. Now she raises her arms again and begins dancing back toward safer ground; and I am relieved.

What does all this mean? I have no idea. I write it down as one of God's secrets. I seek nothing beyond the strange experience and the momentary joy of having witnessed something that deserves remembering. It was both frightening and beautiful:

> She in all her black
> Swirling to Ravel in a
> Vastness of white alongside
> A slowmoving river flowing
> still flowing

With patches of a white bird
frozen
Broken and jagged, flowing
As she waltzed her madness
On some cold wintry shore.

For me that's the way a poem might begin. But, unlike that woman, I won't disappear from the winter whiteness. I have still to travel parts of those roads that passed my father's house. He was right about the unfixed tolls and the unmarked distances. He was right about the devious signs I would see along the way. Sometimes I didn't question them enough. Only now do I understand why they pointed me in certain directions. From the beginning I knew what he meant about the differences in the roads I would take. But not until the trembling days and nights of the black revolution did I understand that "All same things are not really the same." In selecting my enemies, I'm afraid I failed miserably, but I have managed to avoid those things that die easily. And contrary to the warning that his advice might amount to nothing—it has meant everything. It keeps me moving steadily toward other flowering springs.

Epilogue

*S*everal times I have crossed the world; and I remember each stone and spring, each flower and century dying with a kind of dying even rivers can't escape. I've been born again and again, always finding something or someone to love, to win or lose, to mourn or celebrate.

Now, with life quieting down around me, I look back through an autumn mind, searching the clear air for the roots of things I watched growing or expiring along the way. Wherever my feet have taken me I have found both goodness and pain; and that's all I have to give. I could depart with washed hands, keeping the silence and telling nothing. But I have no secret doors to hide the memories.

This memoir, *The Learning Tree,* and *A Choice of Weapons* should hold more than a man needs to explain himself. Not that I'm finished. Having lived a lot and done just about everything I've wanted to do makes me want to live and do even more. In any case, it all boils down to the fact that I've swum the tide with others—some who tried pulling me under; others, who at the risk of going under themselves, helped me toward shore. Naturally the latter ones I consider my heroes. But in the end I had to save myself.

I mentioned heroes. The world is filled with all kinds of them. Every country, city, and town has closets full of them. I've seen a beast in hero's clothing, and I've seen real heroes going· about in rags, searching garbage cans for supper. I've met all kinds—big, fat, ornery ones, black and white—who were so weightless you could carry them like balloons under your arms; and little ones, so heavy with goodness it would take a thousand hands to carry them to their graves. I've known some who raised monuments to themselves while others, who deserve to be remembered, are buried and forgotten. The real size of a hero, it seems, is determined by how you take his measure.

As for all of us ordinary humans—for a long time I have entertained the impossibility of putting each one of us into a tiny room; of letting us remain silent for a moment, and then, separately, speak the absolute truth of ourselves, knowing the smallest lie could hurl us into fiery space. There we might realize how common our needs are; that hunger, hatred, and love are the same wherever we find them; that the earth, in relation to our time upon it, is hardly the size of a grain of sand. Perhaps then, in the justice of understanding, we could escape the past that imprisons us.

As for myself, I still don't know exactly who I am. I've disappeared into myself so many different ways that I don't know who "me" is. I suppose I'm doing all right. Yet I'm never quite sure; there's always some idiot hiding in one of the corners of myself, trying to foul up my intelligence.

Whether to forget my past or respect it, whether to consult it or reject its errors—that has been the problem. I got a lot of advice along the way. I took some and ignored some. When a change was necessary I went along with it—providing it didn't differ too much with the heart my parents gave me. Driven by insatiable hunger, I have gone slowly through many seasons in search of what I wanted most to find.

I don't know what all this means. To me it seems that my years have tumbled upward out of darkness. At times I felt like a tattered black flag gone limp above a wasteland; at other times I've felt like a fine horse galloping the wind. That's the way certain days leave you feeling. That's the way life keeps you dying an interesting death.

In time I had passed my father's words on to my eldest son. He chose the wisdom of their meaning and took the road his grandfather would have approved. But this road, with its unmarked distance, made a cruel turn. Last April Gordon, Jr., died in a plane crash outside of Nairobi, Kenya, paying the toll I hoped he wouldn't have to pay for traveling so short a distance. But what we hope for matters little to the inevitability of things. Each road has its own winding; each night its own song—and there is no worse song to sing than one of grief.

At first, attempting to grasp the reality of what happened was like trying to hold on to a shadow. I could only pray that it was a mistake, or perhaps a bad dream. Then finally the truth of it struck me hard: he was gone forever.

I think back now and then, remembering the boy astride his favorite horse, galloping the wild fields; the strong boy beside me on his skiis, sending snow flying as we plummeted down a mountainside. We had been close, very close, but now it seems we might have been even closer. There are so many things left unsaid, so many confidences and dreams left unshared. What he accomplished during the days alloted to him gives me solace—but not enough. I still question why he was denied the right to travel a longer road.

Gradually I am learning to think of him, as he would have me think, sleeping peacefully at the footlands of Kilimanjaro, the mountain he talked about so much; of his ashes blowing freely over the green hills of Africa, where he wanted them spread, those Kenya hills that he paid homage to.

His love lived in my love for him, and there are moments when I want to see him and talk with him. Fortunately, he left good things for me to remember, to keep remembering, and to make conversation with. His candle flamed out much too quickly, but he left a brighter flame to burn and mark the place where his had ended. That flame will help me endure until his own unborn child arrives to help keep back the darkness. This child, still in its mother's womb—and the bittersweet of my son's death—will, I hope, keep its father's memory and goodness flowing.

B
PARKS Parks, Gordon

To smile in autumn

$11.95

DATE			

MAR 1 0 1980 N

© THE BAKER & TAYLOR CO.